photographing people

portraits | fashion | glamor
new edition

RotoVision

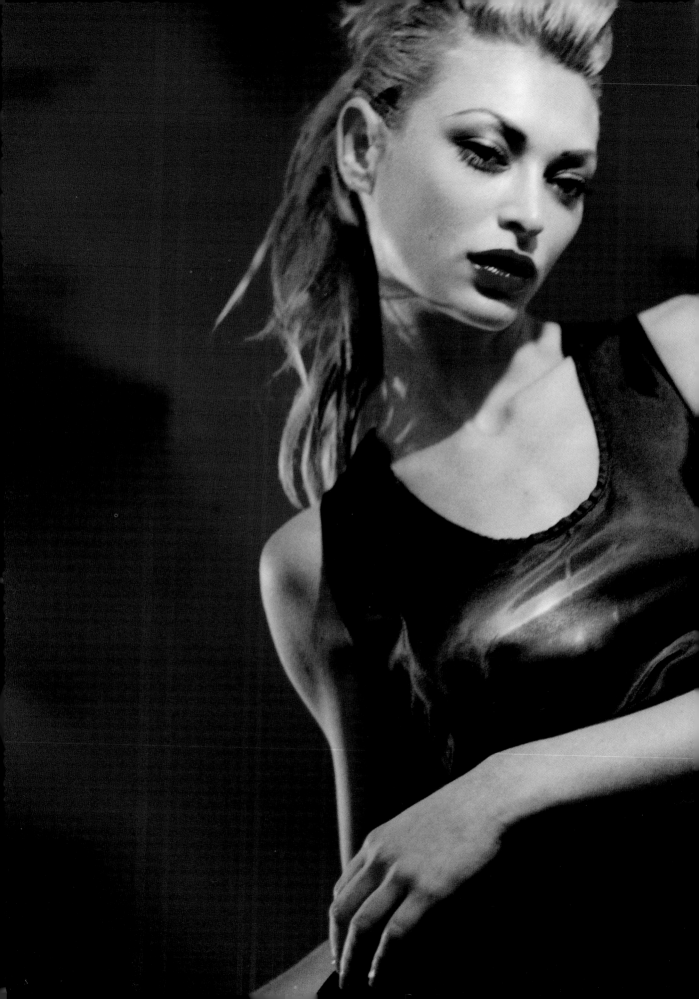

photographing people

portraits | **fashion** | **glamor**

new edition

Roger Hicks | Frances Schultz | Alex Larg | Jane Wood

A RotoVision book

Published and distributed by
RotoVision SA
Route Suisse 9
CH-1295 Mies
Switzerland

RotoVision SA, Sales & Editorial office
Sheridan House
114 Western Road
Hove, East Sussex BN3 1DD, UK
Tel: +44 (0)1273 72 72 68
Fax: +44 (0)1273 72 72 69
Email: sales@rotovision.com
Web: www.rotovision.com

10 9 8 7 6 5 4

ISBN (10 digit) 2-940378-07-X
ISBN (13 digit) 978-2-940378-07-4

Designed for RotoVision
by Becky Willis
at
Design Revolution
Brighton, UK.

Project Editor: Nicola Hodgson

Revised edition 2006 by Steve Luck

Reprographics in Singapore by ProVision Pte. Ltd.
Tel: +65 6334 7720
Fax: +65 6334 7721

Printed in Singapore by Star Standard Industries (Pte) Ltd

contents

foreword

People are easily the most popular subject for photography, with countless millions of pictures of individuals, couples, and groups taken every year. The good news for professional photographers, and those aspiring to join their ranks, is that the market for images of people is enormous, and is growing every day. You need only look at the proliferation of periodicals of all kinds and the omnipresence of advertising and promotional material to know that that is the case. Photographs of people are an essential element for all but a few. Many product shots include a person to capture the interest of potential buyers, and even travel images often feature people enjoying the location.

Of course, there are many different approaches to photographing people, from the straight "portrait," where the intention is to capture something of the character or personality of the person, through to more specialist areas such as fashion, where the emphasis is more on the clothes, and glamor, where creating sexy, erotic images is what is required.

Approaches to people

Whatever the approach or style of the photographer, interpersonal skills are every bit as important as photographic ability. You need to be able to get your subject to relax and cooperate with you. They may not be in the mood, or they might prefer to be somewhere else. Many people tense up in front of the camera, resulting in stiff body language and cheesy grins that ruin the shot. However, with the right approach, using skills to create a rapport and capturing the subject in a natural pose, the picture can be a true and lasting portrait that reveals something of the real person, and not just a superficial snapshot. Just talking to the person about their life and interests is all it takes to break the ice and establish a good working relationship.

Of course, that doesn't mean you can dispense with the technical aspects of picture taking. You still need to light, expose, and compose the shot correctly—but after a while that should be automatic, so well practiced you don't even think about it.

Some decisions will inevitably be more consciously taken, such as how big the person is in the frame, where precisely you place them, and whether you want them looking at the camera or not.

Lighting and location matters

As with all areas of photography, lighting is one of the key factors to consider. Do you work with daylight, adapting it to your needs, or do you create your own lighting arrangements using tungsten or flash?

This will depend to some degree on whether you are shooting in the studio or on location. Studios offer the ultimate in control, but their very nature imbues the results with a degree of artificiality unless great effort is made to create a convincing set. Working on location is more "real," but considerably less controllable. You also have to take all your equipment with you, which creates its own challenges.

The lighting you use will also depend on the style of the image and where it will be used. With "standard" portraiture the trend is toward a simple approach, using one or two heads, perhaps supplemented by reflector boards, to mimic daylight. One light, fired through a large umbrella or soft box, will produce soft, flattering illumination similar to that on a sunny day with thin cloud—and can be set up in a couple of minutes. Where there's more time, other heads can be added as required. With glamor, more lights are often used, to accent or define different parts of the model's body. The more imaginative the lighting the better.

In practice, most photographers quickly establish a repertoire of lighting set-ups that work for them and their clients, to which they return time and again. But it is essential not to get stuck in a rut. You need to keep experimenting if your images are to remain fresh and contemporary. You might also like to investigate specialist lights such as a ring flash, which can be hired in for particular shoots.

Equipment matters

Today the most widely used cameras for pictures of people—whether portraits, fashion, or glamor—are medium format models and their digital equivalent. They provide a comfortable balance between convenience and image quality, where rapid hand-held reaction is less of a priority, but high resolution and smoothness of skin tones are important factors.

Traditionally such cameras were loaded with a variety of roll-film stock, with each stock—whether transparency, print, color, or black and white—offering its own unique qualities. However, more recently photographers have begun to put high-resolution digital backs on their cameras. The resolution tipping-point between film and digital has now been passed, and the technical advantages are with the latest digital backs. Some photographers nevertheless prefer the more forgiving tonal response of film, particularly in the highlights and shadows, and film's overall character.

In all areas of people photography, the 335mm2 format is becoming more widely used on account of its responsiveness and speed of use—and here of course digital SLRs are on a parity in terms of image quality as their film precursors. Again, the instant feedback is popular with both photographer and customer alike. Coupled with sophisticated image-editing software such as Adobe Photoshop and ever-powerful desktop computers, the digital workflow has put the creative aspect of post-production work firmly in the control of the photographer.

Although methods of working and camera technology are slowly changing, lenses remain a constant—taking into account that the smaller image sensors on some digital SLRs have a crop factor of between 1.3 and 1.6. Lenses tend to be either standard focal lengths, giving a natural-looking perspective, or slightly telephoto, producing a flattering perspective without crowding the subject.

Steve Bavister

how to use this book

The lighting drawings in this book are intended as a guide to the lighting set-up rather than as absolutely accurate diagrams. Part of this is due to the variation in the photographers' own drawings, some of which were more complete (and more comprehensible) than others, but part of it is also due to the need to represent complex set-ups in a way that would not be needlessly confusing to the reader.

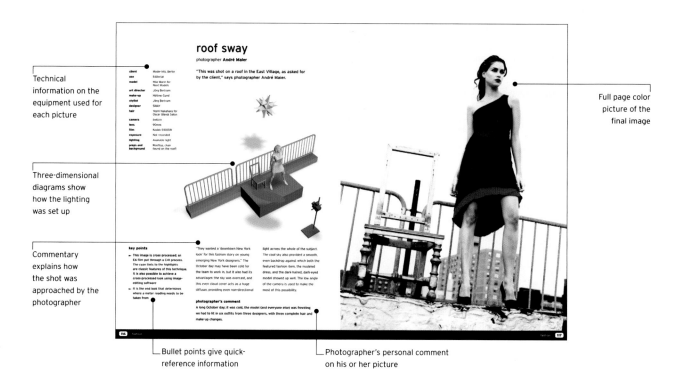

Technical information on the equipment used for each picture

Three-dimensional diagrams show how the lighting was set up

Commentary explains how the shot was approached by the photographer

Full page color picture of the final image

Bullet points give quick-reference information

Photographer's personal comment on his or her picture

Distances and, occasionally, sizes have been compressed and expanded in these diagrams. In addition, because of the vast variety of sizes of soft boxes, reflectors, bounces, and other equipment, we have settled on a limited range of conventionalized symbols. Sometimes, too, we have reduced the size of big bounces, in order to simplify the drawing.

None of this should matter very much, however. After all, no photographer works strictly according to rules and preconceptions. There is always room for improvisation and adjustment, to move this light a little to the left or right, to move that light closer or further away, and so forth, according to the needs of the shot. Likewise, the precise power of the individual lighting heads or (more important) the lighting ratios are not always given. Again, this is something that can be fine-tuned and played around with by any photographer wishing to reproduce the lighting set-ups demonstrated in this book.

We are confident, however, that there is more than enough information given about every single shot to merit its inclusion in the book. As well as discussing lighting techniques, the photographers reveal all kinds of hints and tips about commercial realities and photographic practicalities, and the way of the world in general, such as working with models and creating special effects.

The book can be used in a number of ways. The most basic, and perhaps the most useful for the beginner, is to study all the technical information concerning a photograph that he or she particularly admires, together with the lighting diagrams, and to try to duplicate that shot as far as possible with the equipment that they have available.

A more advanced use for the book is as a problem-solver for difficulties that have already been encountered during a photography session: creating a particular technique of back lighting, say, or of creating a feeling of light and space.

And, of course, the book could always be used, by beginner, advanced student, or professional, simply as a source of inspiration and enjoyment.

The information for each picture follows the same plan, though some individual headings may be omitted if they were irrelevant or the information was unavailable. The photographer is credited first, then the client, together with the use for which the picture was taken. Next come the other members of the team who contributed to the session, including stylists, models, art directors, and anyone else involved. Camera and lens come next, followed by film. With film, we have named brands and types, because different films have very different ways of rendering colors and tonal values. Exposure is listed next: where the lighting is electronic flash, only the aperture is given, as illumination is of course independent of the shutter speed. Next, the lighting equipment is briefly summarized—whether it was tungsten or flash, and what sort of heads there were. Finally, there is a brief note on props and backgrounds. Often, these will be obvious from the picture, but in other cases you may be surprised at what has been pressed into service, and how different it looks from its normal role.

The most important part of the book is, however, the pictures themselves. By studying these, and referring to the lighting diagrams and the text as necessary, you can work out how they were created.

diagram key

The following is a key to the symbols used in the three-dimensional diagrams. All commonly used elements, such as standard heads and reflectors, are listed. Any special or unusual elements involved are shown on the relevant diagrams.

three-dimensional diagrams

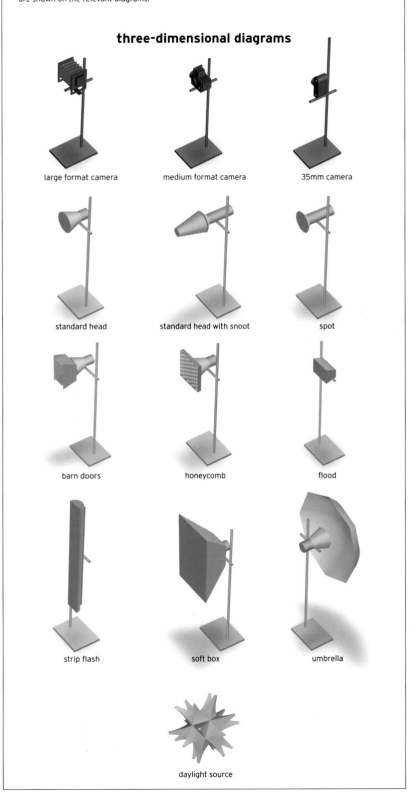

large format camera medium format camera 35mm camera

standard head standard head with snoot spot

barn doors honeycomb flood

strip flash soft box umbrella

daylight source

glossary of lighting terms

Lighting, like any other craft, has its own jargon and slang. Unfortunately, the different terms are not very well standardized. Often the same object may be described in two or more ways or the same word used to mean two or more different things. For example, a sheet of black card, wood, metal, or other material that is used to control reflections or shadows may be called a flag, a French flag, a donkey, or a gobo—though some people would reserve the term "gobo" for a flag with holes in it, which is also known as a cookie. In this book, we have tried to standardize terms as far as possible. For clarity, a glossary is given below, and the preferred terms as used in this book are indicated by an asterisk (*).

Acetate
see Gel

Acrylic sheeting
Hard, shiny plastic sheeting, usually methyl methacrylate, used as a diffuser ("opal") or in a range of colors as a background.

***Barn doors**
Adjustable flaps affixed to a lighting head that allow the light to be shaded from a particular part of the subject.

Barn doors

Boom
Extension arm allowing a light to be cantilevered out over a subject.

***Bounce**
A passive reflector, typically white but also, (for example) silver or gold, from which light is bounced back onto the subject. Also used in the compound term "Black Bounce," meaning a flag used to absorb light rather than to cast a shadow.

Continuous lighting
What its name suggests: light that shines continuously instead of being a brief flash.

Contrast
see Lighting ratio

Cookie
see Gobo

***Diffuser**
Translucent material used to diffuse light. Includes tracing paper, scrim, umbrellas, and translucent plastics such as Perspex and Plexiglas.

Electronic flash: standard head with diffuser (Strobex)

Donkey
see Gobo

Effects light
Neither key nor fill; a small light, usually a spot, used to light a particular part of the subject. A hair light on a model is an example of an effects (or "FX") light.

***Fill**
Extra lights, either from a separate head or from a reflector, which "fills" the shadows and lowers the lighting ratio.

Fish fryer
A small soft box.

***Flag**
A rigid sheet of metal, board, foam-core or other material used to absorb light or to create a shadow. Many are painted black on one side and white (or brushed silver) on the other, so they can be used either as flags or as reflectors.

***Flat**
A large Bounce, often made of a thick sheet of expanded polystyrene or foam-core (for lightness).

Foil
see Gel

French flag
see Flag

Frost
see Diffuser

***Gel**
Transparent or (more rarely) translucent colored material used to modify the color of a light. It is an abbreviation of "gelatine (filter)," though most modern "gels" are acetate.

***Gobo**
As used in this book, synonymous with "cookie:" a flag with cut-outs in it, to cast interestingly shaped shadows. Also used in projection spots.

"Cookies" or "gobos" for projection spotlight (Photon Beard)

***Head**
A light source, whether continuous or flash. A "standard head" comes fitted with a plain reflector.

*HMI

Rapidly pulsed and effectively continuous light source approximating to daylight and running at far cooler temperatures than tungsten lights. They are most commonly used in studios that use digital scanning backs.

Honeycomb (Hensel)

*Honeycomb

Grid of open-ended hexagonal cells, so called because it closely resembles a honeycomb. This increases the directionality of light from any head.

Incandescent lighting

see Tungsten

Inky dinky

Small tungsten spot.

*Key or key light

The dominant or principal light, the light which casts the shadows.

Kill spill

A large flat that is used to block spill.

Electronic Flash: light brush "pencil"

Electronic Flash: light brush "hose" (Hensel)

*Light brush

Light source "piped" through fiber-optic lead. Can be used to add highlights, delete shadows, and modify lighting, literally by "painting with light."

Lighting ratio

The ratio of the key to the fill, as measured with an incident light meter. A high lighting ratio (8:1 or above) is very contrasty, especially in color, a low lighting ratio (4:1 or less) is flatter or softer. A 1:1 lighting ratio is completely even, all over the subject.

*Mirror

Reflectors are rarely mirrors, because mirrors create "hot spots" while reflectors diffuse light. Mirrors (especially small shaving mirrors) are widely used, almost in the same way as effects lights.

Northlight

see soft box

Perspex

A brand name for acrylic sheeting.

Plexiglas

A brand name for acrylic sheeting.

*Projection spot

Flash or tungsten head with projection optics for casting a clear image of a gobo or cookie. Used to create textured lighting.

Electronic Flash: projection spotlight (Strobex)

Tungsten Projection spotlight (Photon Beard)

*Reflector

Either a dish-shaped surround to a light, or a bounce.

*Scrim

A heat-resistant fabric diffuser, used to soften lighting.

*Snoot

Conical restrictor, fitting over a lighting head. The

Tungsten spot with conical snoot (Photon Beard)

Electronic Flash: standard head with parallel snoot (Strobex)

light can only escape from the small hole in the end, and is therefore very directional.

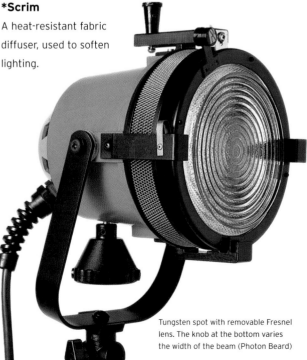

Tungsten spot with removable Fresnel lens. The knob at the bottom varies the width of the beam (Photon Beard)

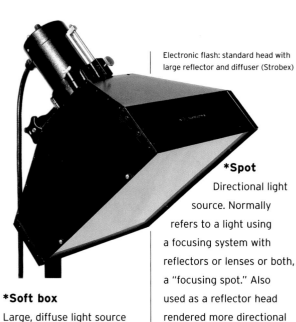

Electronic flash: standard head with large reflector and diffuser (Strobex)

*Soft box

Large, diffuse light source made by shining a light through one or two layers of diffuser. Soft boxes come in all kinds of shapes and sizes. Some are rigid; others are made of fabric stiffened with poles resembling fiberglass fishing rods. Also known as a northlight or a windowlight, though these can also be created by shining standard heads through large diffusers.

*Spill

Light that ends up other than on the subject at which it is pointed. Spill may be used to provide fill or light backgrounds. It may be controlled with flags, barn doors, or gobos.

*Spot

Directional light source. Normally refers to a light using a focusing system with reflectors or lenses or both, a "focusing spot." Also used as a reflector head rendered more directional with a honeycomb.

Electronic flash: strip light with removable barn doors (Strobex)

*Strip or strip light

Lighting head, usually flash, that is longer than it is wide.

Strobe

Electronic flash. Strictly, a "strobe" is a stroboscope or rapidly repeating light source, though it is also

Tungsten spot with safety mesh (behind) and wire half diffuser scrim (Photon Beard)

the name of a leading manufacturer: Strobex.

Swimming pool

A very large soft box.

*Tungsten

Incandescent lighting. Photographic tungsten

Electronic flash: standard head with standard reflector (Strobex)

lighting runs at 3200 K or 3400 K, as compared with domestic lamps which run at 2400 K to 2800 K.

*Umbrella

Exactly what its name suggests; used for modifying light. Umbrellas may be used as reflectors (light shining into the umbrella) or as diffusers (light shining through the umbrella). An umbrella is the cheapest way of creating a large, soft light source.

Windowlight

Apart from the obvious meaning of light through a window, or of light shone through a diffuser to look as if it is coming through a window, this is an alternative name for a soft box.

Tungsten spot with shoot-through umbrella (Photon Beard)

why we did this book

The most common response from the photographers who contributed to this book, when the concept was explained to them, was "I'd buy that." Our aim was simple: to create a book illustrated with first-class photography from all around the world, which showed exactly how each individual photograph featured in the book was lit.

Who will find it useful? Professional photographers, obviously, who are either working in a given field or want to move into a new field. Students, too, who will find that it gives them access to a very much greater range of ideas and inspiration than even the best college can hope to present. Art directors and others in the visual arts will find it a useful reference book, both for ideas and as a means of explaining to photographers exactly what they want done. It will also help them to understand what the photographers are saying to them. And, of course, "pro/am" photographers who are on the cusp between amateur photography and earning money with their cameras will find it invaluable: it shows both the standards that are required, and the means of achieving them.

The lighting set-ups in the book vary widely, and embrace many different types of light source: electronic flash, tungsten, HMIs, and light brushes, sometimes mixed with daylight and flames and all kinds of other things. Some are very complex; others are very simple. This variety is important, both as a source of ideas and inspiration and because the book as a whole has no editorial bias toward one kind of lighting or another.

The pictures were chosen on the basis of impact and (occasionally) on the basis of technical difficulty. Certain subjects are, after all, notoriously difficult to light and can present a challenge even to experienced photographers. Only after the picture selection had been finalized was there any attempt made to understand the lighting set-up.

This book covers the diverse genres of portrait, fashion, and glamor photography. The intriguing thing in all of them is to see the degree of underlying similarity, and the degree of diversity, which can be found in a single discipline or genre. In portraiture, for example, there is remarkable preference for monochrome and for medium formats, though the styles of lighting are very varied. Glamor shots concentrate on models, often nudes, and soft lighting tends to be used, though having said that, many of the bold new-style shots are deliberately stark and provocative and the choice of harsher lighting can be used to good effect in these cases. Fashion changes with each passing year and each trend changes the images being sold, as the collection of photographs in this book shows.

portraits

This section explains the techniques behind a successful portrait shot. The photograph must capture the subject's significance, whether it is the naivety of a child, the importance of a self-made millionaire, or the well-known personality of a celebrity. In each case, the lighting set-up is fundamental to achieving the right effects.

Until the invention of photography, the "likeness" was the preserve of the very rich. Skilled painters and sculptors have always been a rare commodity, and their work takes a long time, which translates into high costs.

Traditionally, portraits were intended to be as flattering as possible. We do not really know what (say) Queen Elizabeth I looked like. We may assume that her famous portraits were passing likenesses, but it is less certain that we would recognize her from them if we were to see her in the street, dressed perhaps in jeans and a T-shirt instead of the magnificent court dresses, stiff with jewels, in which she was usually represented.

The tradition of flattery and aggrandizement lasted well beyond the invention of photography. Think of pictures of Lenin. The style in which his portraits and statues were created makes him look far more heroic than his photographs; but we remember him from his iconic representations, not from his "likenesses."

Even where realistic portraits are readily available, there is still a tendency to accept the iconic over the homely or naturalistic: think, for example, of the countless portraits of Winston Churchill that exist, and of the relatively few that appear again and again in the press and that have achieved iconic status partly as a result of their inherent qualities, and partly through sheer repetition.

To this day, therefore, the portrait lends itself remarkably well to deconstruction. For example, it may be a symbol of The Business Leader, The Family Man, The Professor, The Affluent Consumer, The Sex Goddess. In this sense, it is to some extent independent of its subject. He or she is merely a tool that is used to illustrate a theme or to sell a product (an airline ticket, a brand of beer) or a concept (the American way of life, success in academia, European café society).

In another context a portrait may be a "likeness" of a particular person— but the camera always lies. Through one photographer's lens, the subject is relaxed, cheerful. Through another's he or she is stern, cold, harsh. In yet a third context the image may transcend both personality and symbol: we see an arrangement of curves and textures and lines that is in itself beautiful.

This leads us to the question of why photographers take portraits. Some do it just for money, of course. But even the most commercial of portrait photographers must have a reason to photograph people instead of something else. And many photographers sincerely want to capture a likeness that is more than skin deep; they want to "get under the skin" of their subject, to make a psychological interpretation.

The circularity of the process then becomes apparent: the portrait is as much a psychological interpretation of the photographer as of the subject. There are cruel photographers and there are kind ones, gentle photographers and harsh photographers, light-hearted photographers, and serious ones. The photographer takes portraits for one set of reasons, and the subject may sit for them for an entirely different set of reasons, and the picture is the only place where they meet.

Studios and contexts

The choice between a studio portrait and a portrait of the subject in a wider context—the so-called "environmental" or location portrait—is a matter of personal styles; and besides, there are no real distinctions between the two. Some traditionally minded portrait photographers maintain built sets in which to photograph their sitters: the book-lined library is a well-established favorite, and the boudoir has apparently done well for some. Equally, a location may be so bare that it supplies little more context than a roll of background paper.

Even so, the photographer must consider which approach to take. Some take their lead from Richard Avedon and photograph their subjects against a featureless white background; others like to show people in settings that are crowded almost to the point of surrealism. There are also many options in between. Arguably, though, the photographer must rely more on psychological interpretation when the background is minimal; in a more complex environment, whether a built set or a location, he or she is more concerned with the gestalt, the whole.

Remember, too, that few people are one-dimensional and consistent: they exist in different milieus, and by learning a little more about them, you may be able to place them in a setting with which they, or you, or both, are more at ease. The lawyer, for example, may also be a windsurfer; the accountant may ride a motorcycle. However, remember that there can be a gap between how people want to see themselves, and how they are going to look convincing. Some accountants are never going to look like bad-ass bikers, and some Hell's Angels are never going to look like accountants.

Clothes, props, and make-up

As with the choice between the bare background and the crowded environment, so the photographer (and the sitter) must also choose between

the casual picture, taken in everyday clothes, and the more formal portrait. If the photographer leans toward the formal or the pseudo-informal, or if the portrait is to be used for advertising or some other public purpose, then it may be worth calling on make-up artists and hairdressers and even professional clothing advisers and prop-finders.

Working on a more modest scale, the photographer must at least be aware of what make-up, hair, and careful choice of clothes and props can do, and it is a good idea to talk through a portrait with the subject before they come to the studio. Ask them what they intend to wear, what sort of image they want to project—and advise them to bring a favorite and characteristic personal possession. Everyone has personal foibles; it is the job of the paid portraitist to capture them.

Cameras for portraits

Most portraitists use a medium-format reflex, typically with a longer-than-standard lens; in fact, 150mm and 180mm lenses on medium-format cameras are often known as "portrait" lenses. Medium formats allow better sharpness, smoother gradation, and less grain than 35mm, but are still sufficiently rapid-handling to allow a degree of spontaneity. They are also significantly cheaper to run than large-format cameras. The modern tendency is in any case to shoot a number of similar portraits—typically a roll or two of 120, between 10 and 30 images—and then to select the best.

Another reason why rollfilm is so popular among portrait photographers is that special color negative portrait films in this format are offered by a number of manufacturers. They are optimized for skin tones, and typically have a lower contrast than standard color films. An increasing number of portrait photographers are trying out digital backs on their medium-format cameras. The results are subtly different, with digital images achieving their own characteristic look. Many photographers find the fast digital workflow appealing, but will usually shoot film as a backup.

There is also a place for 35mm in portraiture; either conventional film or digital, often with very long lenses; and surprisingly often Polaroid materials are used, which give effects quite unlike those obtainable with anything else.

Lighting equipment for portraits

The first and most important generalization about lighting for portrait photography, which immediately distinguishes the skilled portrait photographer from the unskilled, is that the background is separately lit from the subject. This allows the background to be lightened or darkened (or graded) independently of the subject. In order to do this, there must be a fair amount of space between the subject and the background: at the least 5ft (1.5m) and preferably 6½ or even 10ft (2 or 3m).

After this, it is surprising how many photographers use a single light to one side of the camera plus a reflector on the other side to provide a fill. If more than one light is used, it should be used with good reason. Hair lights are one example, but they are only one of many kinds of effects lights that are used to draw attention to a particular feature.

Another reason to use extra lights (or multiple reflectors) is to create a very even overall light. As a rule, highly directional lighting is more widely used for men, and more diffuse and even lighting for women and children.

The team

Many portrait photographers work alone, though it is often useful to have an assistant to move the lights so that the photographer can judge the effects without having to leave the camera position. It is also good to have remote controls for the lights so that they can be switched on or off, or turned up or down, from the camera position.

In advertising and publicity photography, and in the higher reaches of corporate portraiture, at least one assistant is all but essential and there is likely to be a need for specialist make-up artists, etc, as mentioned above.

The portrait session

Sometimes a portrait session goes as if by magic. There is an immediate rapport between the photographer and the subject and they spark ideas off one another. At the other extreme, the sitter is in a hurry and does not particularly want to be photographed in any case. As quickly as possible, the portraitist has to put the sitter at ease, get the picture, and get out.

Either way, the preparation is the same. The photographer must have a clear idea of how to set up the session: where the lights are going, what the pose and props will be, and how the picture will be framed.

The photographer should know something about the sitter in advance: easy conversation can make all the difference between establishing a rapport with the subject and a formal, lifeless portrait. Some photographers have a natural gift for this; others do not. Beyond this, it is down to you. Portraits are perhaps the most idiosyncratic branch of photography and the personality of the photographer can be paramount.

gorinsky

photographer **Michael Freeman**

use	Editorial
camera	Hasselblad
lens	80mm
film	Tri-X
exposure	1/125 second at f/11
lighting	Available lighting

Even for posed portraiture, in which the assumption is that there is sufficient time and facilities to set up lighting as necessary, daylight pure and simple can have considerable advantages.

key points

► With color film, judging the bluish color temperature in the shade would have been a matter of guesswork without a color temperature meter, but this was not an issue in black and white

For this portrait of a rancher in the interior of Guyana, the reflected light from a bright tropical day had a luminous quality because of its strength and proximity. Normally, shade in clear weather tends to be highly diffused and as a result rather flat, but here in the tropics the sun is almost overhead and intense. As a result, shadowed areas are much smaller than in temperate climates because the rays are vertical, and the edge of the shadow cast by the roof of this rustic, earthen ranch house is only just in front of the chair, fractionally out of frame (a small chink of light filtering through the edge of the eaves falls on the hat in the man's hand).

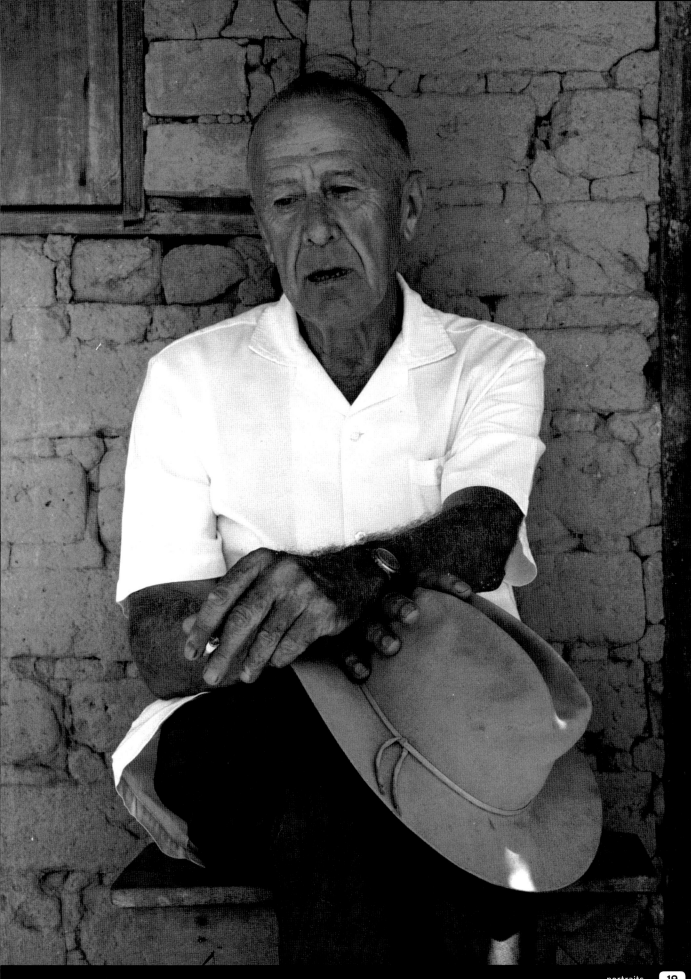

kuma

photographer **Michael Freeman**

use	Editorial
camera	Nikon F5
lens	105mm
film	Tri-X
exposure	⅟₃₀ second at f/5.6
lighting	Electronic flash
props	Wooden slatted walls painted with Japanese characters

Uplighting is not usually flattering for portraiture, but the style of this image was reportage, and the high contrast was softened with an off-camera portable flash aimed from camera right.

key points

► Shooting with black-and-white film made the most of the ambiguity of this setting

This well-known Japanese architect makes considerable use of open slats in various materials as part of a technique he calls "particlising," and this signage display in a pedestrian precinct in Tokyo, designed by the architect himself, seemed an appropriate setting. Free-standing wooden slatted "walls" about 9½ft (3m) high were painted with Japanese characters and illuminated by uplighters.

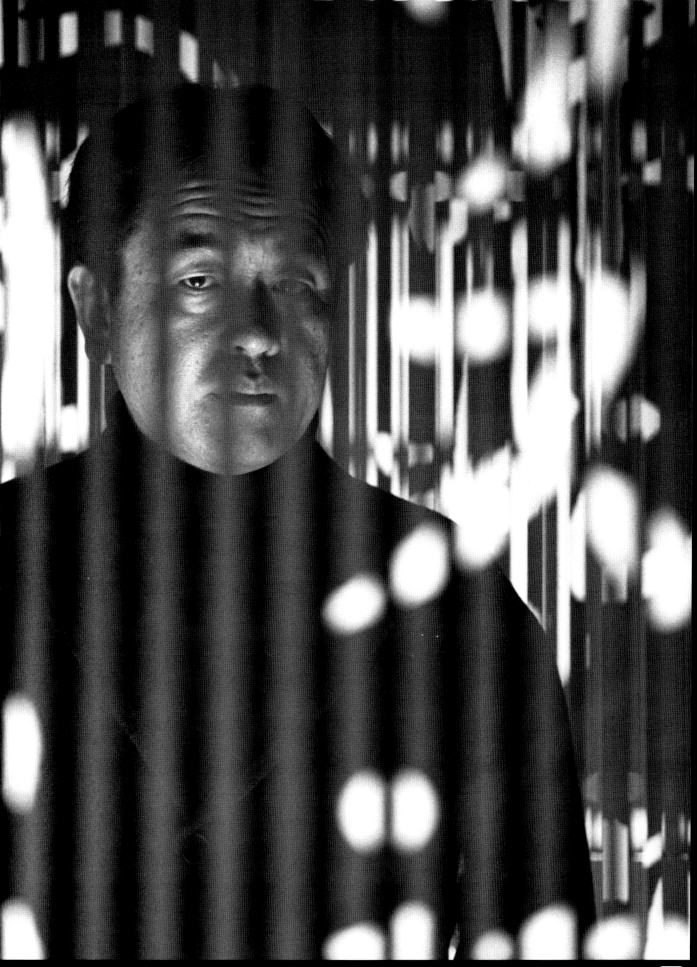

zarina

photographers **Ben Lagunas and Alex Kuri**

client	Michell Ritz
use	Editorial
model	Zarina
assistants	Isak de Ita, George Jacob
art director	Many Boy
camera	4x5in
lens	300mm
film	Kodak Ektachrome EPP 100
exposure	f/11
lighting	Electronic flash: seven heads
props and set	White background

Seven light sources would normally be a recipe for disaster in a portrait, unless you know what you are doing. In this case, four of the light sources are standard heads used to "burn out" the background for a high-key effect.

key points

- ► High-key backgrounds normally require a very great deal of light. The alternative is to light the subject in the foreground relatively weakly, and give a longer exposure (with tungsten), use a wider aperture, or use a faster film
- ► Using gels to distort colors is very much a matter of personal taste and vision—and a picture that one person loves, another may hate

After that, everything is easier to understand. The key is the snooted spot, high (6½ft/2m off the ground) and to camera right. A standard head with a honeycomb provides some fill from camera left, but (more importantly) adds highlights to the model's hair. A purple gel on this head also creates the unusual color effects that are "washed out" on the right of

the picture by the stronger key light. A (non-filtered) soft box to camera left further softens the contrast.

On a 4x5in, a 300mm lens is ideal for portraits: it equates roughly to 100mm on 35mm and 150mm on 6x6cm. Although f/11 is a relatively small aperture on smaller formats, on a 4x5in format with a long lens it allows highly selective focus.

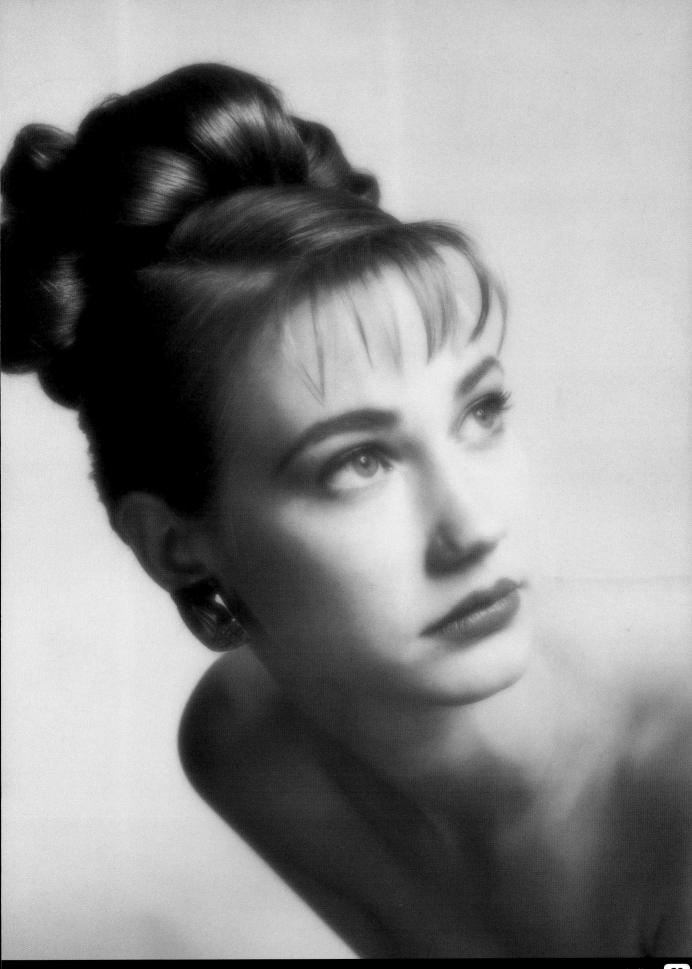

mephistopheles

photographer **Johnny Boylan**

client	Royal Shakespeare Company
use	Poster for Faust
assistant	Belinda Pickering
camera	6x7cm
lens	180mm
film	Agfa APX 100
exposure	f/11
lighting	Electronic flash: one head
props and set	Painted gray background

Mephistopheles comes in many guises; here he is smooth, urbane, ready to strike a deal, always willing to compromise– until he has your soul, when suddenly his true nature is revealed. Quite like the average client, really.

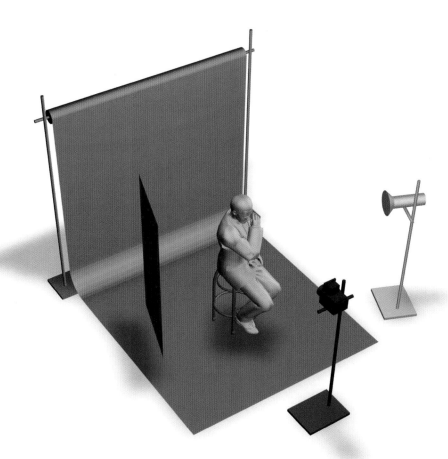

key points

- Monochrome films can deliver superb skin texture
- Different skins differ not only in tone but also in the way that they handle highlights: some are shinier than others, for example
- Adaptation of large, old tungsten lights to flash can create some interesting light sources

Lighting dark skin presents different challenges because highlights tend to be brighter and shadows darker. The key and only light is high and from camera right; the shadows show clearly where it is coming from. The light itself is unusual: an old 2K focusing spot with the hot light source replaced by a flash head. A number of photographers have made similar conversions of big old hot lights because they give a unique quality of lig ft, described by Boylan as a "half poly board," a 4x4ft (120x120cm) white polystyrene reflector, half of a full 4x8ft (120x240cm) sheet.

Photographer's comment

I like Agfa APX because it delivers contrast that is both gentle and clear: not harsh, but not flat either.

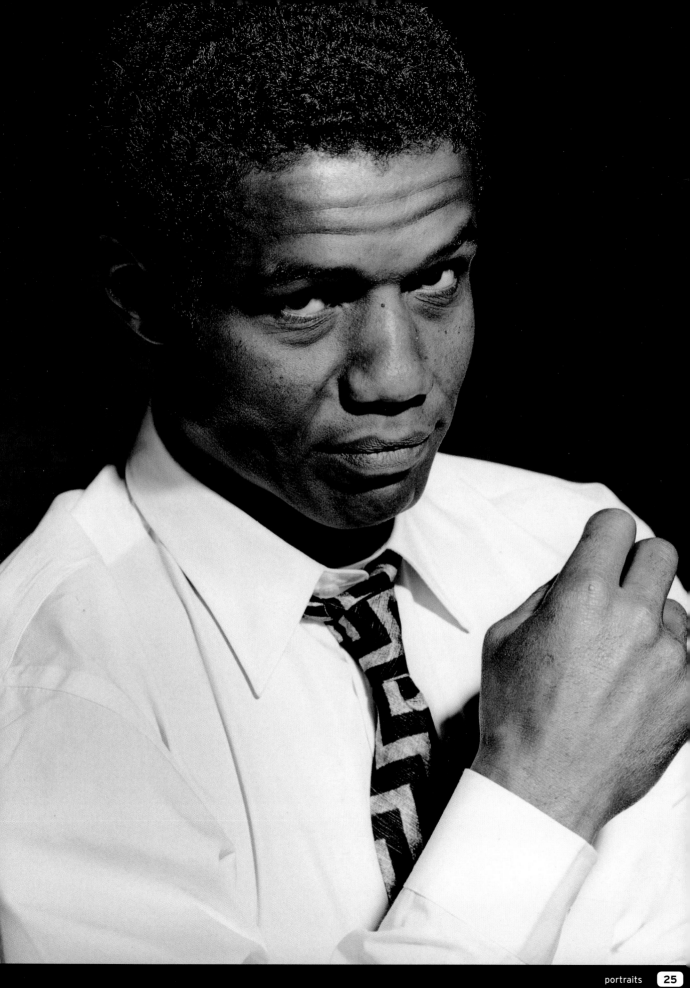

rutger hauer

photographer **Alan Sheldon**

client	Virgin Vision
use	Publicity
art director	Carey Bayley
camera	645
lens	150mm
film	Fujichrome RDP ISO 100
exposure	$\frac{1}{30}$ second at f/11
lighting	Mixed: see text
props and set	Location

This is a classic "fake setting-sun" picture. If you try to shoot by the light of the setting sun, you run into long exposures and more redness than you want—and you have only seconds to shoot.

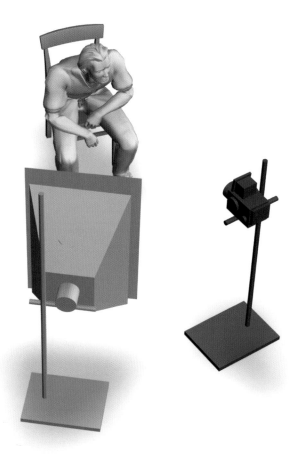

key points

▶ Daylight encompasses quite a wide range of colors: the setting sun is actually redder than tungsten lighting

▶ Over-lighting the foreground when using fill-flash is always a risk; as this shot shows, slight underexposure looks much more natural

▶ Keep light sources far enough away so that they do not reflect as unnaturally shaped catchlights in "sunlit" shots

The technique, therefore, is to meter for the available light; stop down at least one stop, and preferably two, for the "nuit américain" look; then balance your additional light to suit this, still underexposing very slightly in order to get the dark, end-of-the-day look. The additional light in this case is a surprisingly large soft box, about 30x40in (80x100cm) with a straw gel to simulate the setting sun. It is quite a long way away from the subject, so that the shape of the catchlights in the eyes is not a giveaway.

Photographer's comment

I used always to light from the left, but I have found that it is a good general rule to photograph a man from the same side that he parts his hair.

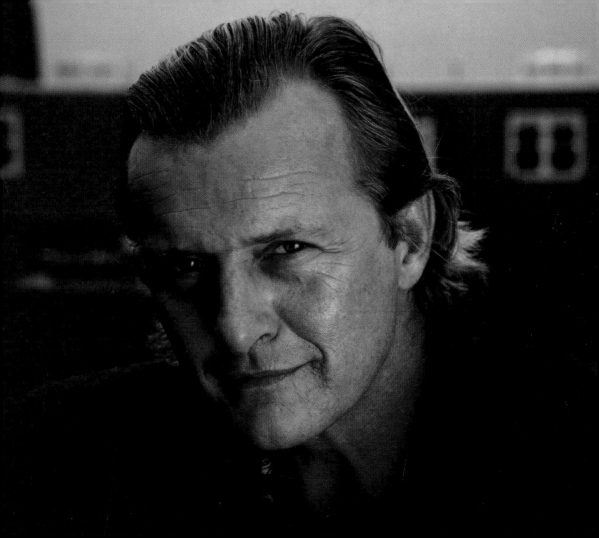

mel brooks

photographer **Alan Sheldon**

client	20th Century Fox
use	Press/publicity
camera	645
lens	80mm
film	Fuji RDP ISO 100
exposure	⅟₆₀ second at f/8
lighting	Electronic flash: three heads
props and set	White background paper

Although an 80mm lens is not normally regarded as ideal for portraiture on 6x4.5cm—something like 150mm is more usual—the advantage of an 80mm is that, if it is used properly, it can convey tremendous immediacy and intimacy.

key points

► For informal portraits, quite modest focal lengths can be appropriate: 80mm on 645 equates roughly to 50mm on 35mm or 180mm on 4x5in

► Large reflectors create an effect between standard reflectors and soft boxes

The lighting on Mel Brooks came from a single standard head with a large, square reflector—about 12in (30cm) square—with a medium honeycomb. It was placed to camera right, about on a level with the subject's eyeline and not quite at right angles to the line of sight. The effect created is more directional than a soft box, but less directional than a spot. A straw gel warmed the light slightly to give a sunnier complexion.

A Lastolite reflector to camera left, just out of shot, provided a modest amount of fill on the right side of Mel Brooks's face. Two more lights, both with standard reflectors, lit the background to a clear, bright white.

Photographer's comment

Mel Brooks had apparently told people that he wasn't going to have pictures made; but fortunately I knew his manager, and I was able to prevail on him that way.

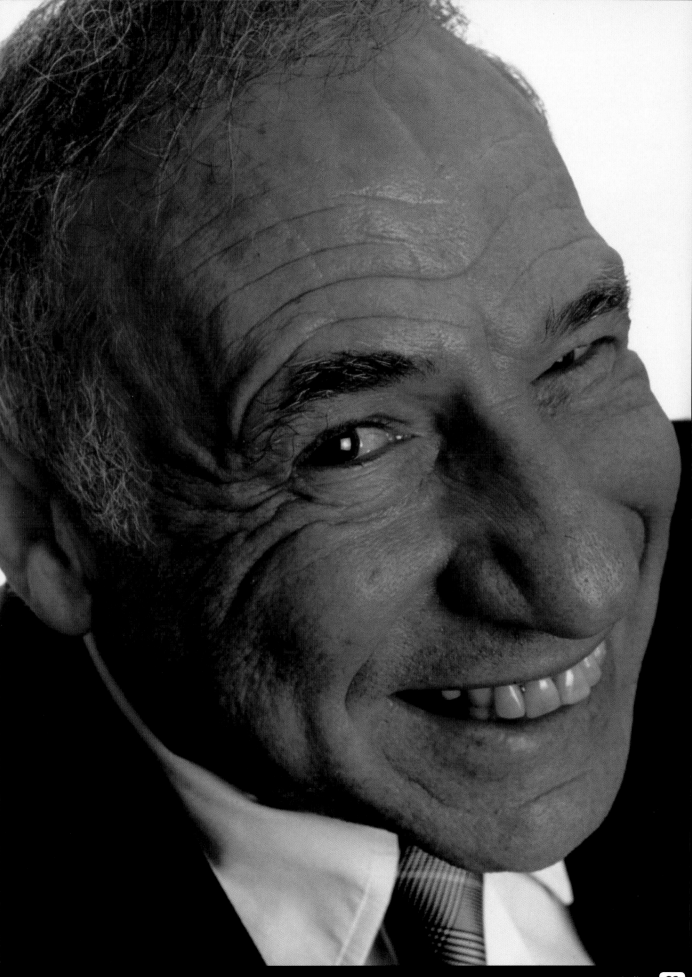

brain lightning

photographer **Michael Freeman**

client	Radio Times
use	Editorial
camera	Sinar P 4x5in
lens	150mm
film	Fuji 100D
exposure	$\frac{1}{60}$ second flash sync at f/22
lighting	Electronic flash

A small amount of spill—flare, actually—was allowed around the edges of the model's profile to soften it and show some shadow detail.

key points

► In this digital version, the white background made it easy to copy-and-paste the sky

The basic design was a profile in near, but not complete silhouette, with a brain scan and flashing sparks superimposed. For the film original this was achieved by multiple exposure on large-format transparency. For the portrait element, the main lighting needed to be the background, and for this, two TK flash heads were aimed toward camera from behind a 1½in (4cm) thick sheet of translucent Perspex (this thickness absorbs a large amount of light but ensures an even diffusion, which was needed here, as a sky had to be added later). A 15¾x15¾in (40x40cm) box light fronted with a diffuser was then positioned on the right of the set aimed at the model's face, and the output adjusted to reveal the forehead, eyes, mouth, and cheekbone, but dimly.

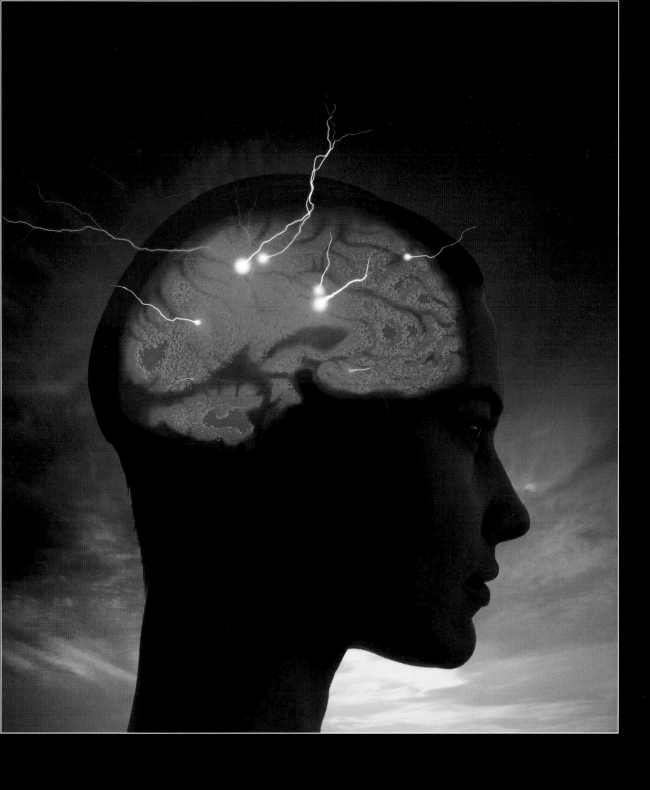

roger corman

photographer **Alan Sheldon**

client	United International Pictures
use	Press and internal publicity
camera	645
lens	150mm
film	Kodak Tri-X Pan rated at EI 200
exposure	f/3.5
lighting	Electronic flash: two heads
props and set	White background

At first glance—and on closer examination, for that matter—this looks very like a classic Hollywood portrait with traditionally complex lighting. In fact, there is only a single light on the subject, with another on the background.

key points

- ► Shooting at full aperture reproduces the shallow depth of field that characterizes traditional Hollywood portrait shots
- ► Skilled printing can add still more to a dramatic portrait

The key light used here was a single standard head, tightly snooted and honeycombed, from camera right. It is positioned very slightly in front of the subject's eyeline, and rather above it. The other light is shaped to the background, which also provides a modest amount of spill to act as fill: look at the reflections on the hair behind the right ear. In practise, though, a good deal depended on the manipulation of the print. The printer, Volker Wolf, darkened down the "hot" forehead; as the photographer said, if he had had any powder, he could have held the forehead with less burning in. The edges of the print have also been darkened appreciably, and the print was toned.

Photographer's comment

In a picture where depth of field is crucial, do not use the microprism center of the screen and then recompose. Check the sharpness of the eyes on the ground glass.

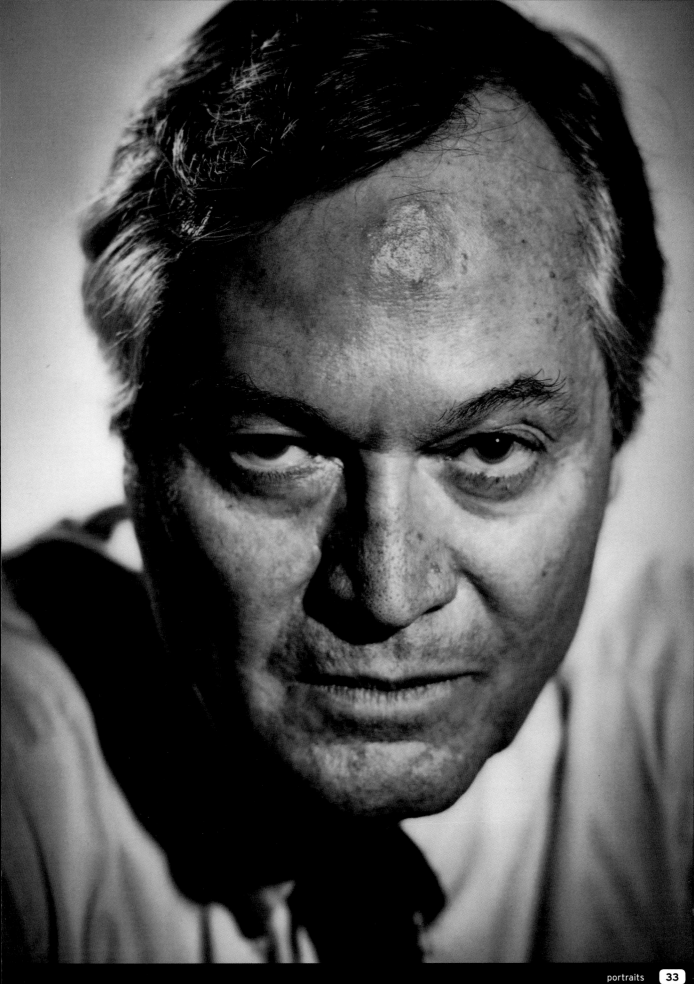

woman with hair over face

photographer **Frank Wartenberg**

use	Portfolio
camera	35mm
lens	105mm
film	Kodak EPR processed as C41
exposure	Not recorded
lighting	Daylight plus reflectors
props and set	Location

The photographer sums up the location very well: "an apartment with two big windows and a door to a balcony." One can well imagine how the light might be attractive, but this is far from a straightforward shot.

key points

- ► "Full gold" reflectors must be used with discretion, except when color distortion is deliberately sought
- ► Long lenses and wide apertures are a traditional combination for portraits, but also lend themselves to non-traditional images

First, the light was modified with the help of two gold reflectors: one on the floor, between the model and the window, and one on the far side of the model from the window. Full gold reflectors can have a remarkably warming effect, almost enough to account for the color without anything further. In addition, though, the transparency film was cross-processed in C41 chemistry to give a negative that was used to make the final image. This gives a soft, grainy effect, often with considerable distortions of color and contrast. If shooting digitally a similar cross-processing effect can be achieved using an image-editing program such as Adobe Photoshop.

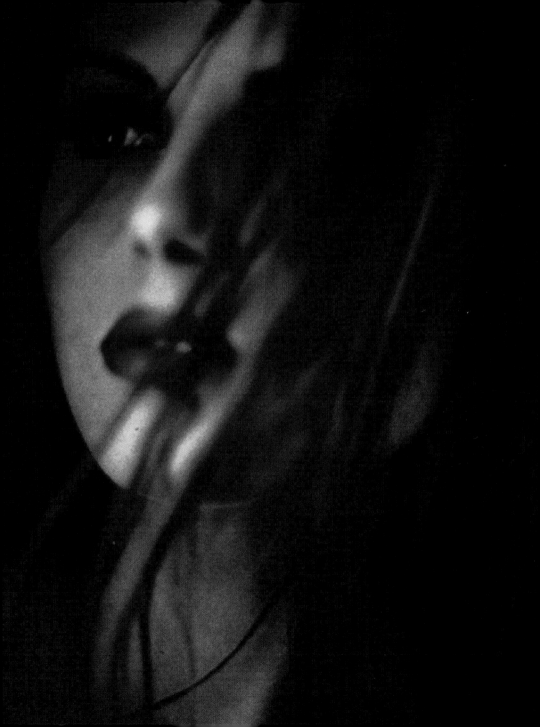

1960s hair

photographer **Frank Wartenberg**

use	Portfolio
hair and make-up	Susan Swoboda
camera	6x7cm
lens	185mm
film	Polaroid 691 (no longer available)
exposure	Not recorded; double exposure
lighting	Electronic flash: five heads
props and set	White background

This is classic "high-key" lighting. The background is strongly lit to achieve a pure white, while the model's face is lit with two standard heads. In addition, the use of two silver bounces helps to even out the light still further.

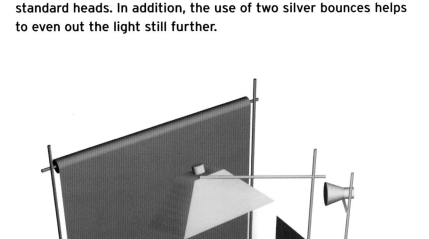

key points

- Exposing separately for the foreground and background gives the photographer new opportunities for control
- Do not always believe the instructions on film boxes that say, "Unsuitable for general photography"

An additional hair light–unusually, a soft box rather than a highly directional light–completes the lighting set-up. There were two exposures: one for the model (with the background lights off), and another for the background (no light on the model). The whole is recorded on Polaroid Type 691, a 3½x4¼in (85x105mm) transparency pack film designed for overhead projector use, but which is no longer available. As with so many specialized Polaroid products, this is capable of delivering interesting results when used in ways other than those envisaged by the manufacturer.

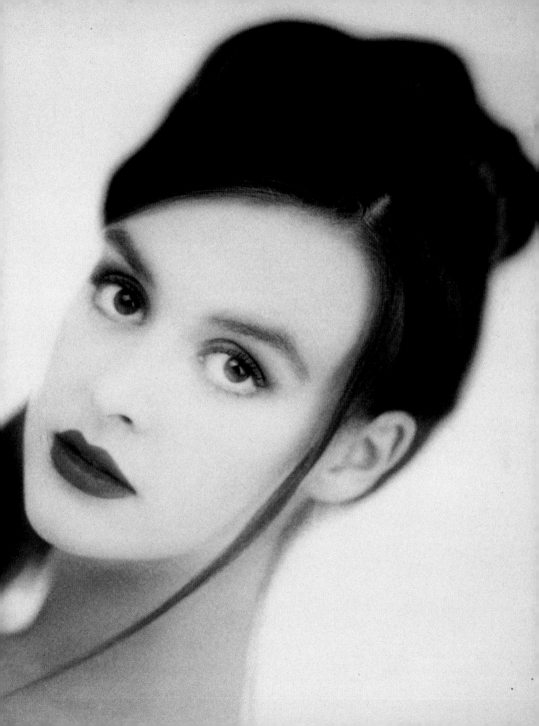

dennis richards

photographer **Roger Hicks**

client	Blandford Press
use	Editorial
subject	Dennis Richards
assistant	Frank Drake
camera	6x7cm
lens	150mm soft focus
film	Fuji RTP ISO 64
exposure	Aperture f/6.3; time not recorded
lighting	Tungsten: 5K focusing spot + 2K flood
props and set:	Black background paper

Your choice of format has considerable influence on what you can get away with. With a true soft-focus lens, 6x7cm is as small as it is safe to go, and the highlights in this shot hover on the edge of overexposure.

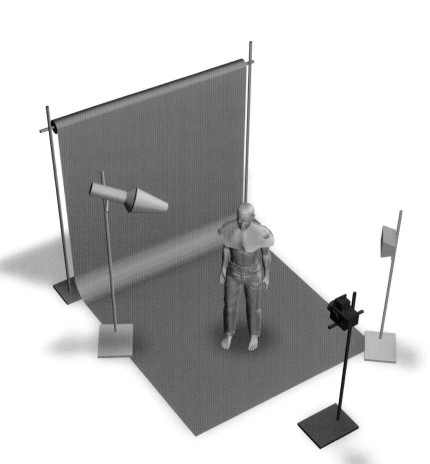

key points

► Surprisingly powerful tungsten lights are needed for convenient exposure times on slow color films

► The eyes have a distant look: the effect would be quite different if they were turned more toward the camera

With 35mm the highlights would be "blown" and the soft-focus would be excessive; with 4x5in or (better still) 8x10in there would be more opportunity to "see into the shadows" in the lower part of the picture. But the hair is adequately differentiated from the background, though the underside of the chin is almost lost.

The key is a 5K spot to camera left, back lighting the right cheek (to the point of overexposure) and delineating the nose clearly. A 2K flood, diffused with a fiberglass scrim, gives the left cheek a more normal exposure. Plenty of room between the subject and the background allows the picture to come out of pure, shadowless black.

Photographer's comment
The deliberate overexposure of the right side of the face is meant to re-create the bright, clear light of Africa.

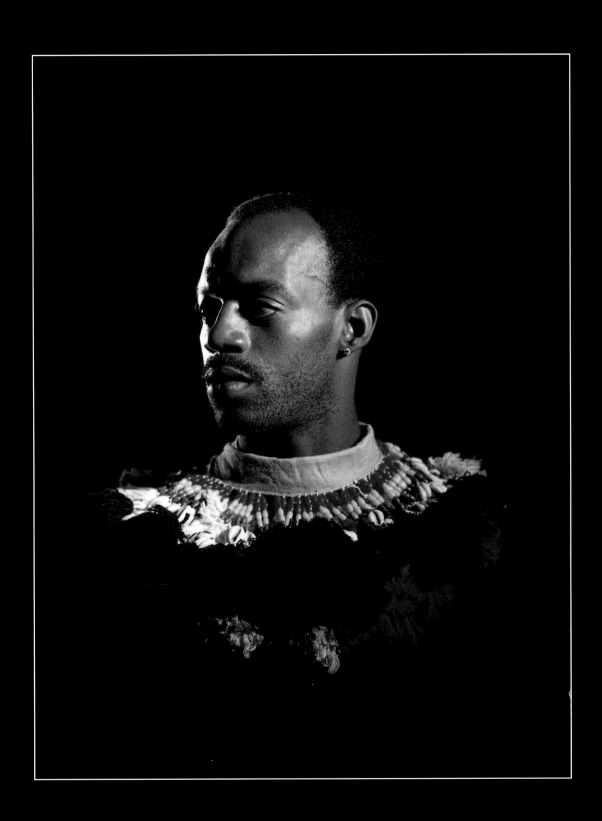

michel roux

photographer **Michael Freeman**

use	Editorial
camera	Sinar P 4x5in
lens	90mm
film	Ektachrome 6117
exposure	1 second at f/32
lighting	Quartz-halogen lamps

The chef Michel Roux, photographed shortly after the opening of his restaurant on the River Thames. Clearly the location was an essential part of this shot.

key points

➤ Without the use of the diffused flash, the subject's face may have blurred due to the long exposure

Because the dining room glass facade had a panoramic view out over the river, this dictated the lighting set-up, which had to combine three elements— dishes on table, chef, and background. The light levels outside, inherently high because of the view of mainly water and sky, were the key to the exposure, and the interior lighting had to match. Nevertheless, for naturalism, the photographic lights were not intended to intrude. Two diffused 3200K quartz-halogen lamps, one aimed at the figure and the other at the table, each filtered with a full-blue gel to give it daylight color balance, raised the ambient level of lighting, while a monobloc flash unit diffused with a window reflector (fronted with translucent Perspex) placed to the right of the camera ensured sharpness in an exposure of one second.

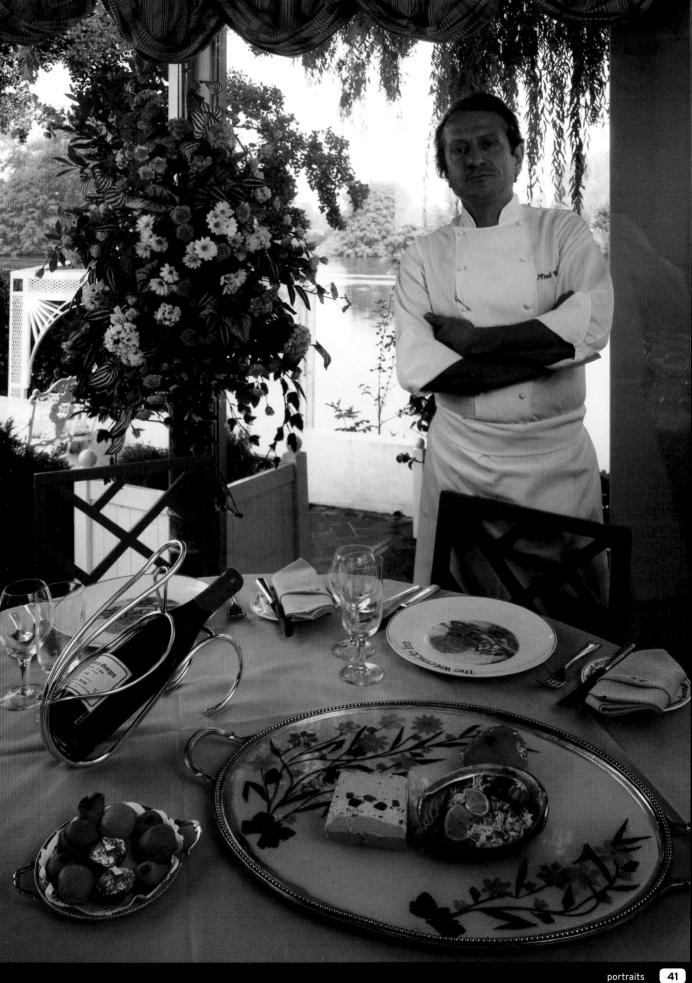

matter creation

photographer **Michael Freeman**

use	Editorial
camera	Cambo 4x5in
lens	90mm
film	Ektachrome 6117
exposure	$\frac{1}{60}$ second flash sync at f/22
lighting	Electronic flash
props	Black drapes

A single light without shadow fill suited the scientific subject, while a drape of black velvet behind the set obscured the usual messy and irrelevant background of a laboratory.

key points

► The precise reflections in the glass cylinder because of the even shape of the reflector

The subject is a science professor at an American university, researching matter creation with precision equipment that includes this magnetically levitated turntable enclosed in a vacuum. The fairly small scale of the set was manageable with a single flash head, diffused with a square window reflector. The apparatus had to be prominent, and this determined the lighting position; the evenness and shape of the reflector made it possible to create precise reflections in the glass cylinder, and the light was positioned carefully so that the central column fell between the two reflections, and so that there were no shadows from obstructions on the face of the scientist.

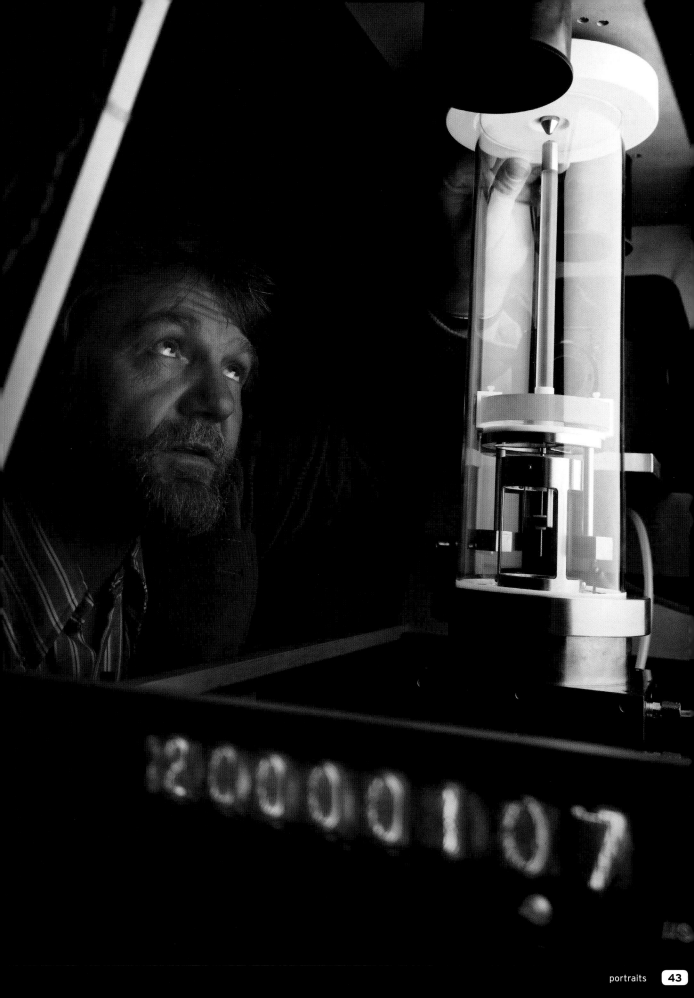

cigar

photographer **Frank Wartenberg**

use	Portfolio
camera	6x7cm
lens	185mm with warming filter
film	Fuji Velvia ISO 50
exposure	Not recorded (multiple exposure)
lighting	Electronic flash: four heads
props and set	Gray background paper

This is a good illustration of the "black-bounce" technique for dramatically directional lighting—and it also illustrates how successful such lighting can be when the source is very broad.

key points

- The line around the head is achieved by multiple exposures with only the background lights switched on
- Bear in mind that there is no such thing as correct exposure; there is only pleasing exposure
- With slow, contrasty films, 1/3 stop bracketing may be essential and 1/2 stop is generally the most that can be used

Three of the four heads illuminate the neutral gray background; the effect of the warming (pale orange) filter is most obvious here. The fourth light is a broad soft box to camera right with two big silver reflectors, one beside it and one on the ground in front of it. The black bounce on the other side helps to kill any potential fill.

Perhaps surprisingly, the film chosen is Velvia, which is very contrasty and "punchy." On the one hand, this emphasizes the directionality of the lighting; on the other, it means that the hand holding the cigar is effectively overexposed in conventional terms, though this makes the lighting still more dramatic.

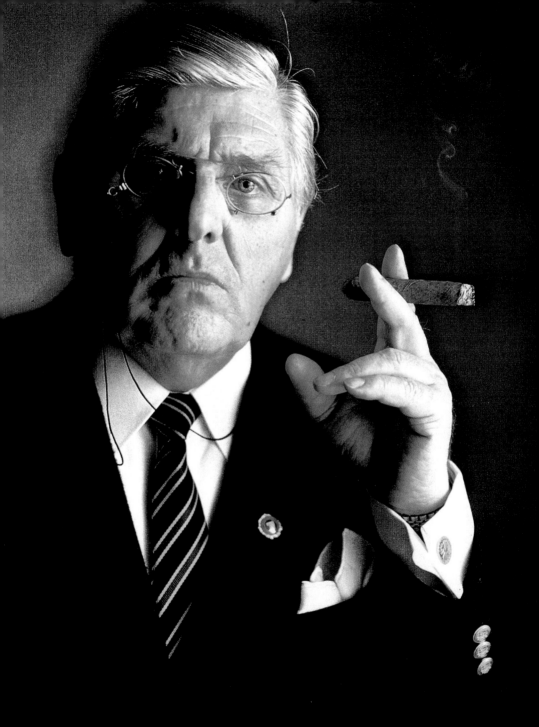

guo brothers

photographer **Frank Drake**

client	Peter Gabriel/Real World Records/Virgin Records
use	Record cover
subjects	Guo Yue (left) Guo Yi (right)
assistant	Sarah Ménage
art director	E.A. Tredwell
camera	35mm
lens	35-135mm at 110mm
film	Ilford FP4
exposure	$\frac{1}{60}$ second at f/5.6
lighting	Mixed: see text
props and set	White background

Printing an FP4 negative through a heavy grain screen preserved the tonality and contrast of FP4, as compared with the tonality and contrast of a film deliberately "pushed" for grain. The lighting is, however, deceptively simple.

key points

► Combine "reportage" (on-camera) lighting with a separately lit background for a dramatic effect

► Grain screens are often an easier alternative than using fast films and processing in paper developer for maximum grain

► Remember the importance of catchlights in eyes

The background is lit with two tungsten floods to give a slightly lighter tone than the faces of the brothers (this part of the exposure is controlled by shutter speed as well as aperture). The only other lighting is an on-camera electronic flash, where the exposure is controlled solely by aperture. On-camera flash gives a "reportage" effect, which is enhanced by the grain screen. The results do not look like on-camera flash because the background is separately lit to be lighter than the brothers. The single catchlight in the eyes is clear, and there is the kind of resolution reminiscent of ring flash—though the use of a non-ring flash also introduces a surprising degree of modeling.

Photographer's comment

The brothers were barely speaking to one another, and I brought them as close together as I could in order to exploit that tension. I think it worked.

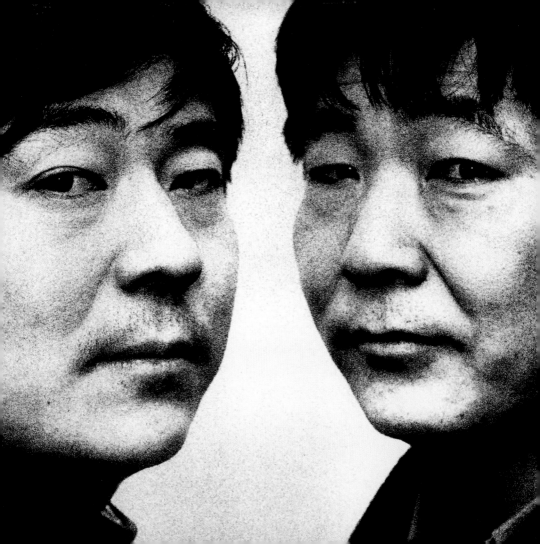

portrait of simone

photographer **Peter Laqua**

use	Competition entry
model	Simone
stylist	Silke Schöepfer
camera	4x5in
lens	300mm
film	Monochrome transparency
exposure	Not recorded
lighting	Electronic flash: two heads
props and set	Spaghetti

All children make "mustaches" by holding something between their top lip and their noses—but most people stop when they are children and do not take it to extremes like this! The reversed baseball cap adds to the playful spirit.

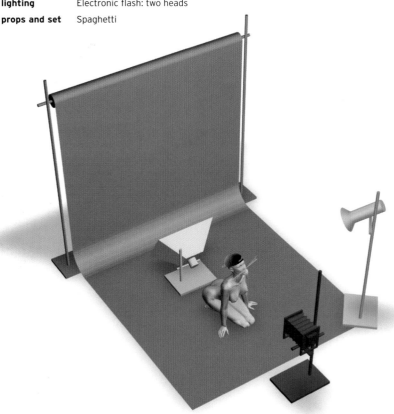

The key and indeed only light on the face is a focusing spotlight, high and to camera right, shining more or less straight down on the model: look at the shadows in her ears. It has to be a focusing spot, as a snooted spot or honeycomb spot would not provide such directional light. A 28x50in (70x130cm) soft box behind and below the model illuminates the background, grading from light to dark. The texture of the background, which is normally invisible when it is lit frontally, adds to the composition.

key points

- ► Agfa's Scala direct-reversal film is available in 35mm, 120, and 4x5in; the only other convenient direct-reversal monochrome films come from Polaroid
- ► The exquisite detail of the 4x5in image should be visible, even in reproduction

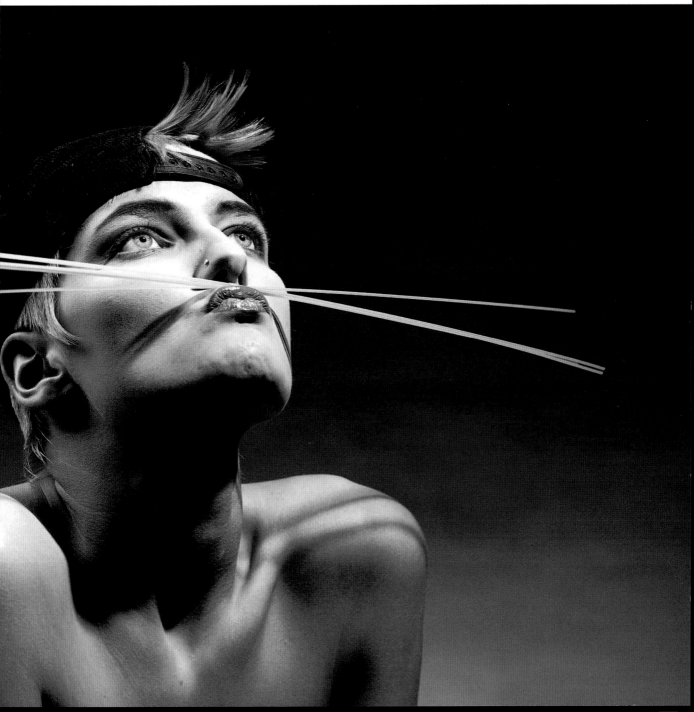

susan

photographer **Massimo Robecchi**

client	Studio Magazine
use	Editorial
model	Susan
assistant and stylist	Teresa La Grotteria
art director	Olga Stavel
make-up and hair	Gianluca Rolandi
camera	35mm
lens	300mm
film	Ilford XP2 ISO 400
exposure	$\frac{1}{500}$ second at f/2.8
lighting	Available light + bounce
props and set	Location

This picture well illustrates that an overcast day can be vastly superior to sunshine, especially if you are shooting in monochrome. With light coming more or less evenly from all directions, the tonality can be exquisite.

key points

► Exposure is a subjective art: arguably, everything in this picture is just a tiny bit darker than it "really" is, but this holds the tones in the white clothing

► A 300mm lens, used wide open at f/2.8, allows the background to be subtly suggested rather than too clearly delineated

Even so, Massimo Robecchi added a white bounce in front of the model to even out the light still further: the white drop of the tablecloth is thereby brought nearer to the tone of the clothes and the background, and the dark stockings are made to read just

a little better. This is one of those cases where a collapsible reflector such as a Lastolite or a Scrim Jim can be extremely useful–and where the effect is completely different from fill-flash, touted by camera manufacturers as the answer to everything.

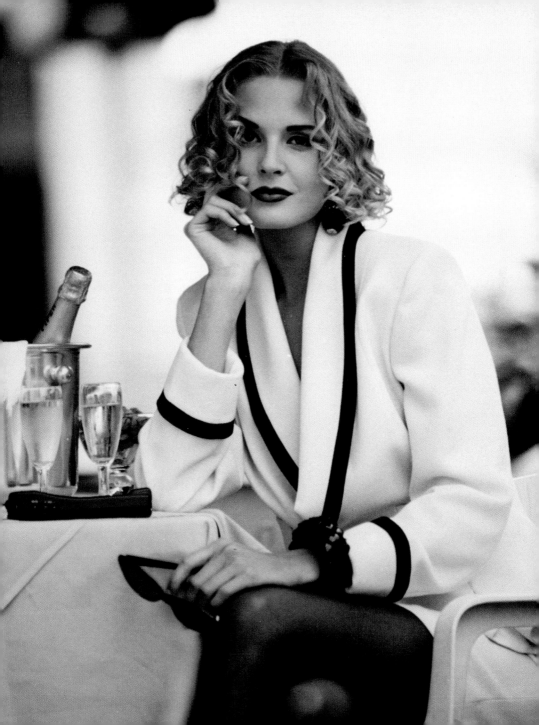

king's road portrait

photographer **Alan Sheldon**

use	Personal research
model	Passer-by on King's Road
assistant	Nick Henry
camera	4x5in
lens	180mm
film	Kodak Tri-X rated at EI 200
exposure	1/60 second at f/5.6
lighting	Daylight plus tungsten plus flash (see text)
props and set	Built "sentry box" (see text)

The leading exponent of this photographic style—the character portrait against a plain white background—is Richard Avedon. Following the lead of the master, Alan Sheldon has explored the same techniques in both color and monochrome.

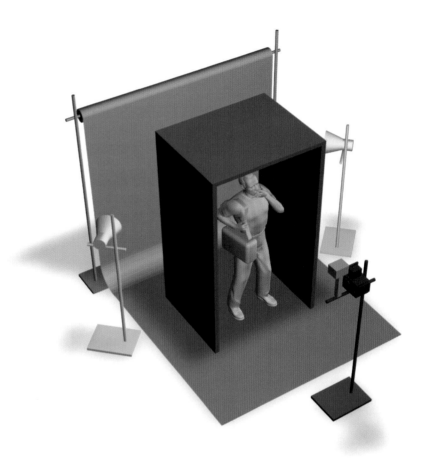

key points

- ▶ A "very small" flashgun on the camera (power not recorded) gives the catchlight in the eyes
- ▶ Increased exposure and decreased development allow the film to capture a long tonal range

This was shot on the King's Road in London. The uprights of the "sentry box" were made of 8x4ft (240x120cm) sheets of expanded polystyrene, painted black; the roof was a half sheet, 4x4ft (120x120cm). The whole was held together with gaffer tape and meat skewers.

The box is about 6ft (180cm) in front of a white backdrop—another 8x4ft (240x120cm) sheet—which is lit with two 800-watt tungsten lamps powered by a generator. This gives a neutral background, while the black sides and roof ensure that the only light on the subject is frontal daylight.

Photographer's comment
After this series I went to a 10x10ft (300x300cm) backdrop: I had trouble with the edges of the 8x4ft (240x120cm) drop getting in the picture.

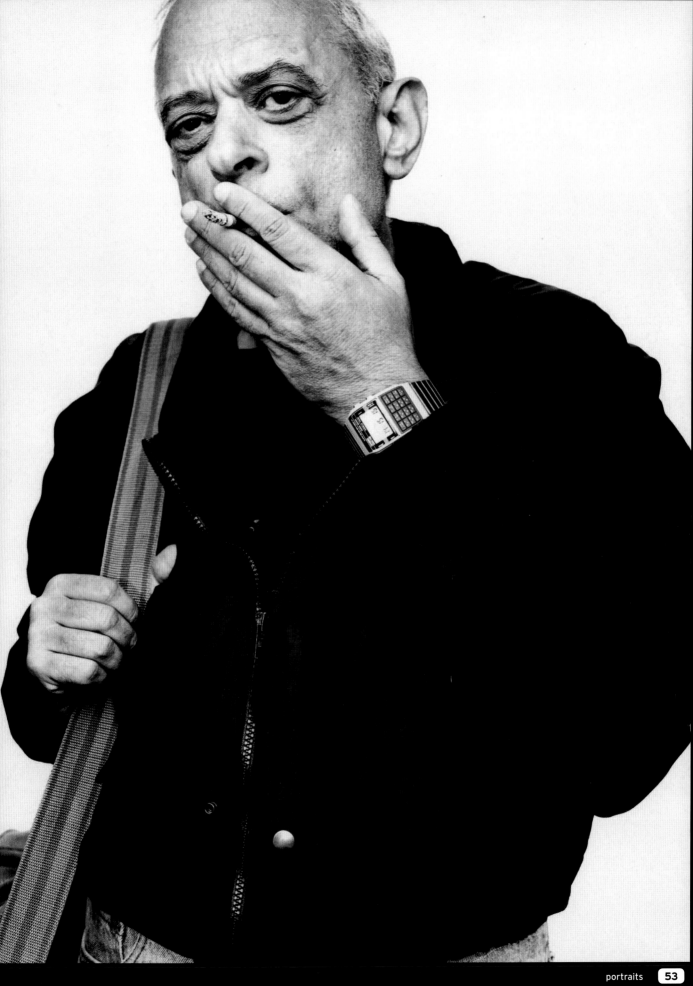

muriel st clair byrne

photographer **Michael Freeman**

use	Editorial
camera	Cambo 4x5in
lens	90mm
film	Ektachrome 6117
exposure	2 seconds at f/16
lighting	Electronic flash

For this portrait of a renowned historian, the detail and atmosphere of her study was important.

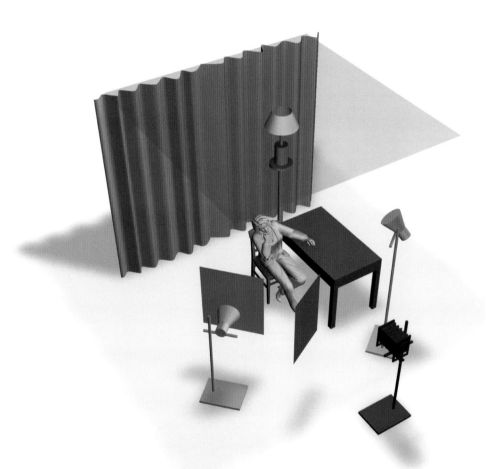

key points

► The two-second exposure allowed the relatively dim ambient lighting to dominate, and add a warm tone to the overall color

The corner lamp determined the exposure, so that it would read naturally. A 750-joule flash head was aimed from left through a diffusing screen to illuminate the face, and a 400-joule flash head was bounced off the ceiling to provide a more general shadow fill. The size of the room made a wide-angle lens necessary (90mm Super Angulon on a 4x5 view camera). Nevertheless, to relieve the lower left corner, some papers were rearranged, and a small desk lamp was placed on the floor just out of frame. The main light at left was flagged to avoid flare in the lens, and the exposure was set at two seconds—which the subject was easily able to hold by supporting her chin on one hand.

photographer's comment

I liked the perspective distortion of the lower part of the image, which was left fairly dark.

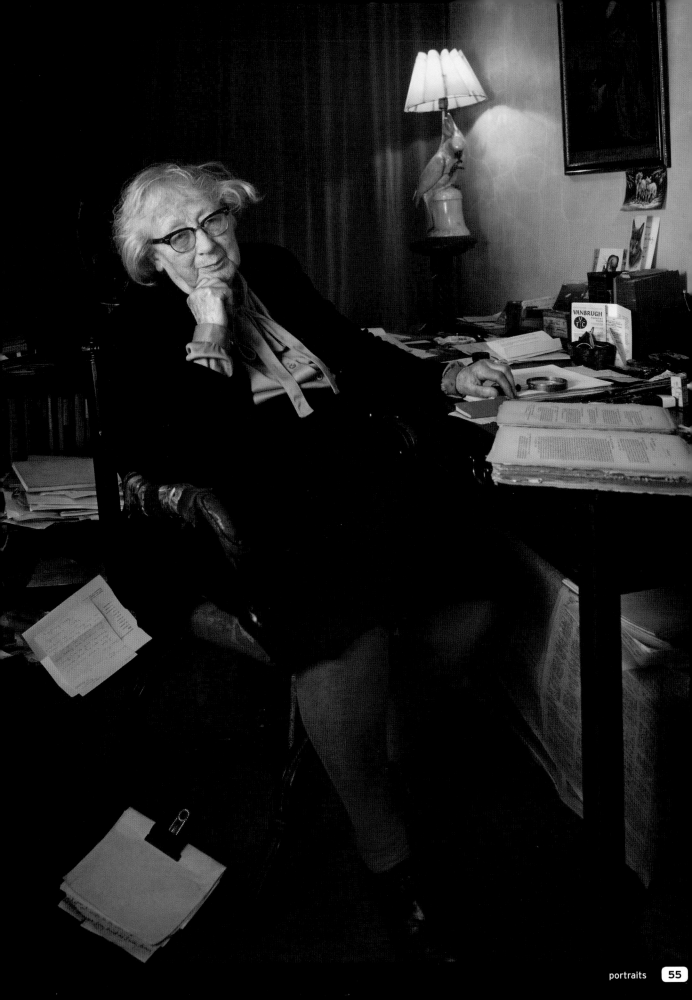

alan cumming

photographer **Jason Keith**

use	Editorial
camera	Mamiya RB67
lens	127mm
film	Not recorded
exposure	$\frac{1}{400}$ second at f/10
lighting	Electronic flash

To catch the full intensity of this versatile actor a straight-on shot was the best option; with the camera placed lower than the subject, the slight downward gaze adds to the intensity.

key points

▸ The position of the head in relation to the camera can dramatically alter the impact of a portrait

The standard head, fitted with a 30 degree honeycomb to help direct the light, was positioned off to the left and slightly above the subject, whose forwardly inclined head position has cast slight shadows across the face, creating the intimate atmosphere of

the shot. A white reflector to the right of camera helps to balance the light. Two standard heads were used to light the plain but textured background, which helps not only to isolate the head, but also the dark wing of the chair in which the subject is sitting.

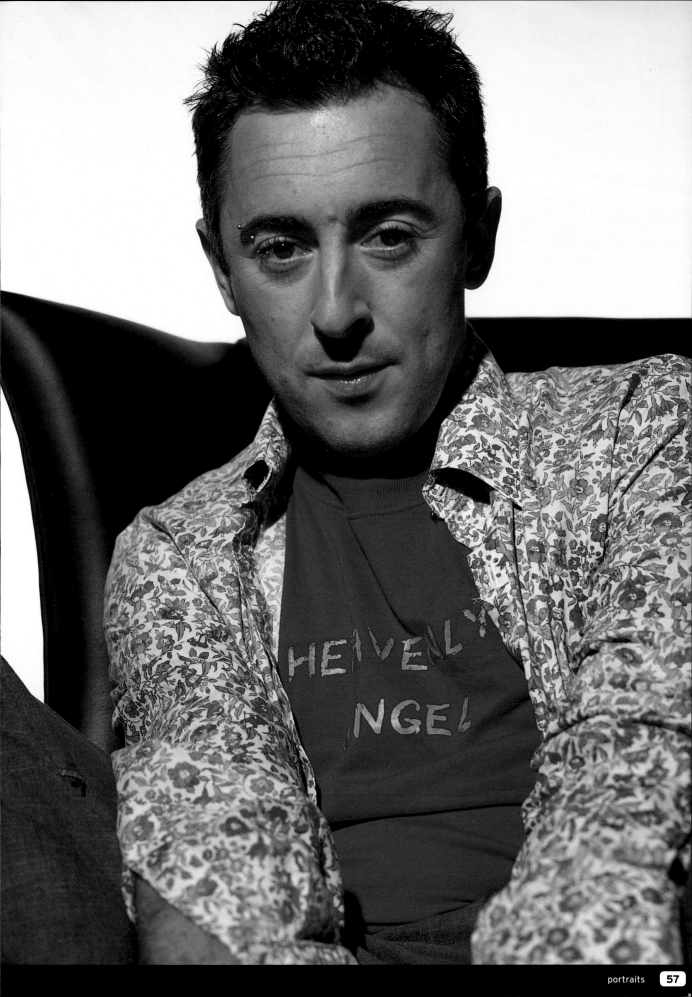

jeannette arata de eriza

photographer **Maria Cristina Cassinelli**

client	Swissair
use	Advertising
art director	Carlos Gerard & Alberto Paladino
camera	6x6cm
lens	150mm
film	Kodak Ektachrome EPP ISO 100
exposure	f/11
lighting	Electronic flash: three heads
props and set	Location

Maria Cristina describes this well herself: "This was a part of a campaign for Swissair where photographers around the world were each asked to create an image in which a VIP customer looked at ease holding an airline ticket."

key points

► Lighting parts of a scene to be reflected in a mirror is often difficult but can be very effective

► Strip soft boxes can give very controllable light for taking "environmental" portraits of people in their surroundings

She continues: "Very soft lighting was used to flatter the looks of this extremely elegant lady. I like her reflection in the mirror, which also reflects part of her living room; this creates a mood without interfering with the main subject."

Three lights were used here, but to keep it soft there is no strong key. The lighting on the subject comes partly from the 30x40in (75x100cm) soft box over the camera and partly from the 18x60in (45x150cm) strip to camera right; the latter creates the slight modeling on the skirt. A third large soft box illuminates the wall opposite the mirror. Careful exposure holds texture in the white suit without being too dark.

Photographer's comment

There were the usual problems with mirrors: you have to be very careful or you'll find some of the lighting, yourself, or even the make-up artist in the picture.

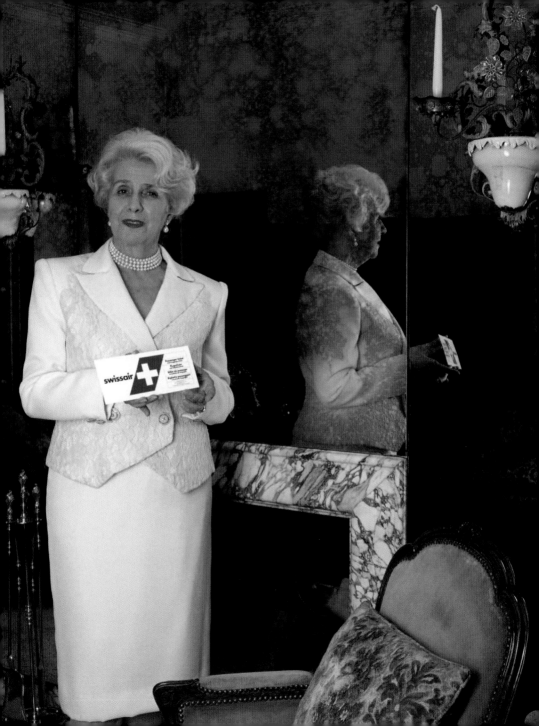

mercedes sosa, folk singer

photographer **Maria Cristina Cassinelli**

The folk singer is lit with a single large 40x80in (100x200cm) soft box to camera left. The other five heads were fitted with grids or snoots and were positioned to create lights and shadows on the background.

client	Polygram Records
use	CD cover
art director	Sergio Perez Fernandez
camera	6x6cm
lens	150mm with Softar soft-focus screen
film	Kodak TMX ISO 100
exposure	$\frac{1}{125}$ second at f/11
lighting	Electronic flash: six heads
props and set	Built set

The photographer comments, "The set was made by a specialist, with dozens of yards of a very light fabric, covering an area of about 20x20ft (6x6m). The idea was to achieve an atmosphere that was light, soft, and romantic, to convey the mood in her songs." The set is unique, so there is no point in describing the functions of each light in detail. However, it is worth noting that they are used in a number of different ways: flat head-on illumination, transillumination, and glancing light to bring out texture. Because of the depth of the fabric, a single light might fulfill two or more of these functions: the positioning of the material can be as important as positioning the lights.

Photographer's comment

She has a wonderful voice, and during the shoot we had a recording of her music playing to help us with the mood.

key points

- ► There are more ways of creating lightness and airiness than by simple high-key

- ► When using very light, trailing fabric like this, remember that even modeling lights can start a fire

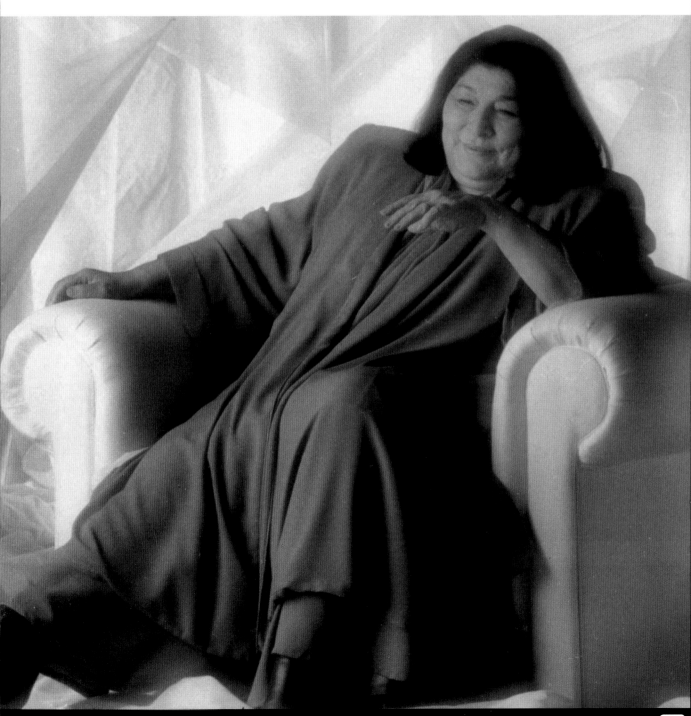

louise

photographer **Stu Williamson**

client	Louise
use	Publicity
camera	6x7cm
lens	150mm
film	Kodak Plus-X Pan
exposure	f/11
lighting	Electronic flash: two heads
props and set	Black shiny material, black gloves, jewels, floor stand fan blowing hair

Louise is a singer, and this was shot as a publicity photograph. It is a good example of Stu Williamson's dramatic, contrasty lighting style: a less original photographer might not dare to "break the rules" in such a way.

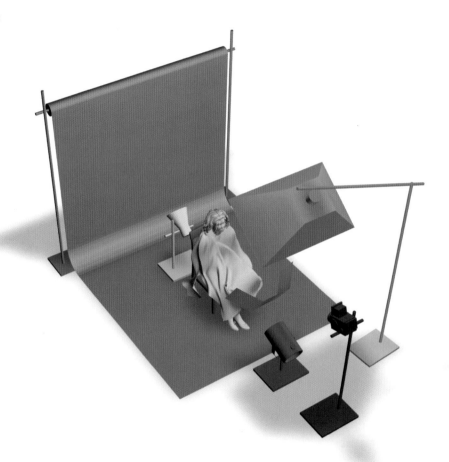

key points

- ► A monochrome portrait does not always have to exhibit "camera club" gradation and skin tones
- ► Wind machines do not always have to be used horizontally
- ► Hand coloring does not always have to be naturalistic

The reflections in the subject's eyes reveal the lighting. The upper reflection is of a 40x40in (100x100cm) soft box, about 40in (100cm) from the subject, above and in front. The lower reflection is of the Tri Flector, a three-panel reflector of the photographer's own design. A small light on the background completes the set-up. The dramatic-looking cloak is just a length of shiny black material; Louise was also wearing black gloves. In the photographer's own words, "The real key to this picture is the wind machine, which was blowing her hair upward. I just shot the way the hair fell."

Photographer's comment

Eye contact is always important, and Louise has beautiful eyes. I colored them yellow to draw still more attention to them.

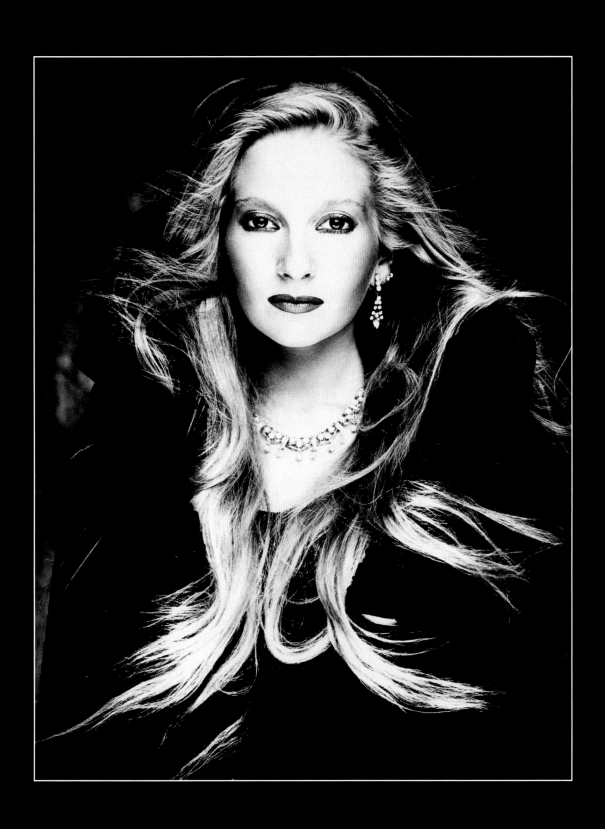

diva

photographers **Ben Lagunas and Alex Kuri**

client	Miami Magazine
use	Editorial
model	Cristina
assistants	Isak de Ita, Janina Cohen
art director	Alberto Mellini
stylist	Toto
camera	4x5in
lens	300mm
film	Kodak Tri-X Pan
exposure	f/8
lighting	Electronic flash: seven heads
props and set	White background

With a pure white burned-out background you do not need as much space behind the subject as usual—but you do need a great deal of light on the background, such as the four standard heads used here.

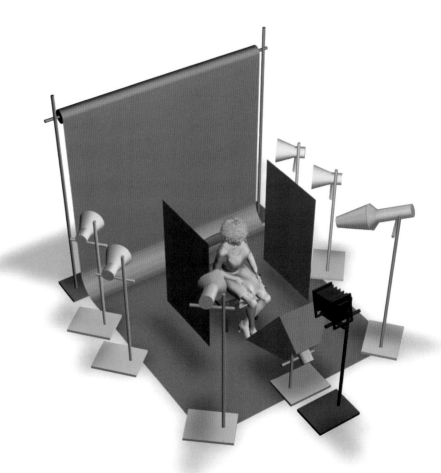

key points

► Dark feathers and dark fur "eat" light and require plenty of illumination if you want to show texture

► Very brightly illuminated high-key backgrounds will often flare through or around the edges of the subject, for good or ill

► High-key effects are often more dramatic in monochrome than in color

The three remaining lights are two snooted spots, mounted high (6½ft/2m) and symmetrically on either side of the camera, with a soft box unexpectedly mounted below and in front of the camera. Normally, lighting a portrait from below is regarded as anathema but in this case it is entirely logical as the soft box is only a fill. In fact, it is similar to the "troughs" of tungsten lamps that were similarly positioned in the portrait studios of yore; unlike them it does not melt the subject's make-up. Considerable amounts of light are needed to make the feathers read at all, and the model's face is at the limit of what would normally be acceptable exposure.

In black and white this adds to the magic of the picture: in a color photograph, it would probably be impossible. The lightness of the model's face is also counterbalanced by the very bright background.

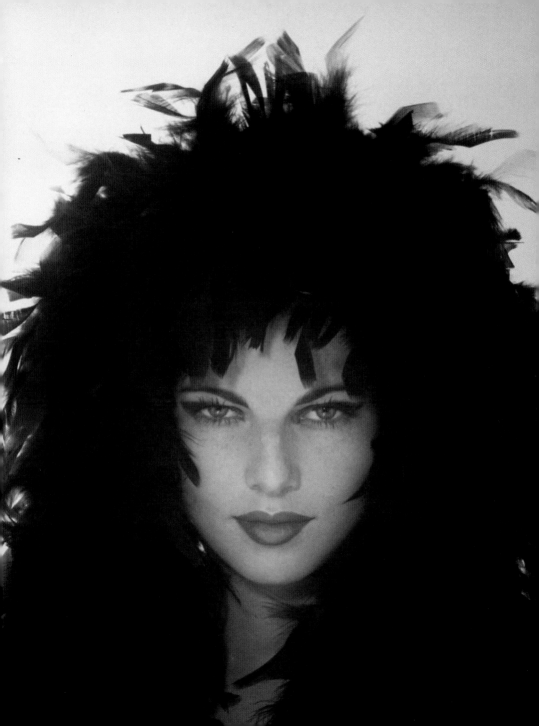

christopher eccleston

photographer **Jason Keith**

use	Editorial
camera	Mamiya RB67
lens	127mm
film	Not recorded
exposure	$\frac{1}{400}$ second at f/10
lighting	Electronic flash
props	Black velvet ground

One bright honeycombed head is often all that is needed to create a powerfully stark and intense atmosphere; a clever juxtaposition with the relaxed cross-legged pose.

key points

► Almost blown highlights need not necessarily be a bad thing; here they help add to the intensity of the subject's gaze

The simplicity of this one-lamp lighting set-up belies the drama created in the shot, which, helped by the use of an unlit black velvet ground, evokes a strong sense of theatrical stage. The powerful lamp, right of and above camera, has starkly lit—almost to the point of deliberate overexposure—the left-side of the face, while the right-side, although bathed in shadow, has been lit by the silver reflector to the point where just enough light has been provided for the viewer to make out the features. With both eyes visible, the intense gaze is more evident.

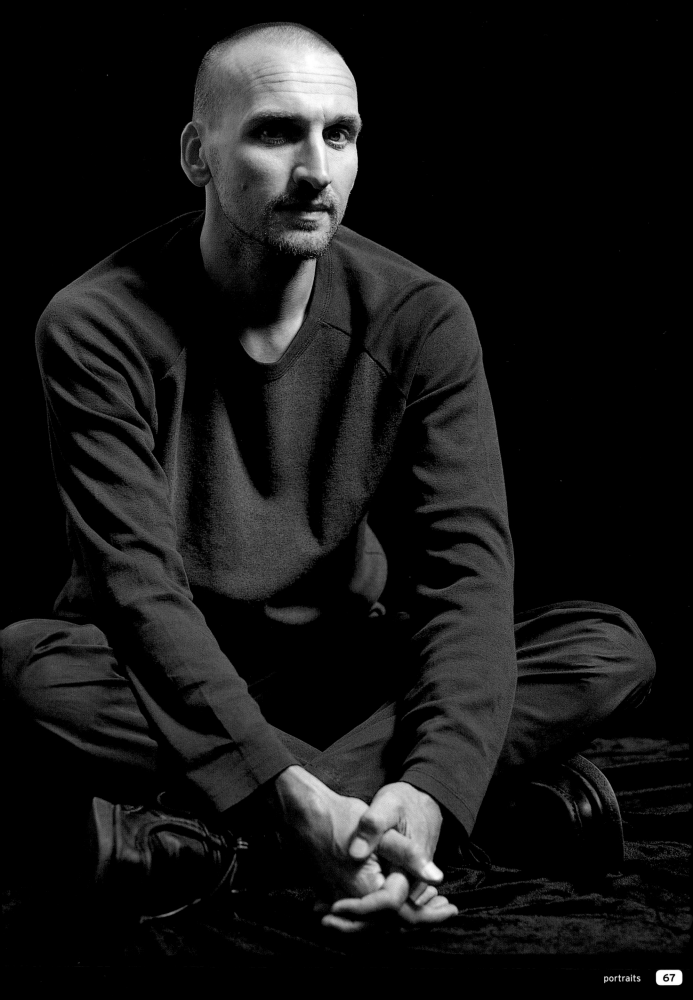

mourning flowers

photographer **Lewis Lang**

use	Exhibition/Print Sales
camera	35mm
lens	28mm
film	Ilford XP1 rated at EI 250
exposure	Not recorded
lighting	Daylight (see text)
props and set	Basket of flowers; table with pedestal and statue

Lewis often describes his own pictures best: "Déja-vu all over again... My main job here was to open up the window shades/venetian blinds and say 'aaahhh!' to the lighting."

key points

► The control available from opening and closing curtains and blinds (fully or partly) can be immense. Remember, this is how our ancestors' daylight studios worked

► Available light does not always look more natural than careful artificial lighting: the eye adapts quickly to widely varying illumination levels

The key light is in effect a large window to camera right, about 4–5ft (1.2–1.5m) from the subject. This provided soft yet directional side illumination from indirect sky-lighting. A very large, long window behind the camera provided frontal fill, again from indirect sky-lighting. This window was 10ft (3m) or more from the subject.

The white walls acted both as background and as built-in reflectors to even out and fill in the large area taken in by the wide-angle lens. Although 28mm lenses are normally associated with "violent" perspective, the strong symmetry of the composition, together with careful alignment of the camera, means that the picture "works" very well indeed. Also, the quality available from the best 35mm lenses can surprise the users of larger formats.

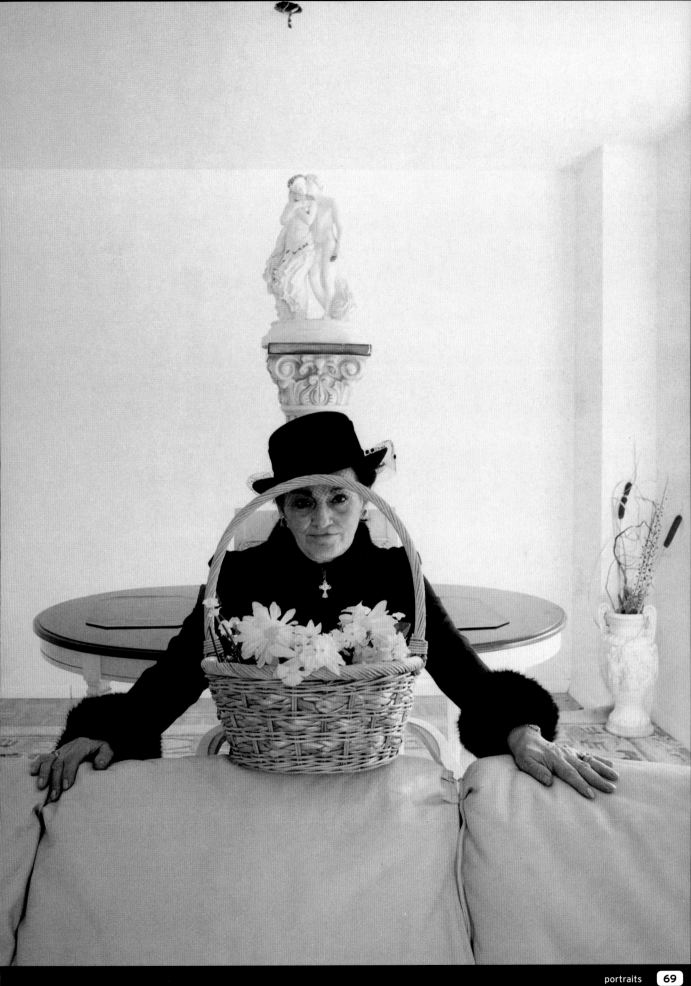

monica

photographer **Peter Laqua**

use	Self-promotion
model	Monica
stylist	Silke Schöepfer
camera	35mm
lens	85mm
film	Monochrome ISO 125/22
exposure	f/1.8
lighting	Electronic flash: two heads
props and set	White paper background

The glasses, the hair, the self-conscious pout: the effect is pure 1950s, with overtones of Gary Larson's The Far Side cartoons. The high-key effect is rendered more dramatic by the dark hair.

key points

► With 35mm, long lenses of wide or very wide aperture are required in order to approach the shallow depth of field our ancestors took for granted in portraits

► The "photo booth" simplicity of the presentation adds still more to the surrealism of the image

The lighting is simple enough, though the background well illustrates the need to light the background separately (and reasonably powerfully) in a high-key picture. A standard head fulfills this task.

The key light is a 40x40in (100x100cm) soft box to camera left, set slightly forward of the model's head: this provides some light even on the left side of her face, though a more conventional high-key approach would also have used a reflector to camera right to approach more closely Japanese-style notan, the antithesis to European chiaroscuro.

Photographer's comment
The eyes and the lips are the point of focus.

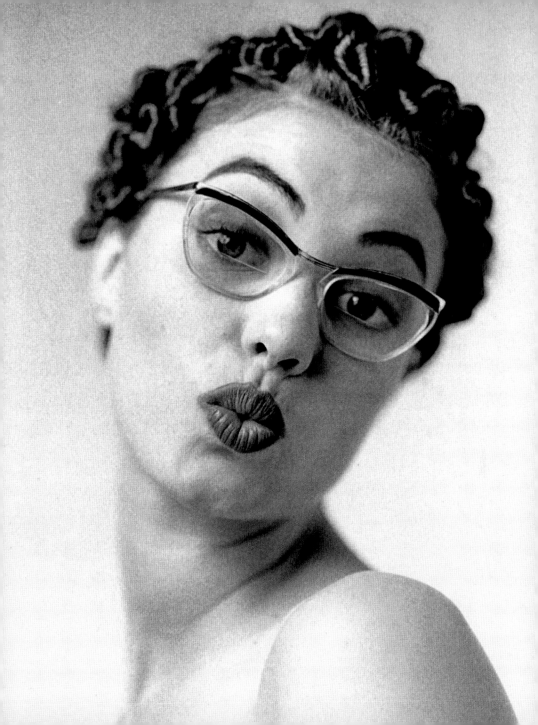

old man and cane

photographer **Frank Wartenberg**

use	Portfolio
camera	6x7cm
lens	185mm + light orange filter
film	Fuji Velvia
exposure	Not recorded; probably about f/5.6
lighting	Electronic flash: four heads
props and set	Gray background paper

Strongly directional lighting is often very successful when photographing people who are no longer in the first flush of youth—though men are normally more willing to accept "character" portraits than women.

key points

► Lighting the subject from one side, and grading the background from the other, can be very effective

► The larger the format, the better it will "see into the shadows"

The subject is very slightly back-lit from camera right by a large soft box supplemented with silver reflectors, so illumination is much stronger to camera right than to camera left: a black bounce kills any reflections that might act as a fill on the right side of the subject's face.

The background is lit with three heads to provide a graded ground that is darker to camera right and lighter to camera left, thereby making the subject stand out all the more clearly.

For the initial exposure, both the soft box and the background lights were on; for several subsequent exposures, only the background lights were on. This produced the black shadow around the head and the softness of the outline.

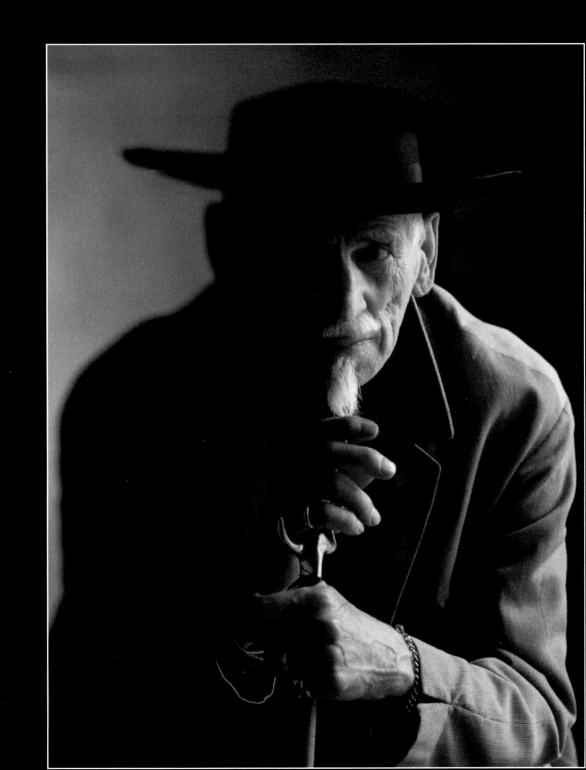

miner

photographer **Johnny Boylan**

client	S.M.I./Powergen
use	Advertising
assistant	Siri Hills
art director	Roy Brooks
camera	4x5in
lens	210mm
film	Agfa APX 100
exposure	f/8; shutter speed not recorded
lighting	Mixed flash and tungsten
props and set	Painted backdrop, timber

There is a variety of portrait, unusual today, which was popular with our 19th-century ancestors. It is effectively a cross between reportage and the formal portrait. The overall effect can be very striking and powerful.

key points

► Large formats not only render detail well, but also have an ability to "see into the shadows" that is unequalled by smaller formats

► In a built set a very skilled make-up artist is usually necessary to make the scene convincing

Such pictures were shot both on location and in the studio. Some 19th-century shots may seem contrived today, but they are always distinguished by what is, to modern eyes, an exquisite level of detail–a consequence of the large formats employed. Johnny Boylan followed in this tradition by using a 4x5in camera and his favorite Agfa APX film.

The lighting recreates the harsh light of a mine in an unexpected way. The key is arguably the big soft box to camera left, slightly in front of the subject, but a great deal of the impact comes from the direct, almost challenging stare. The eyes were lit separately, with a 2K tungsten lamp flagged down to a letterbox slot directly above the camera.

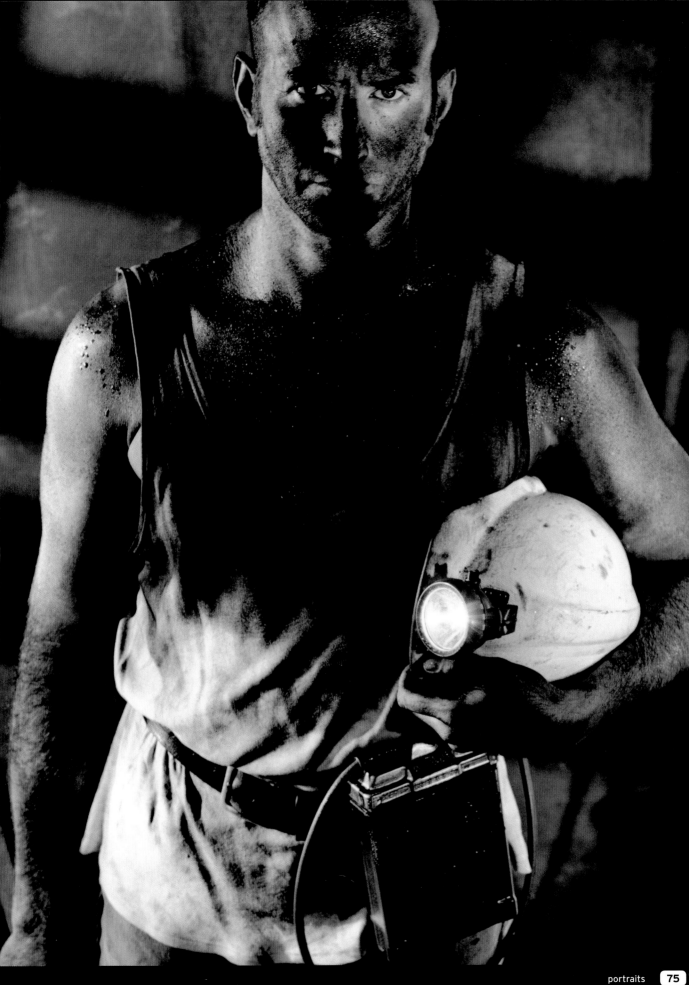

niña detras de la ventana

photographer **Dolors Porredon**

client	Studio
use	Poster
camera	6x6cm
lens	150mm
film	Kodak Vericolor III
exposure	f/8
lighting	Electronic flash: single soft box
props and set	Built set

A perfect moment, captured by chance—or careful planning? The latter, of course. The window is part of a built set, transilluminated with a 40x40in (100x100cm) soft box, supplemented only by a white bounce to camera left.

key points

► Soft yet directional lighting is often very effective with children

► Flash is usually best for children, as they may screw up their eyes against tungsten lighting

► Some photographers believe that flash can damage the eyes of young children, but there is absolutely no evidence to support this: it seems to be an old wives' tale

Although this was designed for a poster, the same techniques (and forethought, and organization) could equally be applied to a picture for less public consumption. Window sets are not particularly hard to build; a selection of hats can be kept at hand; the rest of the clothing is hardly elaborate, though the light color emphasizes purity and innocence; and the lighting is elegantly simple. It is true that, often, surprisingly complex lighting set-ups are used to mimic simplicity; but it is also true that a simple lighting set-up can (if it is well executed) be remarkably effective. Diffuse light generally works very well with children, emphasizing the delicacy of their skin texture and the roundness of their features: "character" lighting is considerably more difficult before the features have reached their adult lineaments.

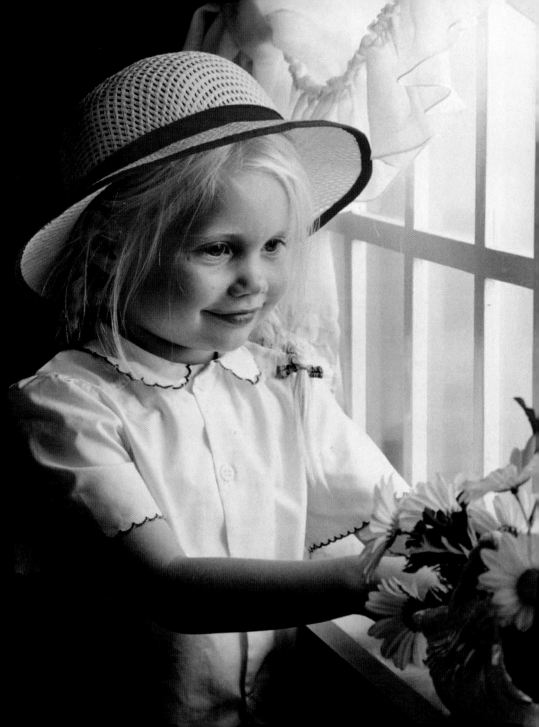

carlo maria giulini, conductor

photographer **Terry Ryan**

client	Symphony Hall
art director	Malcolm Davis
camera	6x6cm
lens	120mm macro
film	Kodak Ektachrome 100 Plus
exposure	¹⁄₂₅₀ second at f/11
lighting	Electronic flash: two heads
props and set	Location

As with so many pictures that look as if they were taken by unusually felicitous available light, this picture is in fact quite carefully lit with two heads—one of which illuminates the portrait of the conductor on the wall behind him.

key points

► Without the background light, the portrait on the wall would be unhappily bisected by a line of light and would not read well at all

► The face is arguably slightly overexposed, but this adds to the light, sunny, even joyful mood of the picture

The key light is a 3x3ft (90x90cm) soft box with 1600 joules of light to camera left. This is supplemented by a Lastolite folding reflector below the subject's knees, throwing some light back up to lower the contrast—particularly important as the subject is wearing a dark suit and a white shirt.

The other light, on the background, is a 500 joule standard head to camera right; it is honeycombed to reduce spill, and to obviate having two catchlights in the subject's eyes. There is also sunlight coming through a window to camera right: it is this that casts the shadows of the flowers.

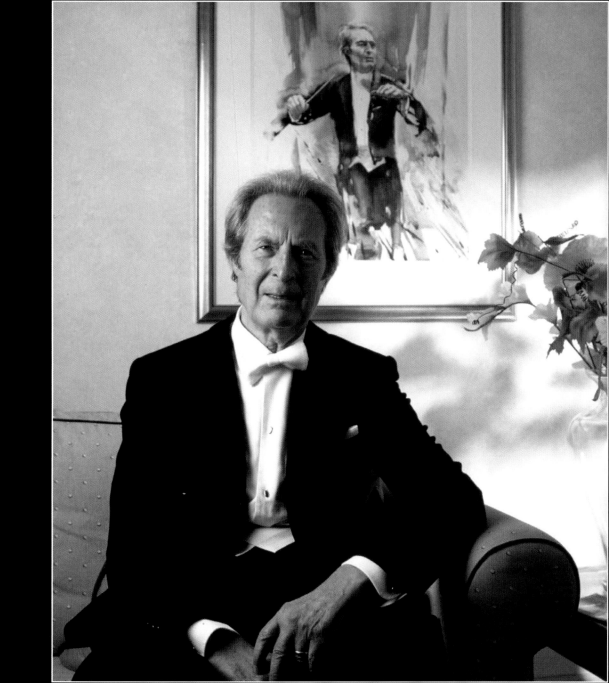

brian cox

photographer **Jason Keith**

use	Editorial
camera	Mamiya RB67
lens	250mm
film	Not recorded
exposure	$\frac{1}{400}$ second at f/11
lighting	Electronic flash
props	Black velvet ground

An unbalanced lighting set-up has helped to emphasize an appropriately narrow depth of field in this classic portrait of a classic stage and screen actor.

key points

► A long focal length lens allows for a narrower depth of field, and ensures that the already dark background is thrown out of focus

The key light here is the soft box to right of camera. With no other lights to balance the portrait an appropriately theatrical atmosphere has been created, but one that has been tempered by the use of a soft box rather than a honeycombed head or standard spot. Although the soft box has mellowed the subject, it still creates a sufficient amount of directional light to create character in the portrait, helped by the use of light-absorbing black card to left of camera, and a black velvet background cloth.

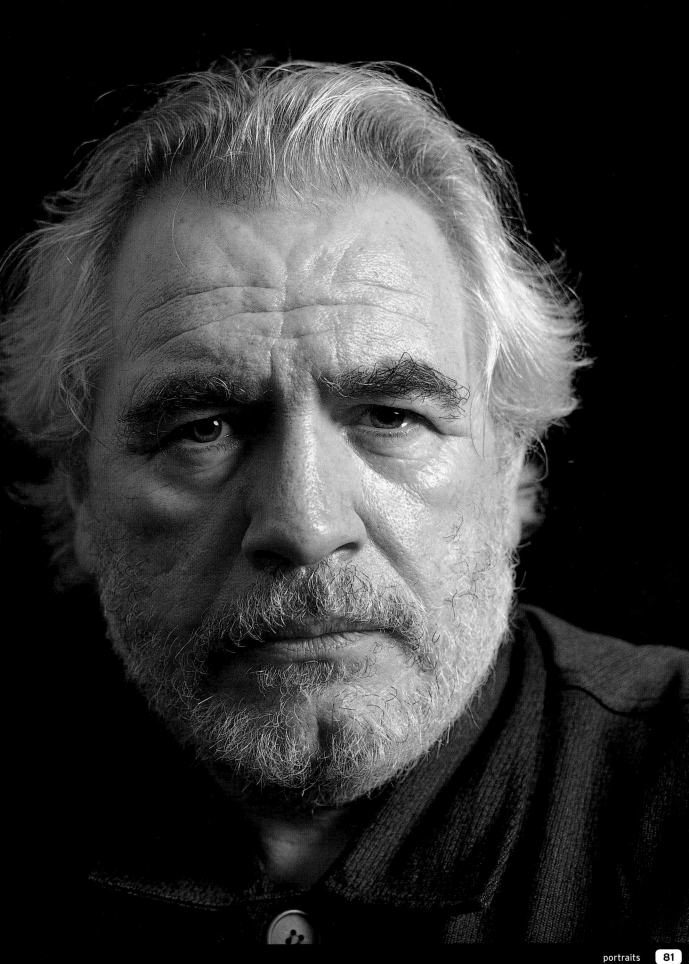

raymond's revuebar

photographer **Johnny Boylan**

client	Sunday Telegraph Magazine
use	Editorial
subject	Paul Raymond
assistant	Siri Hills
camera	6x7cm
lens	127mm
film	Kodak Tri-X rated at EI 200
exposure	⅛₅ second at f/11
lighting	Electronic flash plus available light
props and set	Location

Raymond's Revuebar and its proprietor Paul Raymond are London landmarks. The challenges here were, first, to show both together in a way that showed as much as possible of the Revuebar, and, second, to balance the lighting.

key points

- ▶ Any slight movement by the subject during the 1/15 second exposure would be insignificant compared with the flash exposure that "freezes" him
- ▶ In pictures such as this you have to decide which compromises to make when considering composition, sharpness, and lighting

The obvious approach would have been to use a wide-angle, but that would have reduced the impact of the Revuebar itself. Equally, too long a focal length would have led to depth of field problems. A 127mm lens on a 6x7cm camera was the answer, but Mr Raymond had to stand on a milk-crate to obtain the right angle. Because it is so recognizable, and because all the print is so large, the Revuebar could be left to go slightly soft. This set-up required more power than would have been available from portable flash, so a studio flash unit with a long extension cable was used. It was mounted high and to camera left, while an assistant with a collapsible white bounce stood out of shot to camera right to provide some fill on the left side of the face.

RAYMOND REVUEBAR

Paul Raymonds

LAVISH REVUE LICENSED BARS

RAYMOND
REVUE B
THE WORLD CE
EROTIC ENTER

2 SHOWS
NIGHTLY
8
&
10
(NOT SUNDAYS)

strange trinity

photographer **Lewis Lang**

"This shot breaks several 'rules' of lighting. It was taken at noon with the sun overhead, with full-frontal on-camera flash to illuminate the ugly shadows cast by the overhead sun—and the camera's built-in flash cast the shadow of the lens into the picture!"

use	Exhibition/print sales
camera	35mm
lens	20mm
film	Fujichrome 100 RDP
exposure	Not recorded
lighting	Daylight plus on-camera flash
props and set	Truck wheel

Lewis sums up his own photography best. He goes on: "Normally, these 'three strikes' would justify throwing such a shot into the trash, but here they add up to a powerfully wild and wacky portrait—the lens's shadow over the bottom of the two gentlemen's faces makes them appear more ominous/sinister/mysterious, and the smiling dog seems to agree." He also describes the light as "Weegee-esque," after the New York photographer who gained fame and notoriety for his harshly lit scene-of-crime shots; an example of the intellectual resonances that often suffuse powerful pictures, whether we recognize their origins or not.

All too often, photographers ask other people what will "work" in a picture—and are too often willing to accept others' views. Lewis Lang demonstrates that the best answer is normally, "Try it!"

key points

▶ On-camera flash can be exploited in
a surprising variety of ways

▶ Harsh lighting, bright colors, and
simple shapes often go together well

algerian family

photographer **Alan Sheldon**

client	Elle magazine
use	Editorial
assistant	Nick Henry
camera	6x7cm
lens	165mm
film	Agfa APX 25
exposure	$\frac{1}{125}$ second at f/8
lighting	Daylight: see text
props and set	Built "lighting box: see text

This was shot using a development of the "sentry box" technique described on page 52. The background is 10x10ft (3x3m) while the box is made from two 4x8ft (120x240cm) black uprights and an improvised roof.

key points

► A large background and a significantly longer than standard lens reduces problems with the edge of the background showing (165mm on 6x7cm is equivalent to 240-280mm on 4x5in)

► Bright sun on the background and shaded sun on the foreground gives a naturally high-key effect

The increased size of the custom-made backdrop of eyeletted canvas stretched over a collapsible frame means there is no problem with its edges intruding into the picture, even when it is placed well behind the box (as here) so that it is lit by bright sun while the subjects in the box are shaded by it. Because the backdrop is independently supported (it was in fact secured against the side of the photographer's truck), both the backdrop and the box can be manoeuvred into the appropriate position with respect to the sun. The subjects come from Berber villages in North Africa.

Photographer's comment

I had to improvise a roof because I could not get them all under the standard 4ft (1.2m) wide roof.

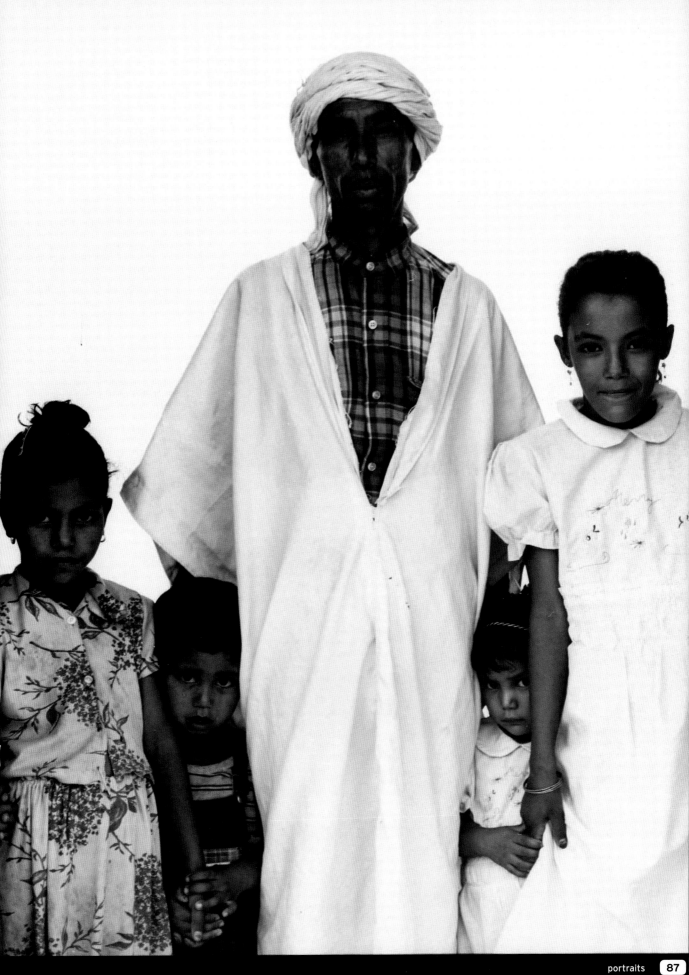

black and white

photographer **Frank Wartenberg**

use	Portfolio
camera	35mm
lens	105mm
film	Polaroid Polagraph
exposure	Not recorded; probably f/4 to f/5.6
lighting	Electronic flash: four heads
props and set	Gray background paper

A single large soft box to camera right is the key and only light here; it is further softened by a large silver reflector on the floor in front of it, and another large silver reflector beside it.

key points

- ► "Specular" skin reflections often work better in monochrome than in color
- ► Transitions from light to dark require careful composition if the picture is not to appear "busy"

A black bounce to camera left means that there is no fill, and the choice of a contrasty film (Polaroid Polagraph) further accentuates contrast: the dark parts of the faces merge into the black background. This technique, using the kind of skin reflections which for want of a better term are often called "specular," is feasible with monochrome but with color can lead to an unpleasantly greasy or sweaty looking skin texture.

With such contrasty lighting, a large part of the skill in the picture comes from very precise posing, so that the bright part of the face to camera left overlaps with the deeply shadowed part of the face to camera right.

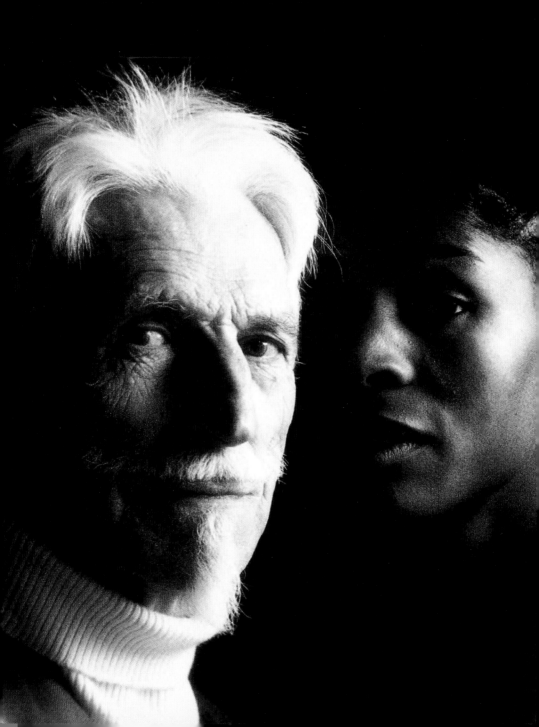

fragile movement

photographer **Rudi Mühlbauer**

use	Self-promotion
model	Eva
camera	6x6cm
lens	80mm
film	Agfa Pan ISO 100/21
exposure	1 second at f/2.8
lighting	Tungsten
props and set	White background, black leather jacket

People used to call a portrait a "likeness," and commonly demanded just that: a picture that was as literal as a police mug shot, but preferably more flattering. Today, we are perhaps more open to artistic interpretation.

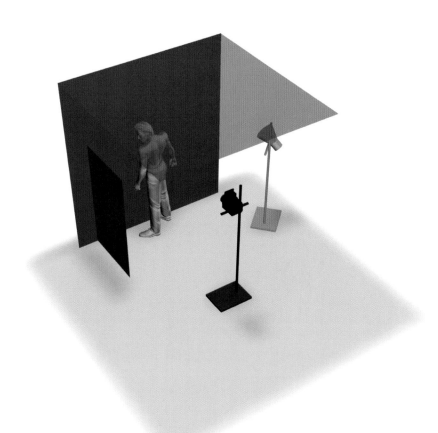

key points

► Deliberate subject movement during exposure is normally most effective in the 1 second to 1/8 second range

► Second-curtain flash synch (or synch on the closing of a leaf shutter) can be very effective, though it was not used here

Rudi Mühlbauer used a low, white ceiling (10½ft/3.2m) to diffuse the light: the 1000 watt lamp was mounted on a lighting stand roughly at head height (5½ft/1.7m) and bounced upward. The subject was only 18in (50cm) from the wall, which served as a background and was lit solely with spill from the key. A white bounce to camera left and just out of shot provided some fill on the face. Asking the subject to move during the exposure is experimental, and it is normally necessary to shoot a good number of exposures from which only a few—or even just one—may be usable. Finally, the monochrome negative was printed on Kodak Ektacolor Ultra paper in order to achieve the color. Similar effects can be achieved using photo-editing software.

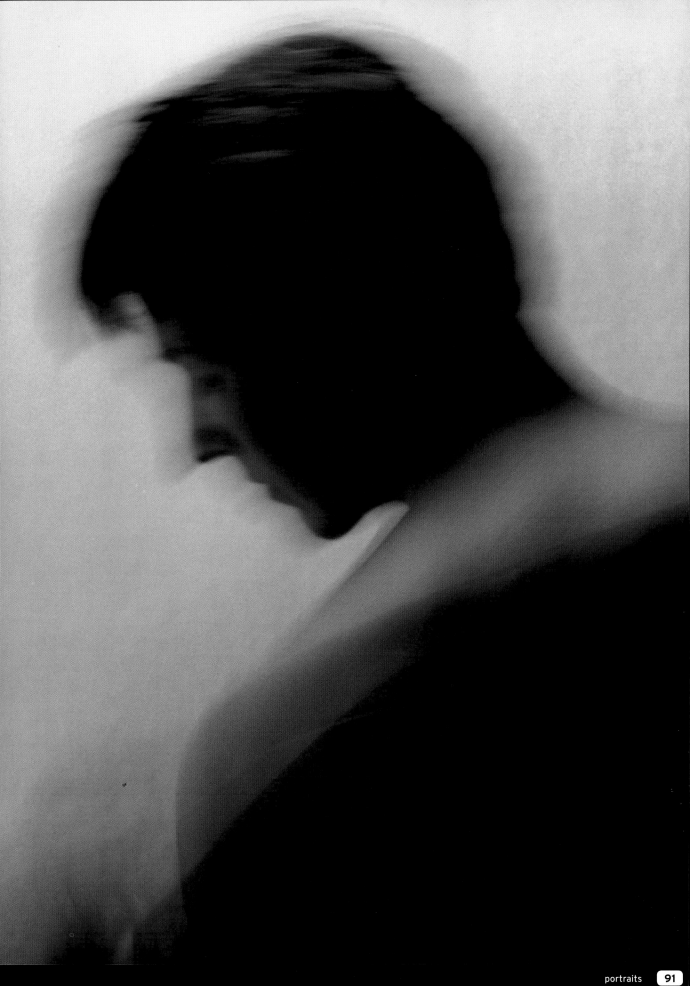

dark angel

photographer **Lewis Lang**

Remarkably, this is a self-portrait. The shadow of the camera is blocked by the shadow of the head; it is pointed at the wall, and slightly to the right, at an angle of 45 degrees or less.

use	Exhibition/Print Sales
subject	Lewis Lang
camera	35mm
lens	25-50mm zoom at 25mm
film	Fujichrome 100 RDP
exposure	About 1/125 second at f/16
lighting	Direct setting sun
props and set	Santa Barbara County Court House, California

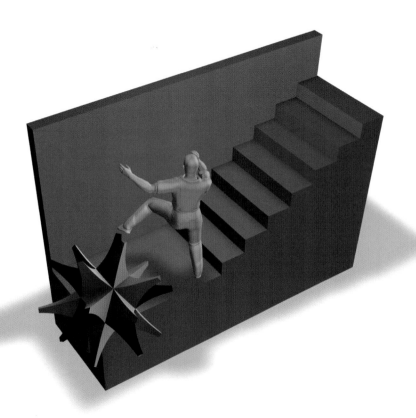

Most photographers are intrigued by the light of the setting sun, and want to play with it–but to get the best results you have to plan ahead, so as to be in the right place at the right time, and you have to hope there is no cloud. Californians, more than most people, can generally rely on the latter.

Much the same considerations apply to shadows: they are fascinating to play with, but getting a successful picture depends on very precise exposure (usually slightly under, against a white background, in order to get adequate density) as well as a combination of imagination and determination.

Photographer's comment
A low, west-coast setting sun at an oblique angle to the court house, and some deft positioning of my body, enabled me to get a shadow that is both a flat shape and appears to recede three-dimensionally.

key points

- ▶ Plan ahead to be in the right place at sunset
- ▶ Look for a white-painted or at least pale-colored wall
- ▶ Use stairs, etc, to create distortions in the shadows

zena

photographer **David Dray**

This picture demonstrates a technique for which David is noted, that of color photocopy transfer. The original photograph is made into a color photocopy, then transferred by a solvent technique onto water-color paper, which gives a unique effect.

use	Stock/library
model	Zena Christenson
camera	35mm
lens	100mm
film	Fujicolor ISO 100 (negative)
exposure	f/8
lighting	Electronic flash: one head
props and set	White paper, length of muslin material

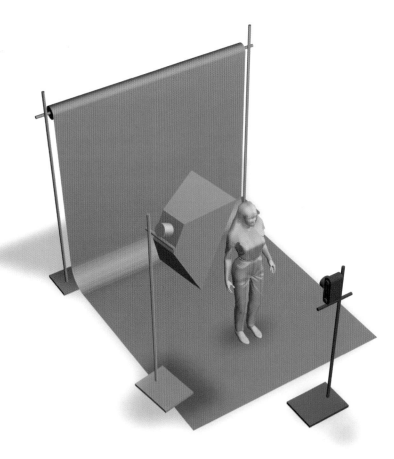

The subject here is positioned well in front of the background, which is about 8ft (2.5m) behind her; the amount of spill reaching it is therefore trivial. The only light is a small 16x16in (40x40cm) soft box set rather above the model's eye-line and angled down at her. It is about 40in (1m) away from her. Immediately out of shot, low, and to camera left, is a bounce that throws light back up into the model's face. The white muslin also acts as a combination flag (or at least scrim) and bounce, partially shading the model's face but also reflecting light down onto the bounce.

▶ When pictures are subject to after-treatment of this kind, there is rarely any need to use formats larger than 35mm

▶ A landscape (horizontal) composition emphasizes the drape of the muslin head-covering; a conventional portrait (vertical) orientation would have created a completely different mood

peter scissorhands

photographer **Peter Barry**

use	Christmas card
model	Peter Barry
make-up and hair	Celia Hunter
camera	6x6cm
lens	150mm
film	Ilford FP4
exposure	f/11
lighting	Electronic flash: two heads
props and set	Scissors, paper cut-out Christmas trees

Peter Barry's Christmas cards are eagerly awaited by his friends and business contacts every year: he has been The Joker from *Batman*, a pantomime dame, Scrooge, The Mask, and more. The lighting on this is actually one of the simpler ones.

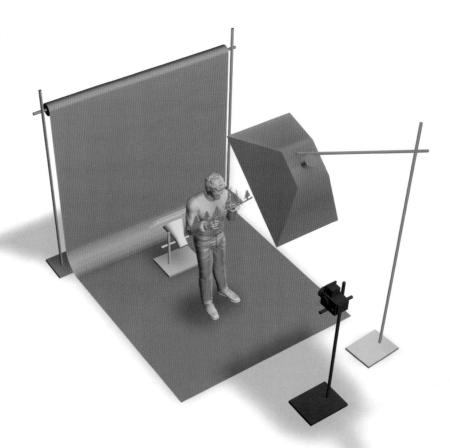

key points

- ► Classic "horror" lighting is from underneath, but flat frontal light can be just as menacing
- ► There is a place for humor in photography, though successful humor is not always easy to achieve

A single soft box, 5ft (150cm) square, was placed directly over the camera for a dead flat "horror movie" light; reflections off the blades of the scissors (which were taped to his hands) were essential, as was the threatening leather jacket which also reflected the light well. A large print was made, and the cut-out Christmas trees were hand-colored (they were white in the original). The painted canvas background was lit by a single diffused light on the floor behind the subject: a scrim over a standard head. A great deal obviously depends on the make-up, and on the topicality of the image: this was made in the year that *Edward Scissorhands* was released.

Photographer's comment

I do this sort of thing every year. It's fun, and it is effective promotion as well.

hysteria

photographer **Johnny Boylan**

client	Terence Higgins Trust
use	Publicity (not used)
assistant	Christine Donnier-Valentine
camera	6x7cm
lens	180mm
film	Agfa APX 100 printed on lith paper
exposure	f/11
lighting	Electronic flash: four heads
props and set	White background

This was from a series of pictures designed to convey emotion; in this case, "hysteria." Rather than going for the sort of harshly lit pseudo-reportage shot that some might choose, Johnny Boylan went for a very formal, graphic interpretation.

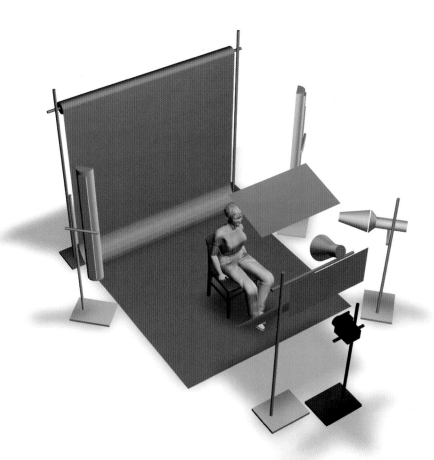

key points

► Directional lighting, no matter how heavily modified with reflectors, always gives more modeling than flat frontal lighting

► The reflections on the hair are from the bright background

Two lights were used here, a hard top light from above (look at the shadows on the tongue) and a "beauty light" from the right, a soft spot that gives extra modeling: look at the differences between the two sides of the neck, and the cheeks. The directional effects of these two lights are much diminished by generous use of white expanded polystyrene bounces all around the subject; you have to look closely to see that the light is directional at all, though the modeling of the face would have been far less obvious if it were not. Finally, the high-key background comes from two strip lights on either side of the subject. It is lit about half a stop down from the main subject.

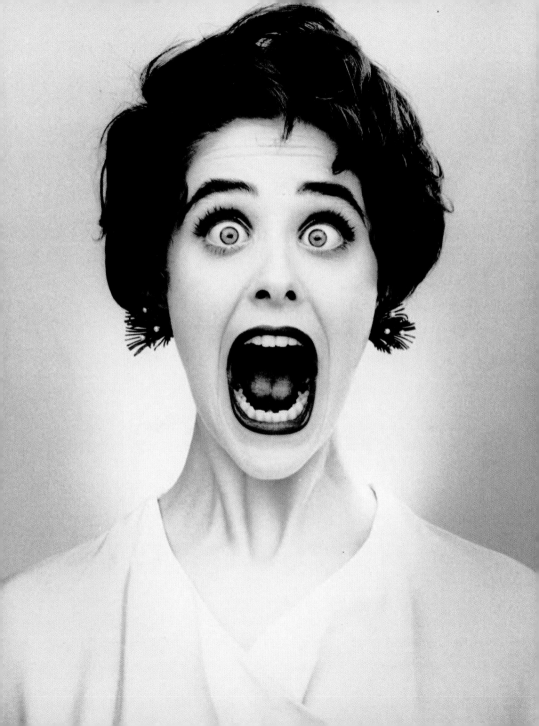

tim roth

photographer **Jason Keith**

Such a large space would seemingly require a complex lighting set-up, but in fact simple has worked best here; the clever use of a straightforward set-up has allowed the ambient light to permeate the cavernous room, without detracting from the subject.

use	Editorial
camera	Mamiya RB67
lens	65mm
film	Not recorded
exposure	$\frac{1}{400}$ second at f/11
lighting	Electronic flash

Two standard heads left of camera have been used with sheet tissue paper clamped over to provide a softened but still fairly high-contrast light. One lamp lights the center of the room, the other concentrates on the subject. With a reflector placed forward and right of camera, the shadow cast across the subject's face is allowed to remain, but has been tempered. The use of a shorter focal length lens than would normally be used for a portrait has ensured the entire space is in focus, which has helped the subject to be a part of the surroundings rather than appear a temporary visitor to it. Using a black flag forward and left of camera has stopped any potentially distracting light spilling in from the left.

key points

► The short focal length lens ensures
the entire room remains in focus

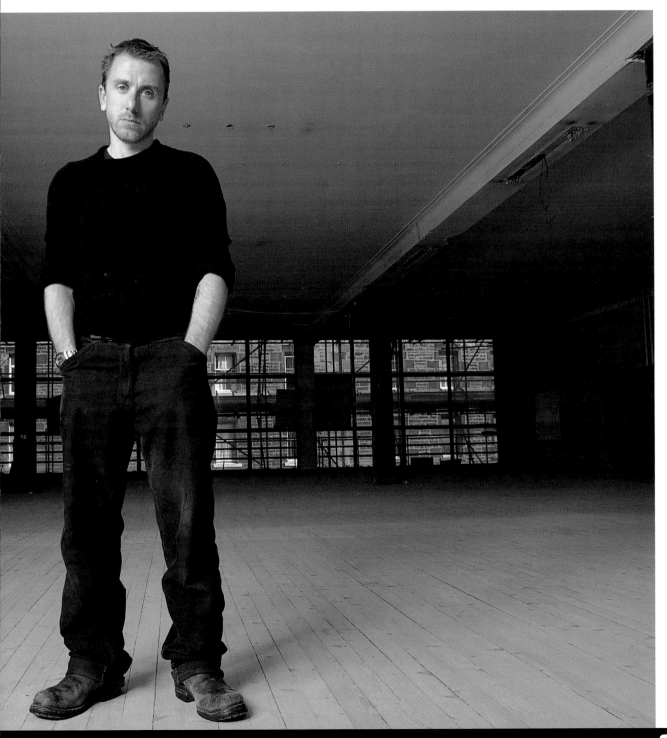

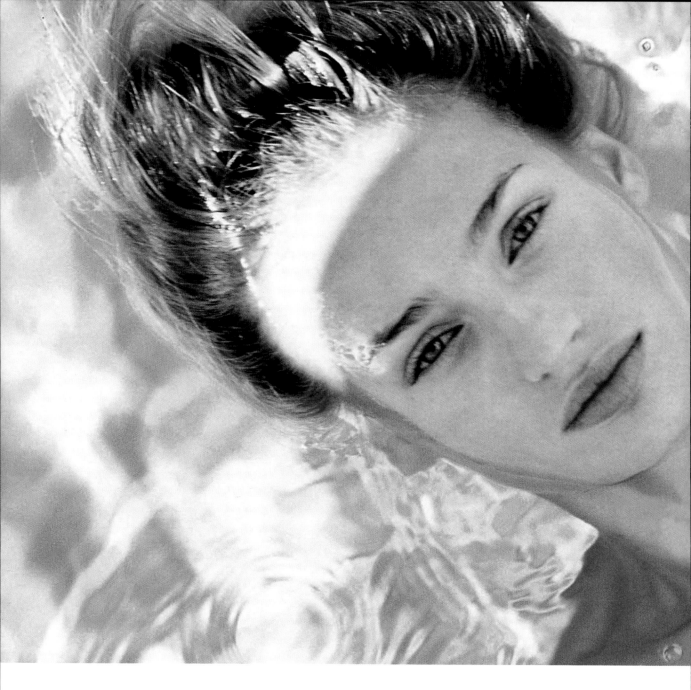

fashion

This section demonstrates the variety possible in a field known for its tempestuous, fleeting, and often fickle nature. The shots here explore a wide range of work, from the influence of setting and costume to the creation of different moods with a slight shift in lighting. Fashion images produced for commercial, editorial, personal, and fine art work are featured.

Photography is an ideal medium for the fashion industry to utilize as a publicity machine. Just as fashion is swiftly changing, so the photography industry can quickly produce the images needed to keep up with the fashions, giving the necessary immediacy and sense of "the moment." In many ways the two industries feed off each other. An enormous proportion of commercial photography is associated with the world of fashion. Ironically, it is the very accessibility, the ease and swiftness with which images are produced and the ease of mass reproduction of the images, that has been held against photography in its struggle to be recognized as an art form in its own right. The fact is that photography does seem instant. However, not everybody has the creative vision or the eye for an image that distinguishes the casual snapper from a master such as Cecil Beaton.

Working with fashion models

The evolution of the supermodel is a phenomenon heavily dependent on the photographer. Many supermodels, indeed, attribute their breakthroughs to one pivotal photograph, the one that got them the crucial front cover or campaign. The relationship between certain models and their photographers is legendary, and a good long-term working relationship with a model gives the photographer certain insights and advantages when on a shoot.

Matters of personality are always going to be important when working closely with individuals, but it is especially important to be aware of the sensitivities of fashion models, whose face is their fortune.

Modeling is an intensely competitive industry, emotions can run high and the potential problems of highly strung individuals are exaggerated by an over-excitable press in pursuit of a good story. Reality rarely matches up to these hysterical accounts. The more experienced the model, the more reliable the photographer can assume they will be during a shoot.

The situation to strive for is a clear brief, a good rapport with the model, and clarity of communication. Professionalism on both sides of the camera is the key.

The team

There will usually be a make-up artist and stylist on hand to create the look required by the client and photographer. Studio assistants will also be needed, especially where the lighting set-up is complicated and extra help necessary to position gobos, hand-held bounces, and props. While the camera assistants concentrate on technical aspects of the shoot, the photographer can take on more of an artistic director role.

The client's representative is often a crucial member of the team. It may be that the agency and/or the client require art directors and publicity managers to be present to ensure that the look created is the one wanted for a particular fashion product. In such situations, it is essential that the brief has been thoroughly discussed and agreed beforehand.

Hospitality is a consideration. If the client enjoys the shoot as well as liking the end result, they are more likely to return to that photographer. It is also important to keep the working team refreshed, since a long shoot can be tiring and no one can afford to have any team members flagging. This is particularly important in the case of the model.

Cameras, lenses, and films

As constant variation in style and techniques is the key to the fashion industry, it is difficult to generalize about what equipment is appropriate for a fashion shoot. Most fashion photographers swap between different formats and stocks to exploit the different qualities of the formats and films available. It depends on what look is wanted, what is currently in vogue, the nature of the product, and what the client has in mind.

The 35mm camera is very light and ultra-fast, with modern digital SLRs capable of shooting five frames per second. Medium format is slightly more cumbersome but is still very quick and easy to use, and many fashion photographers are experimenting with digital backs to speed workflow. Large format (4x5in and 8x10in, among others) need more time, but offers the potential for crystal-clear images and excellent shadow detail—as well as the sheer joy for the enthusiast of those glorious, beautiful large transparencies!

Telephoto lenses are generally used as they give a more flattering look. This means that more studio space is required to take full-length images, though less background area is required.

If film is used, transparency film offers superior quality, but at the expense of a relatively small exposure latitude. But with Polaroid testing and experience this is not such a high price to pay. Negative stock, although theoretically of lower quality than transparency film, offers a greater degree of flexibility in exposure latitude and tonal renditioning. Some people choose negative film specifically because of the look of the inferior film quality, and this is a valid choice if circumstances allow for it.

Lighting equipment

A whole plethora of lighting equipment is required for the fashion shoot. Large soft boxes, small soft boxes, several standard heads for lighting the background, accessories such as honeycombs, colored gels, barn doors, gobos, umbrellas, bounces and panels, white, gold, and silver reflectors, mirrors, and flags will often be used. Fashion shoots are model-based, so the only item of lighting equipment that is not commonly used in a fashion shoot is the light brush, which generally needs a perfectly still subject for an extended period of time.

The flash-versus-tungsten decision will be based on the look that is required and personal preference on the part of the photographer; again, there are no hard and fast rules. One reason for preferring electronic flash is that it has lower temperatures and so may help prevent the model—and indeed the whole team and studio—from getting overheated. An advantage of the more physically hot tungsten light, which is in fact traditionally preferred for the fashion shoot, is the esthetic quality inherent in the continuous source. It is something for the individual photographer to weigh up depending on the particular conditions of a particular shoot.

Studio or location?

In a fashion show situation, there is no choice but to be on location, and that location will be the venue of the catwalk show. There are implications to this. For one thing, there will be a considerable amount of ambient lighting from the spotlights in the hall to light the runway. There are matters such as flare to be taken into account, and little opportunity to have the space to set up the camera to avoid

this. There will be little elbow room, probably no choice of position or view, not to mention the constant flashes from the sea of cameras of the other photographers attending the show. There is only one attempt at every shot—the show will go on whether the photographer has the image that he wants or not—so speed is of the essence and a sense of anticipation is invaluable. The photographer must be ready to shoot a great deal of film in these less than ideal circumstances to have a chance of a reasonable number of shots turning out successfully amid so many uncontrollable factors.

In other situations, a commissioned shoot may take place in the studio or on location. The studio offers the fullest control of the situation, and especially of the lighting, whereas the location may offer a more elaborate set than can be managed in the studio and this may be essential for the particular brief and setting of the shot. The choice of site for the shoot can only be determined in relation to the needs of the final image; whether the setting is significant, what kind of look is wanted, and so on. It is broadly true to say that the more spontaneous kind of "street" images may well happen more commonly on location, while the more formal cover shot-type images are likely to take place in the studio.

The clothes

In a fashion shoot the clothes are the very raison d'être of the session. It is therefore essential that every detail is right; that the clothes are displayed exactly as the client wants and any important features are noted beforehand so that the photographer knows which elements are to be emphasized in the final image.

The assistance of a stylist/costume dresser will be extremely helpful in ensuring that the clothing is worn and presented correctly, that it is pressed and free from specks or flaws, and that replacement items are available in case there are any problems with one particular item in the collection. In cases where a unique designer garment is the subject, it will probably be the case that the designer of the item will be on hand to supervise the wearing and presentation—and safety—of the clothing. In such cases, the designer may be the only person who can decide what to do should any accident or problem arise with the garment; whether to repair or amend the garment, or whether to replace it entirely. Needless to say, when valuable unique items are involved, insurance is even more important than usual!

If the garment is especially unusual in some way, it is essential that the photographer has an opportunity before the shoot to become familiar with its particular features and become aware of any peculiarities that might require special treatment during the shoot. This is really no more than normal good practice in terms of making sure that the briefing session is thorough and comprehensive, but it is just as well to be aware of any surprises that a designer fashion item can present.

It may also be necessary to allow for rehearsal and fitting time for the model who is to work on the shoot so that time is built in for any adaptations to the garment to take place to allow for a particular model's height and figure. Good preparation is essential.

café royal

photographer **Michael Freeman**

use	Advertisement
camera	Sinar P 4x5in
lens	150mm
film	Ektachrome 6118
exposure	1 second at f/5.6
lighting	Quartz-halogen lamps
props and background	The Savoy Grill

The lighting plan aimed to re-create a period atmosphere with soft light and muted colors, while establishing that this was a real location.

key points

► The choice of location was important in creating the period feel

► Ambient lighting was all that was required to light the setting, with quartz-halogen lamps picking out the significant element of the shot: the dresses

The shot was framed to include the window, which was allowed to flare. Approximately half the amount of the interior lighting comes from the ambient lights, with a pair of 3200K quartz-halogen lamps diffused through translucent umbrellas from the right helping to pick out the long dresses, and a third bounced off the ceiling at left. The rich dark furnishings absorbed much of the light, and provided a soft backdrop for the delicate lace clothing. The exposure was long at one second, as would have been a photograph taken during the period, forcing the models to adopt formal postures that they could easily hold still.

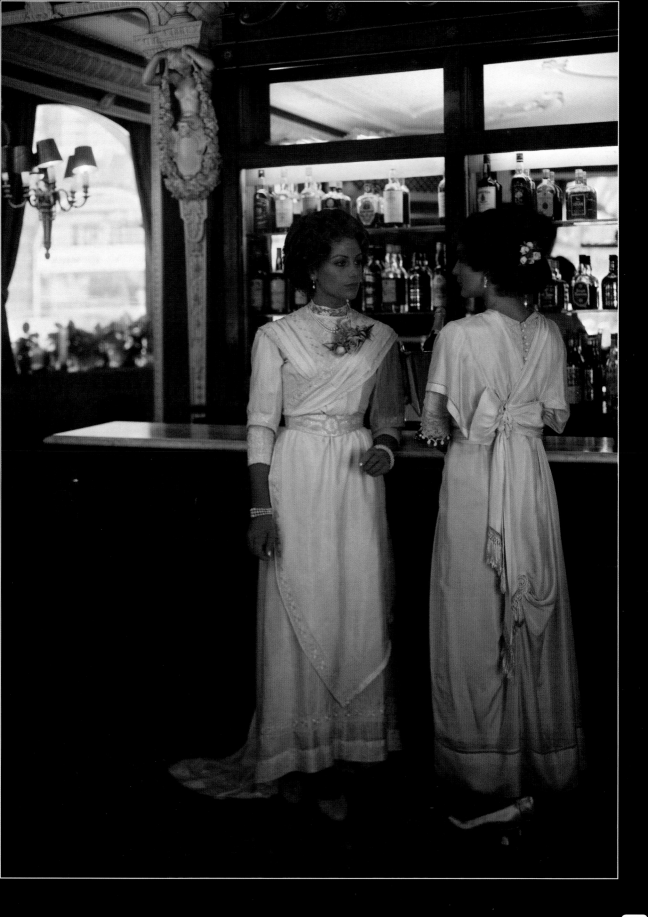

alberto

photographer **Jason Keith**

use	Portfolio
camera	Nikon D70
lens	55mm
digital ISO	200
exposure	¹⁄₂₅₀ second at f/10
lighting	Electronic flash

Using only the interior diffuser in the soft box—the exterior diffuser has been left off—provides light with more contrast, which was appropriate for this shot.

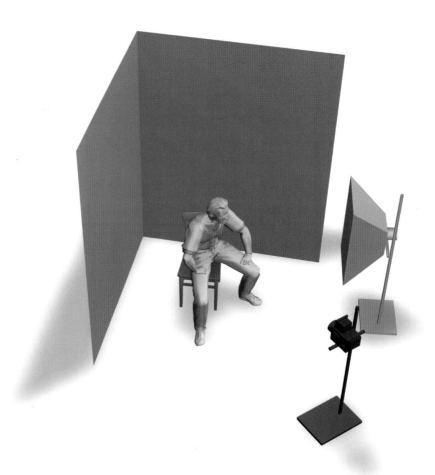

key points

► Taking the front diffuser of the soft box has helped to create harsher light

This simplest of all lighting set-ups— with just one semi-diffused lightbox at camera right providing all the light for the shot, and no reflector to balance the unlit side of the face—has provided a suitably atmospheric scene. By placing the subject in the corner of the room, the 90 degree angle where the walls meet has added some interest to the background. The image has been desaturated of color in Photoshop, and with adjustments of the Hue and Saturation controls, a sepia tone has been added which complements the single tonality of the clothing.

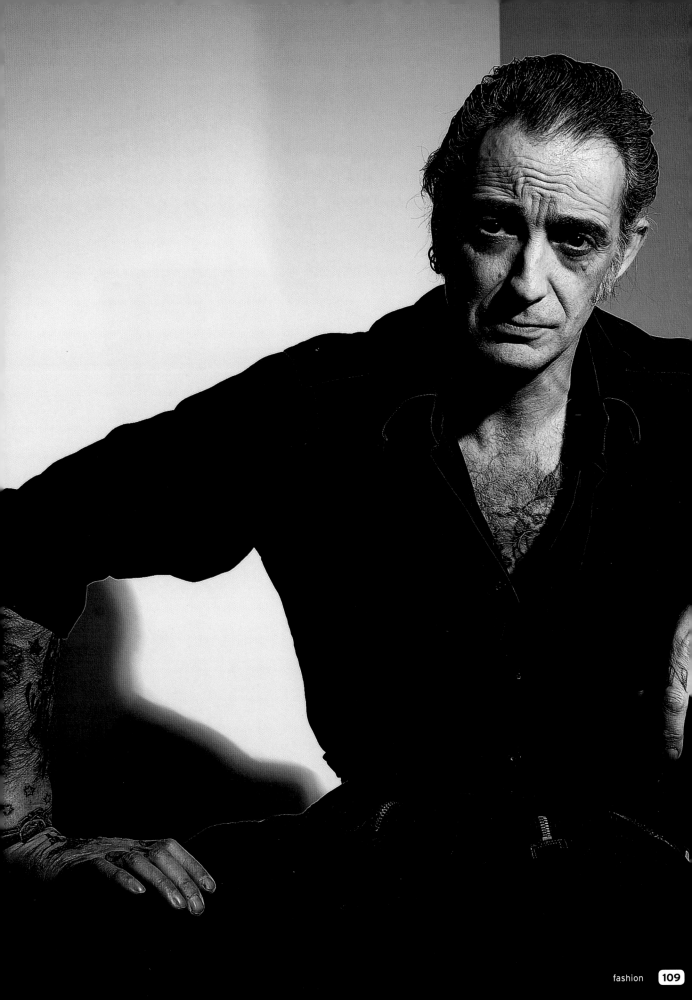

orange trousers

photographer **Corrado Dalcò**

use	Personal work
model	Manici Patrizia
assistant	Matteo Montawari
art director	Corrado Dalcò
camera	Polaroid Instant 636CL
lens	38mm
film	Polaroid 600 Plus
exposure	Not recorded
lighting	Electronic flash
background	Corchia, Italy

A built-in flash can be the simplest of lighting devices to carry about for a location shoot, and in certain circumstances it is as much as you need to get the right look for a shot.

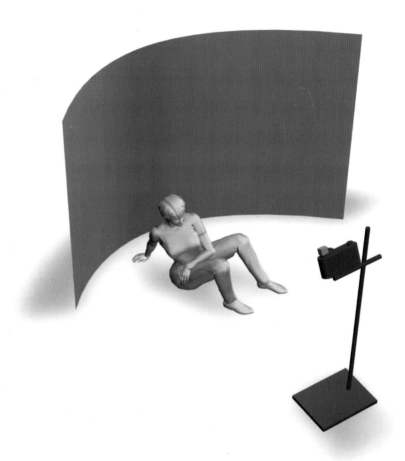

key points

► A built-in flash allows the photographer to be mobile and to adjust position and view constantly, in the safe knowledge that the lighting will be in a constant position in relation to the lens

► On-camera or built-in flash can be modified by gel or tissue paper

Immediacy and spontaneity are often vital ingredients in a fashion shoot to get the model to perform well, to get the shutter snapping and the results flying out of the back or front of the camera with an air of excitement and capturing an "of the moment" look. The Polaroid range of cameras and stock are excellent tools for just these circumstances, coming into their own for a more permanent result than their other major use as a tester before the real thing is shot on a different format. As Corrado Dalcò shows here, they are more than capable of producing "the real thing."

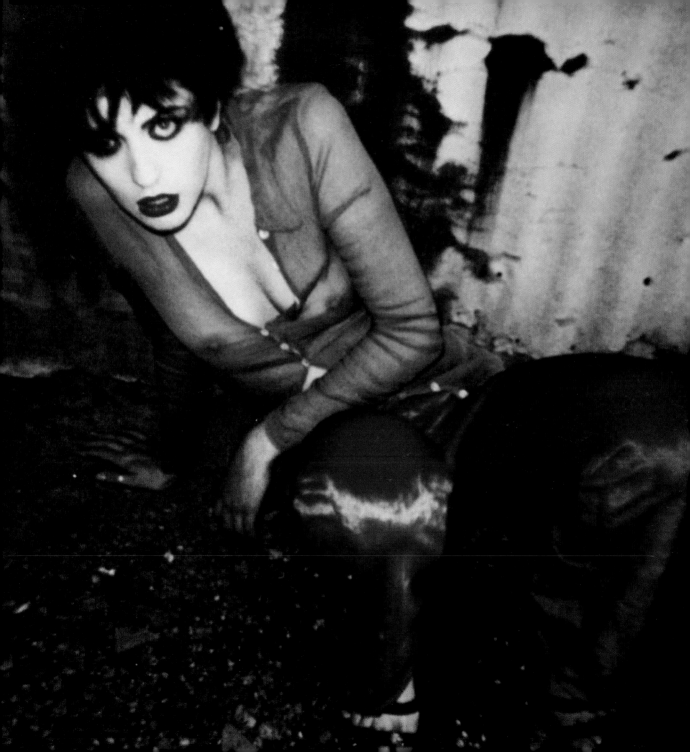

bicycle shot

photographer **Jeff Manzetti**

client	Madame Figaro
use	Editorial
model	Viola
art director	William Stoddart
hair	Brunno Weppe
make-up	Elsa Auber
stylist	Charla Carter
camera	6x6cm
lens	100mm
film	GPX 400
exposure	f/8
lighting	Available light
props and background	Fondation Cartier (rooftop terrace)

This shot is a classic example of a photographer using coincidental elements as if they were the closely controlled elements of a studio situation.

key points

► Reflections in glass can be avoided by use of a polarizing filter

► It is possible to lose up to three stops of light when using a polarizing filter, so bear this in mind when choosing film stock or selecting the ISO setting on a digital camera

Natural sunlight swathes the scene from high overhead; note that such shadows as there are, are very short and give a good indication of the midday position of the sun.

The diffusion material above the camera and model reduces the intensity of the sunlight, while a reflector panel in front of the model reduces the depth of the shadows that there are. The foreground glass pane acts as a kind of diffusion filter, slightly softening the image. This is doubly the case for the background, being shot through two panes of glass.

A polarizing filter was used over the lens to alleviate any reflections in the glass and accentuate the colors.

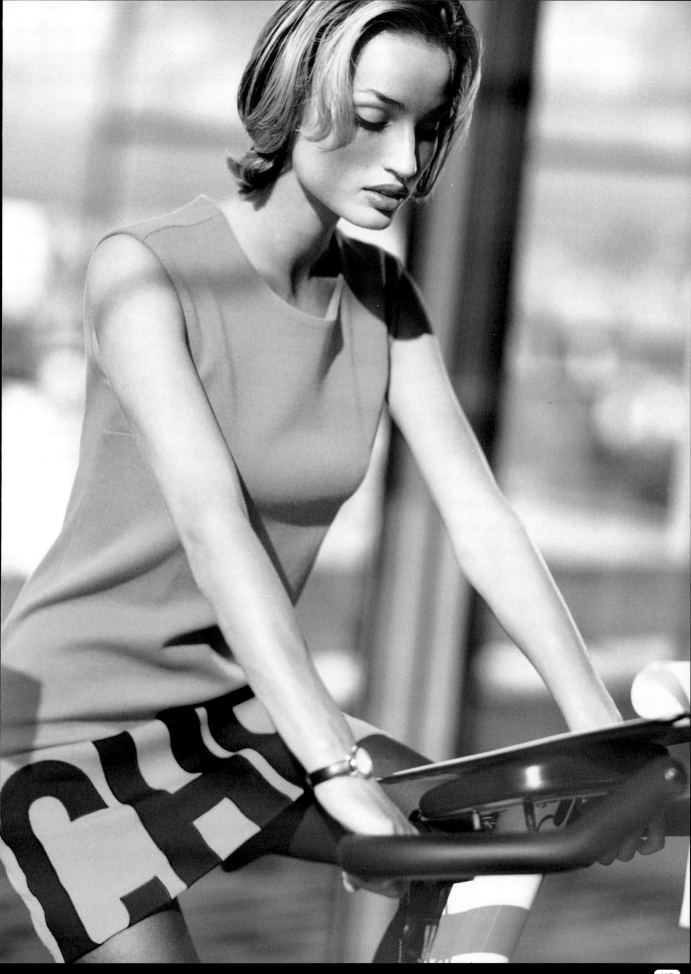

hand-painted dress

photographer **Gèrard de Saint-Maxent**

use	Editorial
camera	Mamiya 645
lens	55–110mm
film	Tmax 400
exposure	Not recorded
lighting	Available light

The camera was as much as 13ft (4m) above the model for this shot. The rocky cliff terrain is visible in the outcrop formation in the lower edge of the picture.

key points

- ► Push-processing black and white film stocks or manipulating the image using image-editing software are two methods you can use to increase contrast in an image
- ► Capitalize on naturally occurring reflectors by considered positioning of the model

The model was kneeling on the seashore with her face tilted upward toward the sun and toward the camera above. Her eyeline, however, is downward, to protect her eyes from the glare of the sun and therefore avoid squinting.

No reflectors were used as this would have undermined the whole effect the photographer was trying to

achieve; sufficient fill is provided by the rock faces of the landscape behind the model.

The hard, stark, high-contrast imagery is a combination of the direct sunlight and the contrasty film stock. To add an extra element of interest, selected areas were finally hand-tinted.

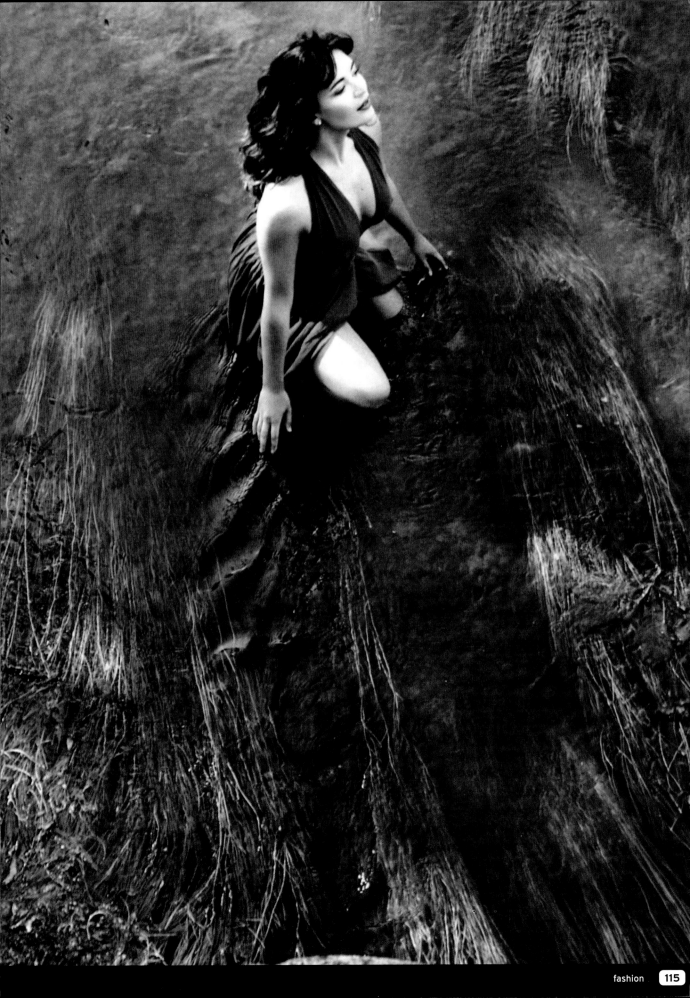

roof sway

photographer **André Maier**

client	Mode-Info, Berlin
use	Editorial
model	Hila Marin for Next Models
art director	Jörg Bertram
make-up	Hélène Gand
stylist	Jörg Bertram
designer	SWAY
hair	Yoshi Nakahara for Oscar Blandi Salon
camera	6x6cm
lens	90mm
film	Kodak E100SW
exposure	Not recorded
lighting	Available light
props and background	Rooftop, chair found on the roof!

"This was shot on a roof in the East Village, as asked for by the client," says photographer André Maier.

key points

► This image is cross-processed; an E6 film put through a C41 process. The cyan tints to the highlights are classic features of this technique. It is also possible to achieve a cross-processed look using image-editing software

► It is the end look that determines where a meter reading needs to be taken from

"They wanted a 'downtown New York look' for this fashion story on young emerging New York designers." The October day may have been cold for the team to work in, but it also had its advantages: the sky was overcast, and this even cloud cover acts as a huge diffuser, providing even non-directional light across the whole of the subject. The cool sky also provided a smooth, even backdrop against which both the featured fashion item, the modeled dress, and the dark-haired, dark-eyed model showed up well. The low angle of the camera is used to make the most of this possibility.

photographer's comment

A long October day; it was cold, the model (and everyone else) was freezing; we had to fit in six outfits from three designers, with three complete hair and make-up changes.

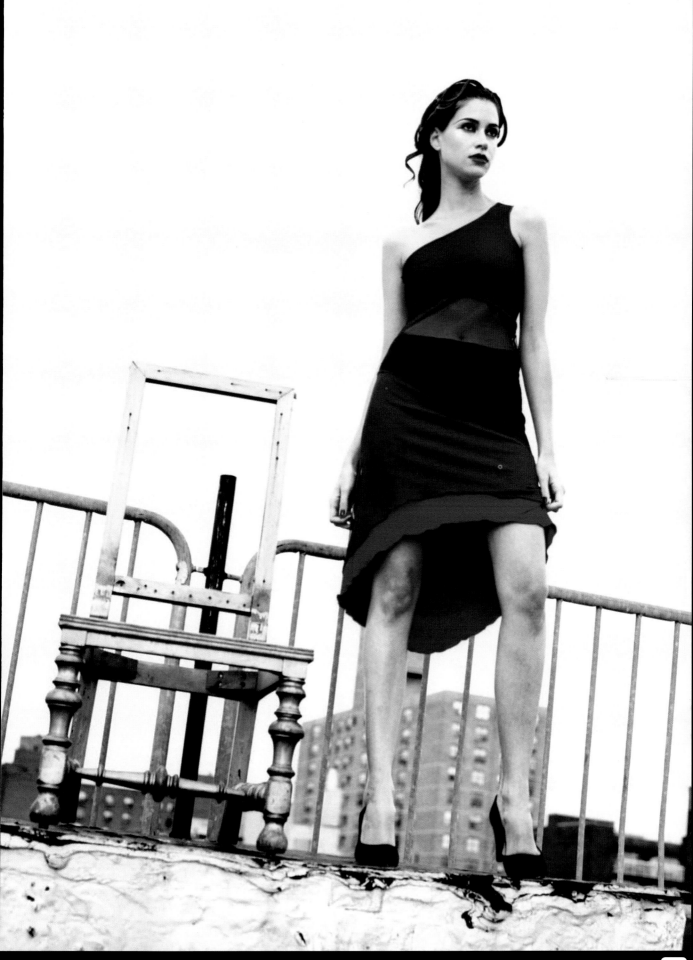

crochet outfit

photographer **Frank Wartenberg**

use	Publicity
camera	6x7cm
lens	105mm
film	Fuji Velvia
exposure	½ second at f/5.6
lighting	HMI

Frank Wartenberg searched very hard to find this fabulous and evocative location.

key points

- ► Key lighting from behind is a good way of avoiding inappropriate shadows
- ► When shooting on location, it is as well to inform the local police and to be very vigilant of equipment and of course safety

Of course, if a night shot is what you have in mind, then the locations must be viewed after dusk and when the normal available ambient light is present. In the daytime, this scene would look completely different. The HMI, which is three-quarter back lighting the model and car, is the

key light in this shot. A large silver reflector opposite the light lifts the near side of the model's costume and the car hood.

The daylight balanced key light is deliberately chosen to match with the film stock so that the background ambient light adds warmth.

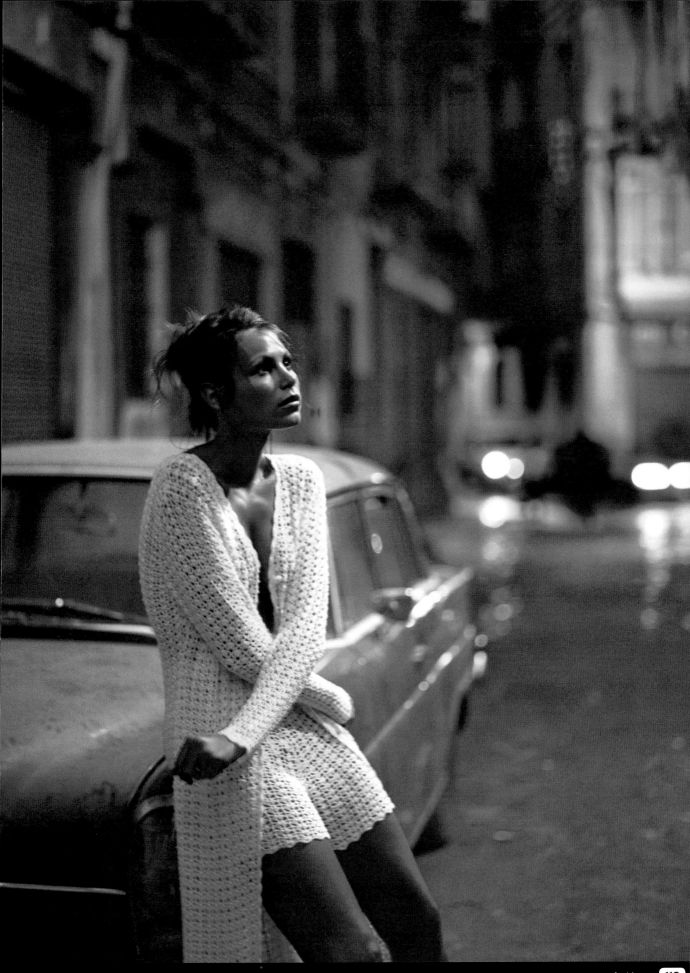

water bed

photographer **Jeff Manzetti**

client	Madame Figaro
use	Special beauty editorial
model	Viola
art director	William Stoddart
hair	Brunno Weppe
make-up	Elsa Aubert
stylist	Charla Carter
camera	6x6cm
lens	100mm
film	Fuji EPT 160
exposure	f/5.6
lighting	Available light
props and background	Pool

The model is floating in an outdoor pool of water and is positioned directly under a bridge, which provides access for the photographer to gain this viewpoint from directly overhead.

key points

► Controlled use of color can add to the coherence of a shot

► An orange 85 filter will correct tungsten-balanced film for daylight

The shot was taken at midday with the sun at its highest point in the sky giving good overhead light.

The blueness of the pool color in the rippling water is echoed by the shade of the bathing costume. Taking this use of a color further, Jeff Manzetti has also achieved blueness in the shadows on the model's body by use of a blue filter combined with a tungsten film. Both of these contribute to the blue hue. The skin is so brightly lit by the direct sunlight that it avoids a blue pallor, but the shaded areas on the throat, shoulder, and arm show the color quite distinctly.

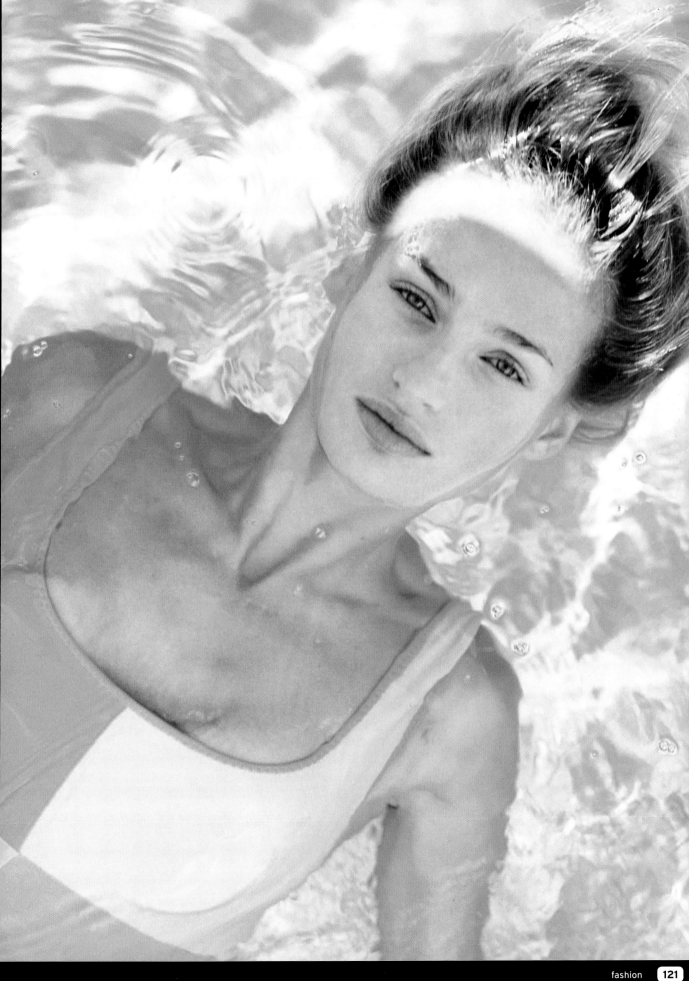

silvie

photographer **Michael Freeman**

use	Portfolio
model	Silvie
camera	Nikon D2X
lens	24-120mm at 120mm
digital ISO	ISO 100
exposure	¹⁄₁₀₀ second at f/32
lighting	Electronic flash
props	Backlit sheet of Perspex

For this portrait, one of the primary aims of the lighting was shadow control, in the sense of no significant deep shadow areas such as under the chin, and no visible shadow edges.

key points

► Distributing the power asymmetrically between the two main soft boxes in favor of the left light gave more directionality

The model's skin is a delicate shade of brown, and the idea was to concentrate attention on this and its color relationship with her bleached hair. The lighting configuration chosen, therefore, was one variant of standard beauty lighting, relying on a frontal and moderately high well-diffused main light, with substantial fill. With the model seated, two 23½x31½in (60x80cm) soft boxes fitted to flash-heads were positioned in three-quarter positions on either side, only just out of frame. The model then held a 19½in (50cm) collapsible silver fabric reflector just above waist-level, aiming the reflection upward to fill the area under her chin. Finally, a thick translucent sheet of Perspex was suspended vertically behind the model, and lit from behind by a third flash diffused through a soft box.

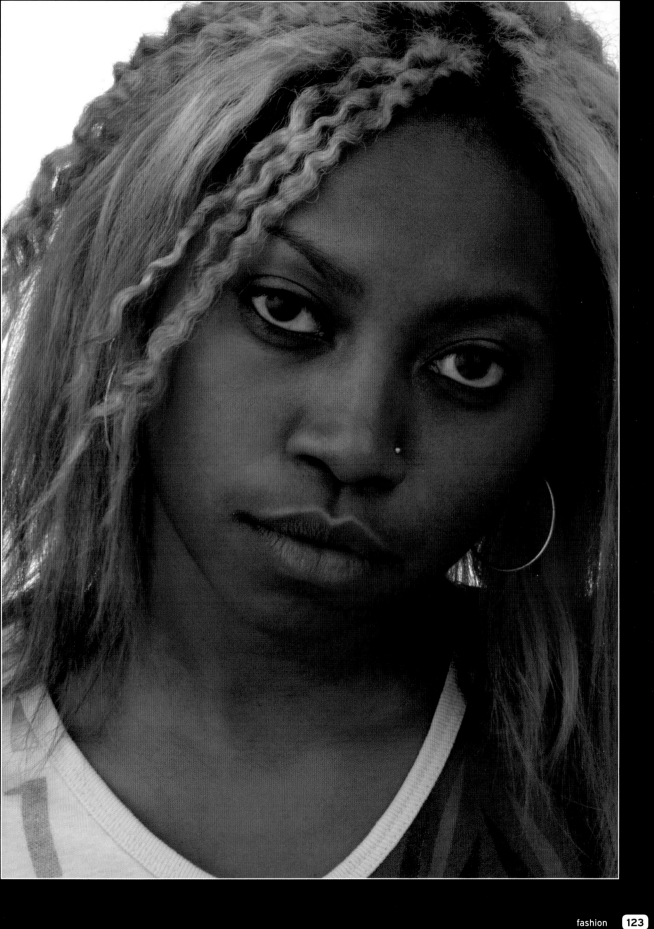

shadow

photographer **Craig Scoffone**

client	Fad Magazine
use	Editorial
model	Dawn
camera	35mm
lens	75-125mm
film	Pan-X
exposure	Not recorded
lighting	Available light
props and background	Abandoned industrial site

The long, low shadows of the late afternoon sun have a dramatic impact all of their own.

key points

► It is important to get permission to shoot on derelict sites, and possibly inform the police beforehand. Check that there are no guard dogs on patrol that might interrupt the shoot!

► It is much more difficult to work with direct hard light than it is to work with soft light, but when it is used well the effect is stunning

In this situation, the photographer has used the direct light on the model's face to emphasize the discomfort that the model is feeling looking into the sun. This is the motivation for her holding the shawl protectively around her body. The sun falls full on the model's face "giving a flat, bright evenness with the features of eyes and lips apparently painted onto a tabla rasa," says Scoffone. "The geometric hairstyle adds to the flat, graphic effect of the head. The modeling and textural interest comes lower down, in the curvature and folds of the shawl and tassels and the highlights in the fabric of the skirt."

photographer's comment

The sun was very near the horizon. This was the last shot of the day. The shadows that were being cast were too dramatic not to incorporate into the final composition.

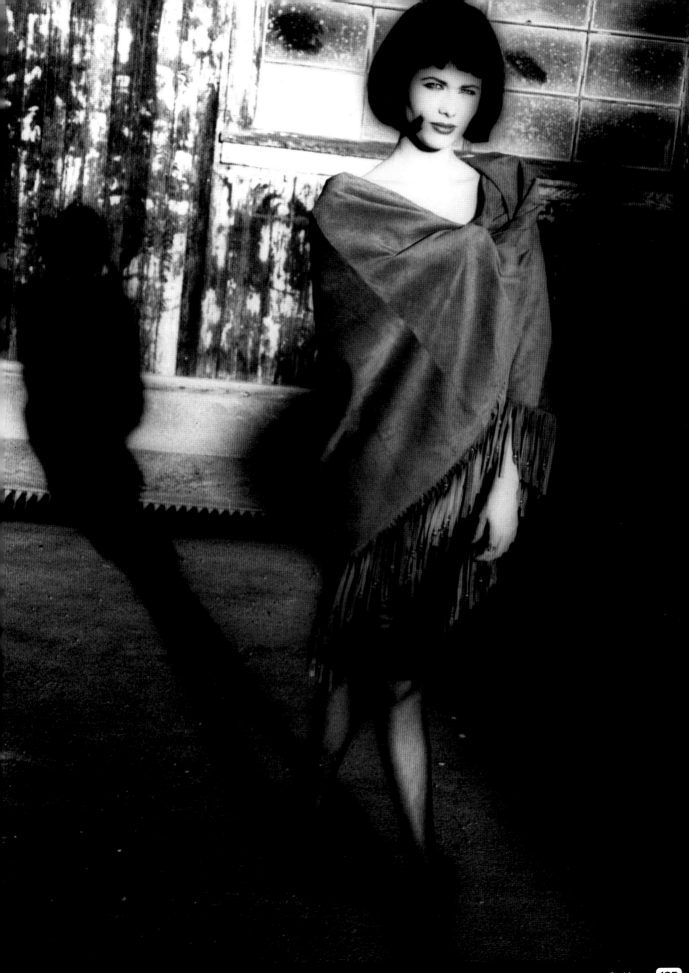

woman

photographer **Antonio Traza**

use	Self-promotion
camera	RZ67
lens	127mm
film	Ilford FP4
exposure	f/8
lighting	Electronic flash

"It is said that if you have a beautiful model to photograph, you already have 95 percent of the picture done. The other five percent is the lighting—very easy in this case, just a soft box and a reflector!" comments Antonio Traza.

key points

► It is interesting to note the absence of a catchlight. In classic Hollywood movies, a catchlight was often applied by the use of a small light directly above the camera

Indeed, the lighting set-up here could not be much simpler. A soft box is placed on the right-hand side of the model and tilted 30 degrees downward to give top light. A reflector is placed on the left-hand side very close to the armchair to fill in the shadow. The impression is of a woman in a pensive mood, sitting in an armchair with the beautiful morning light streaming in through a window. The straightforward, unobtrusive way in which the pose shows off the simple lines of the clothing, within a realistic context, make this a simple and classic fashion shot.

strap top

photographer **Simon Clemenger**

use	Model portfolio
model	Gurri
make-up	Caroline
stylist	Siobhan
camera	Mamiya RZ67
lens	50mm
film	Kodak Plus-X
exposure	⅟₆₀ second at f/16
lighting	Electronic flash
props and background	Blue Colorama

Rim light can add an almost magical quality to a shot when used to good effect. Here it creates a halo for the hair and a silvery definition for the arms.

key points

► It is very important that the flash head is hidden, not only because it is unwanted in the composition, but also because the model's head flags the camera from flare, which might otherwise appear as a milky cast across the image

► A light gray background can often be preferable to a white background when using black and white stock to reduce the contrast ratio

This effect is especially striking on the model's right arm, where the pose ensures a bold vertical line in contrast with the curved body parts.

A single standard head is placed directly behind the model's head so that she completely obscures the lamp itself. This is what produces the aura-like sparkling rim light around the model's hair and limbs. There is no frontal light source, but the three large white panels arranged around the camera bounce any available light back onto the face and background. The choice of a blue Colorama background for a black-and-white shot creates an appropriate shade of gray behind the model.

The starkness of the image derives from the way the make-up and styling combine with the dramatic lighting.

photographer's comment
I metered off a gray scale card in front of the model's face.

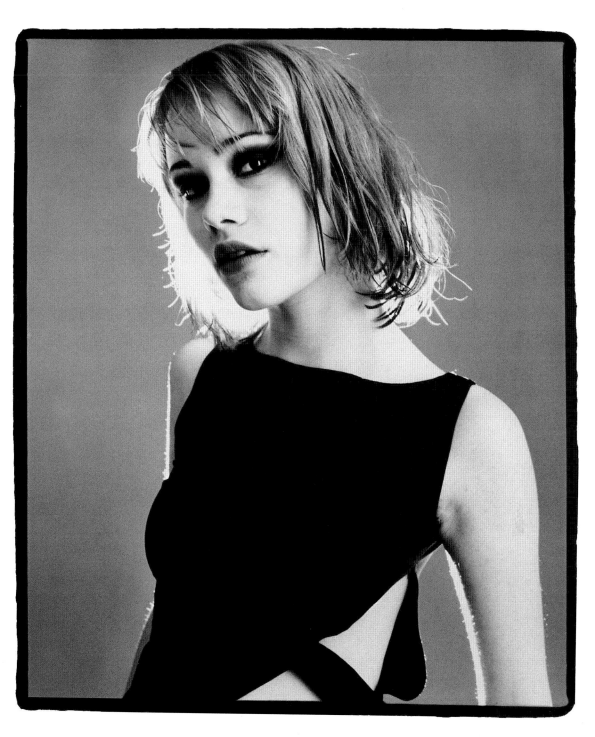

purple velvet

photographer **Frank Wartenberg**

use	Personal work
camera	6x7 cm
lens	90mm
film	Fuji Velvia
exposure	Not recorded
lighting	Electronic flash
props and background	Colored paper

A pair of soft boxes are placed alongside each other, straight on to the model.

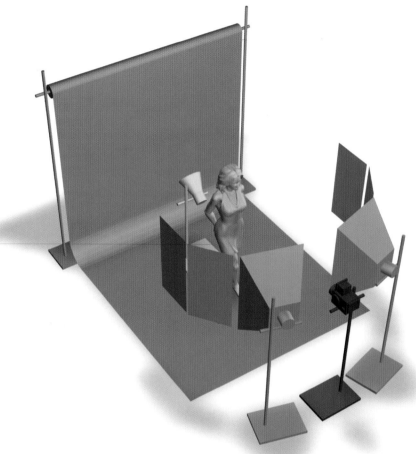

key points

- ▶ Honeycombs can be used to give soft light a degree of directionality
- ▶ Props and even a model can be used to hide a light source

A wall of silver styro reflectors are arranged into a crescent-shaped wall to either side, and these reflect back the spill light on to the model. The colored paper background is lit by a single light, which is located directly behind the model and hidden from the camera's view by her. The even light across the whole subject gives the bright, smooth look to enhance the model's skin, and shows off the velvet of the costume to good effect.

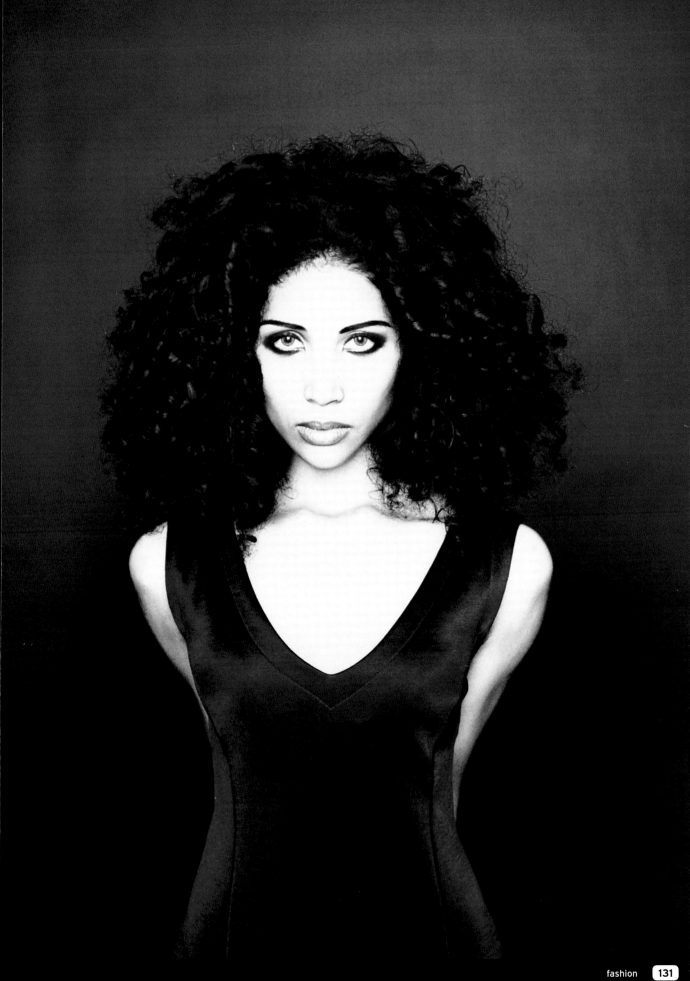

smile

photographer **Jeff Manzetti**

client	Grazia
use	Cover
model	Petra
hair	Lucia Iraci
make-up	Michelle Delarne
editor	Stefania Bellinazzo
camera	6x7cm
lens	135mm
film	Fuji EPL 160
exposure	f/4
lighting	Electronic flash

A large assortment of lights contribute to the dazzling look of this beautiful cover shot.

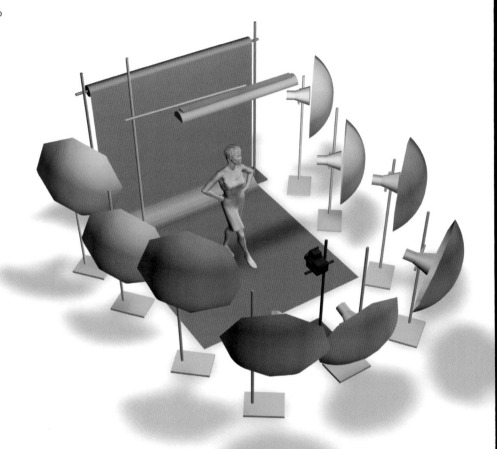

key points

- ▶ The purpose of a shot will dictate aspects of the look and technique
- ▶ Using just a restricted range of saturated colors against a predominantly light or pale background can create a very strong impact

The dazzling smile and gleaming complexion are shown to good advantage as they are bathed in an even spread of light emanating from a virtual wall of light in the form of a series of umbrellas arranged in an arc behind and around the photographer. These all shoot through a curtain of diffusion material, softening and evening the effect on the subject. In addition to this is a key light, a daylight-balanced HMI to camera right, which is the only direct light on the model. It is positioned just high enough to give a gentle amount of modeling below the chin.

On the background are four more umbrellas, one pair on either side. The resulting lightness and evenness of a large part of the final image makes a good background against which the necessary cover text can "read" clearly. A very mottled or light-and-dark image makes it difficult for text to show up well, and this is always a major consideration for a cover shot.

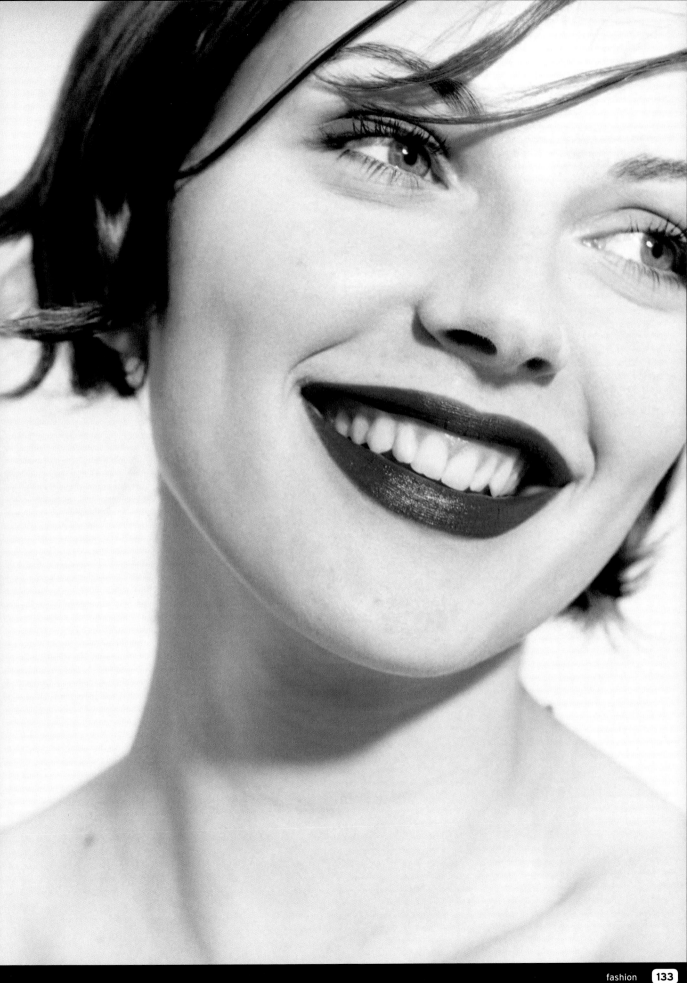

emma

photographer **Jörgen Ahlström**

use	Personal work
model	Emma
camera	6x7cm
lens	90mm
film	Kodak PXP 125
exposure	Not recorded
lighting	Available light

Though this may look like a classic studio portrait, it is in fact a location shot.

key points

▶ Depth of field is dependent on several factors: the proximity of the subject to the camera, the focal length of the lens, and the aperture setting

▶ Depth of focus, not to be confused with depth of field, is located at the film plane

The model is standing in a doorway with a white wall providing a plain background. The photographer is on a balcony a little higher than the model. The sun is to camera left, but the position in the location chosen gives a relatively non-directional look as the light is bounced from the building walls and doorways around.

There is a shallow depth of field and the camera is in close proximity to the model to give the soft look to the peripheral areas of the shot. Only the detail of the central face (the eyes and complexion) is in sharp focus, to emphasize the model's features and immaculate make-up. There are shapely highlights on the cheekbones, but the make-up ensures that these do not register as an unflattering shine. Instead, the make-up maintains a perfect gleaming matt complexion.

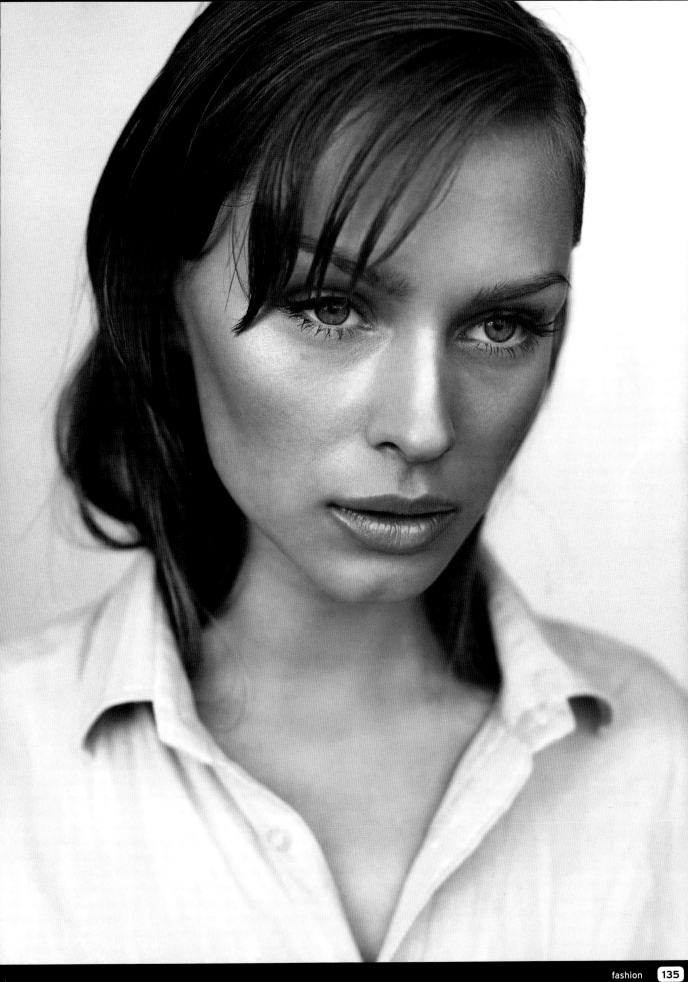

hila

photographer **André Maier**

client	Mode-Info, Berlin
use	Editorial
model	Hila Marin for Next Models
art director	Jörg Bertram
make-up	Hélène Gand
stylist	Jörg Bertram
hair	Yoshi Nakahara for Oscar Blandi Salon
designer	Mark Montano
camera	35mm
lens	135mm
film	Kodak E100SW
exposure	⅟₁₅ second at f/11
lighting	Available light, fill-in flash
props and background	Rooftop at sunset

This shot was executed on a rooftop, with the New York skyline visible behind serving as a backdrop. It is dusk and the color of the sky ranges from rich mauve orange to deep blue.

key points

► The introduction of a small amount of colored light can really add to the impact of an image

► Sometimes areas of both sharp and soft focus on the same main subject can enhance the shot

A hot-shoe flash is linked to the camera via an extending cable, allowing for greater flexibility in positioning what is basically an on-camera flash, off the camera. The flash is hand-held to the right of camera and gives even illumination on the face and good catchlights in the eyes. A straw filter on the flash adds warmth to the face.

This is a long exposure for a hand-held shot at 1/15 second. The flash is fired only at the end of the exposure (rear curtain flash) to ensure the frozen clarity of the final image, so that only the periphery of the subject melts away into a haze as a result of the small amount of movement during the first part of the exposure.

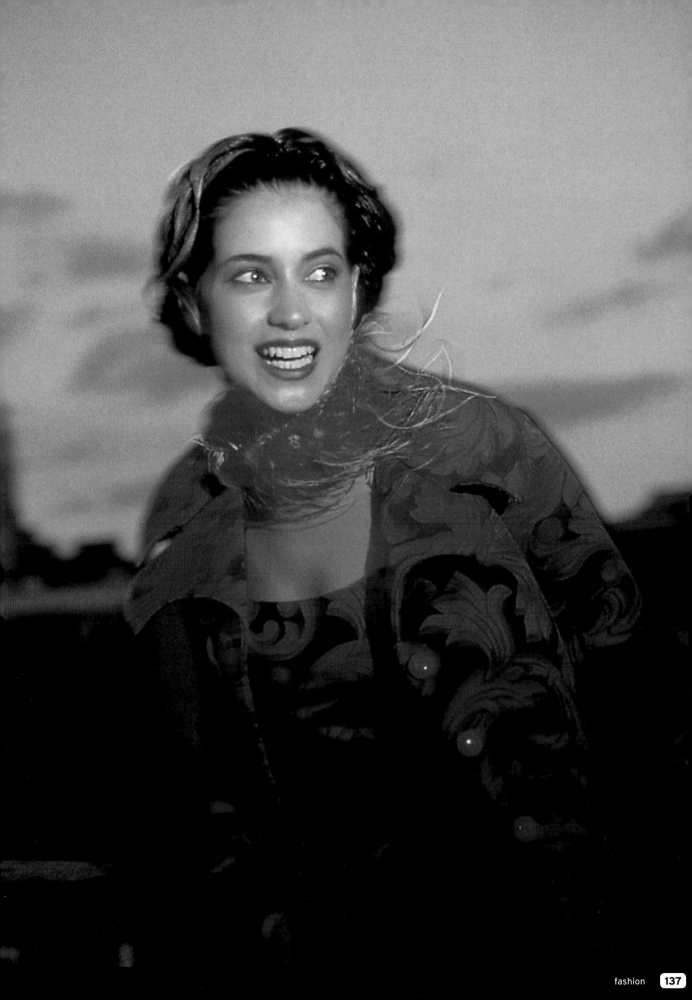

girl on box

photographer **Wolfgang Freithof**

client	Mardome Collection
use	Promotion
model	Jewel Turner
art director	Jimmell Mardome
make-up	Nikki Wang
camera	35mm
lens	105mm
film	Fuji RDP
exposure	$\frac{1}{60}$ second at f/5.6
lighting	Electronic flash
props and background	Yellow paper backdrop, box

It is a common accusation that a picture of a fashion model must have been distorted for her to look quite so tall, thin, and elegant.

key points

- ► Polyboard wedges can be multi-purpose, throwing light forward and backward and also flagging the camera from lens flare
- ► Light shot through a translucent silk umbrella has a different quality from light reflected off one that is non-translucent

"They do it with mirrors" or "they do it with lenses," say the sceptics. Well, "they do it with boxes," as the title gives away, would uncover the trick in this particular case. The model, tall, thin, and elegant as she is, is standing on a pedestal for extra height in order to show off the long designer dress in all its splendor; the effect on the proportions in the final shot is superb.

The hair design is tall, too, and is lit specifically by a dedicated spot from behind. The main light from the front is high up and behind the camera and shoots through a silk umbrella.

Two standard heads shooting into a wedge of white reflectors are positioned on both sides to give diffused fill to the sides and to light the background.

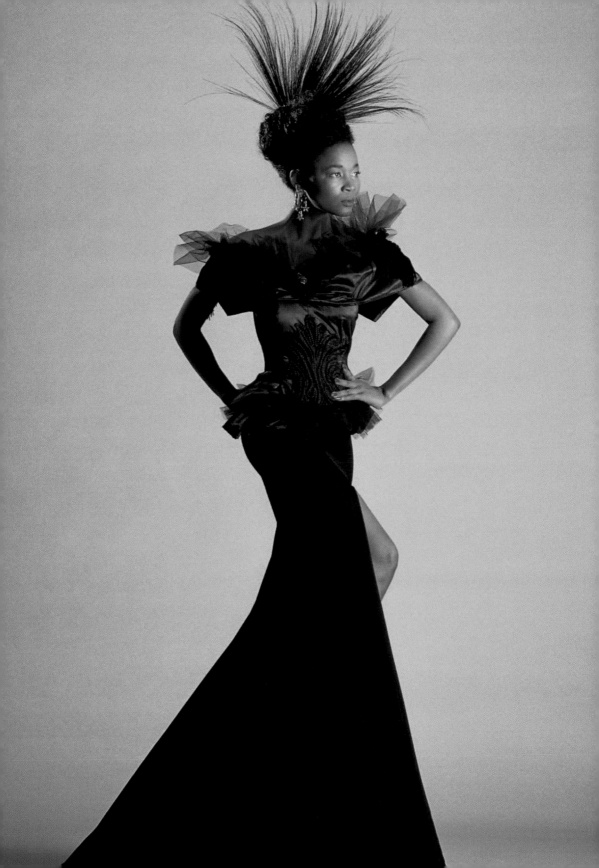

wedding head

photographer **Renata Ratajczyk**

Use	Personal work
Model	Joa
Camera	35mm
Lens	135mm
Film	Fuji Provia 100
Exposure	¹⁄₆₀ second at f/11
Lighting	Electronic flash
Props and background	White background

The model's large, dark velvety eyes, emphasized by make-up, her carefully dressed dark hair, and exquisitely painted lips, have a very dramatic impact when set among the froth of wedding white lace and net.

key points

► Never underestimate the importance of the make-up artists and stylists— no amount of soft lighting or petroleum jelly will give a romantic final image if the styling (make-up, hair, expression, pose) of the subject is not right in the first place

► A small reflector can be just as important as a very large soft box

The model's face and the bulk of the dress are lit separately. To the far right there is a medium soft box on the whole of the model. Also to the right there is a standard head with a snoot, honeycomb, and diffuser keying the right side of the face. To the left of the camera, a standard head with barn doors bounces off the large white reflector panel to the left of the model. This lights the dress on that side, and gives a lower level of light than on the face. Diagonally opposite the soft box there is a standard head with honeycomb and barn doors to light the veil from the rear. Finally, there is a small reflector to the left of the model to lighten the shadows on her face.

photographer's comment
Strobes were used. I wanted to create soft romantic light with some dramatic highlights.

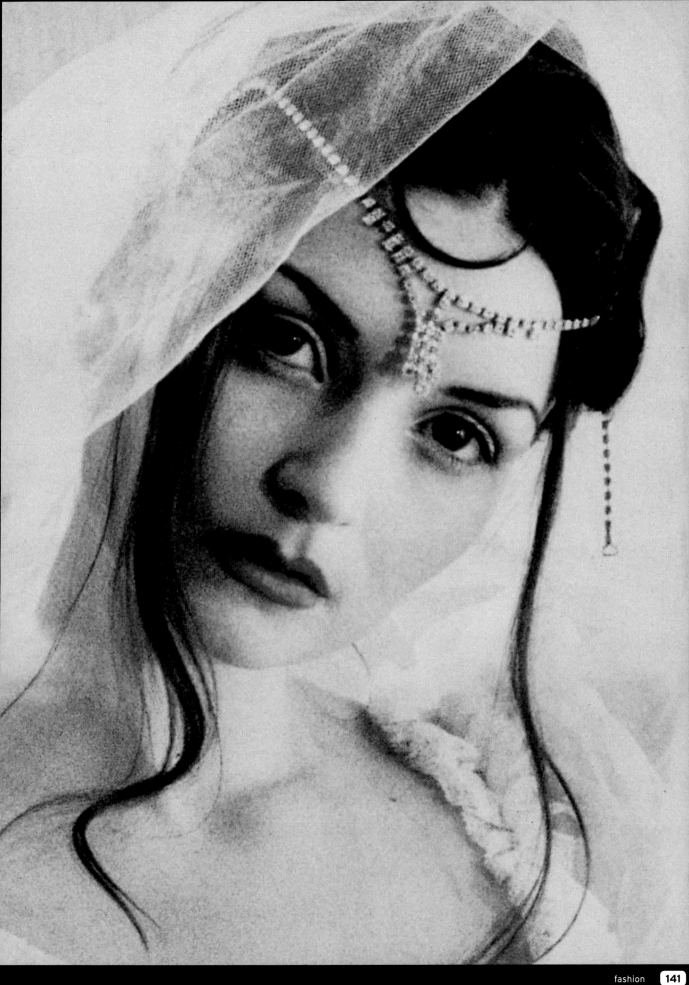

girl, cartagena

photographer **Michael Freeman**

use	Personal work
camera	Nikon F5
lens	105mm macro
film	Velvia ISO 50
exposure	⅟₁₂₅ second at f/9
lighting	Available light

A daylit portrait taking advantage of, and enhancing, a slightly unusual lighting effect. In fact, the effect, that of bounced strong sunlight, initiated the idea for the shoot.

key points

► A reflector was used to temper the uplighting effect

The setting was under a huge, old mango tree, which provided plenty of shade but at the same time allowed small amounts of bright sunlight to filter through gaps among the branches and leaves. These formed a chiaroscuro pattern of brightly lit patches on the ground. The model, wearing the hat for the shoot, was positioned so that the light from one of these patches bounced upward. This added to the bluer light from the sky, and in fact overwhelmed that higher color temperature. The uplighting effect was interesting but a little extreme (this is, after all, not a normal lighting style for fashion), and so a collapsible silvered fabric reflector was placed on the other side of the model, reflecting more sunlight from another patch.

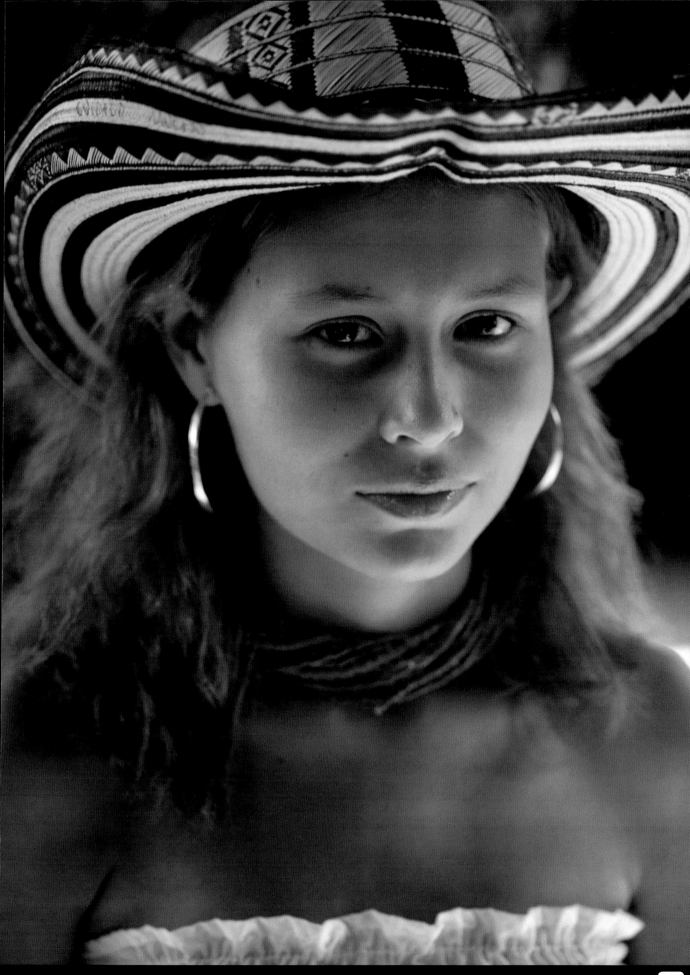

tilda swinton

photographer **Jason Keith**

use	Editorial
camera	Mamiya RB67
lens	250mm
film	Not recorded
exposure	$\frac{1}{400}$ second at f/11
lighting	Electronic flash
props	Black velvet cloth, burgundy couch

A sumptuous, almost decadent pose, from one of Britain's most challenging actors, is complemented by soft but uniform lighting that shows the subject's profile to its best advantage.

key points

► This shot has worked so well thanks to the use of a black suit with contrasting white shirt, the angle of the hand, the burgundy couch, and the velvet background—together these elements have combined to create the aloof, opulent atmosphere

The use of two shoot-through umbrellas positioned either side of the camera has created a large area of soft light that illuminates the profile gently but evenly. The light is soft enough so that the sleeve of the dark jacket is almost lost in the black velvet background, which helps to draw our attention to the face, neck, and shirt, as well as the elegant angle of the hand. The rich atmosphere of the entire scene is helped by the burgundy couch. A black flag was placed at the end of the couch to ensure that no distracting light spilled in from the left.

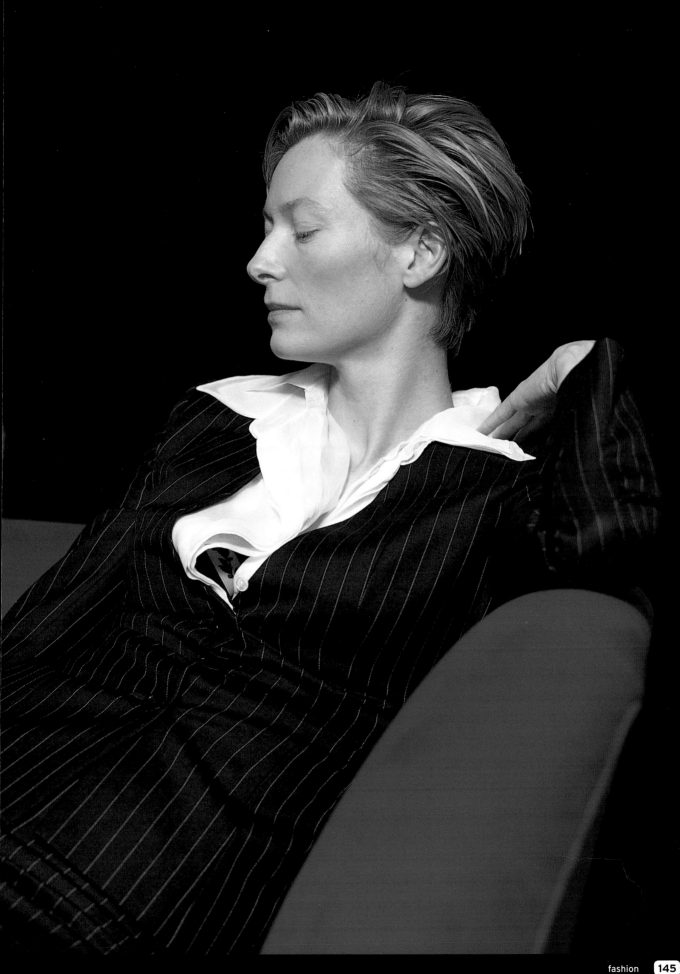

fearful glance

photographer **Kazuo Sakai**

client	Personal work
camera	35mm
lens	85mm
film	Kodak E100SW
exposure	¹⁄₁₂₅ second at f/5.6
lighting	Electronic flash

This striking and somewhat disturbing image was created in several stages by Kazuo Sakai. The image of the woman was shot in a studio with a basic lighting set-up.

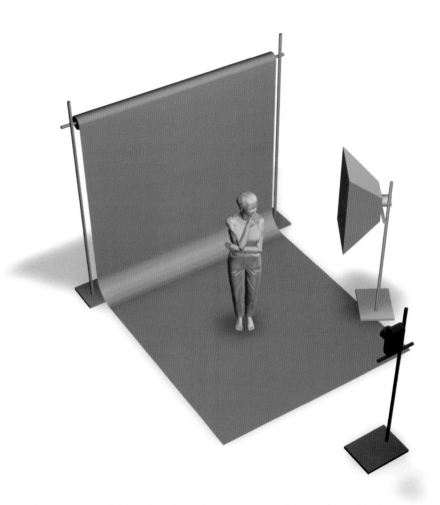

key points

- You should plan out an image carefully when electronic manipulation is to be introduced
- Continuity of contrast is important when different elements are being used to construct a shot

There is a large full-length soft box to the right of the camera and a white reflector slightly to the left of camera. The model is standing against a plain off-white textured canvas background. This canvas allows the photographer to place a more appropriate backdrop onto this canvas, using a computer paint package.

The model was directed by the photographer to look fearful, hence the body language and self-embracing pose. The lighting also reflects this, being somewhat stark and contrasty.

Adobe Photoshop was used to add a chaotic background to achieve the result that the photographer had in mind.

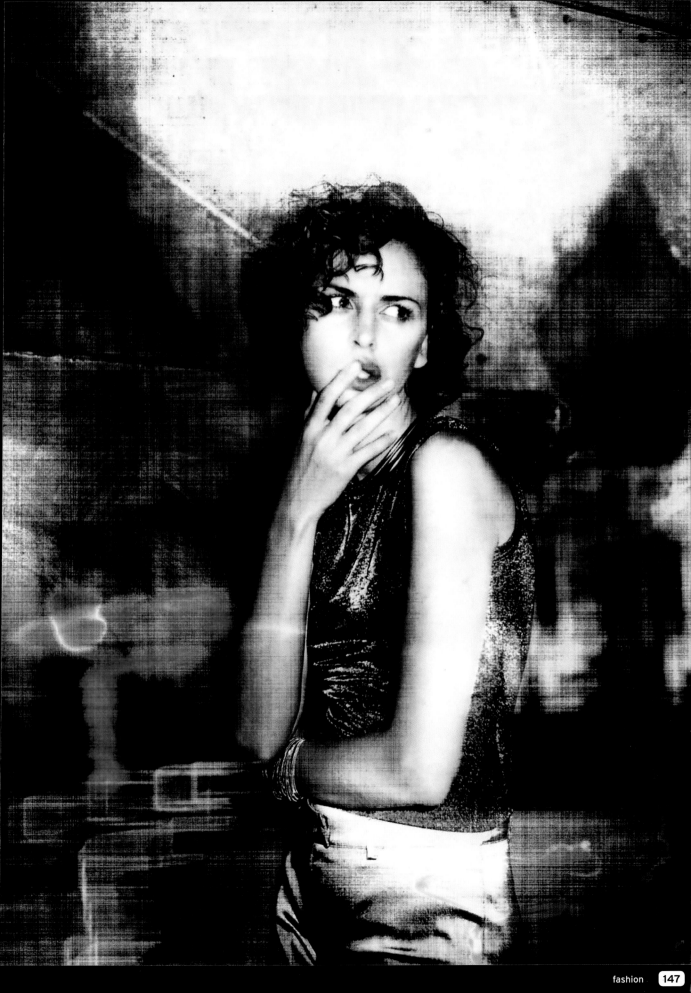

suit

photographer **Simon Clemenger**

use	Model portfolio
stylist	Steven Young
designer	Steven Young
camera	35mm
lens	28-80mm at 35mm
film	Ilford XP2
exposure	Not recorded
lighting	Available light

"Mad dogs and Englishmen"—or, in this case, a model and a photographer—"go out in the midday sun"...

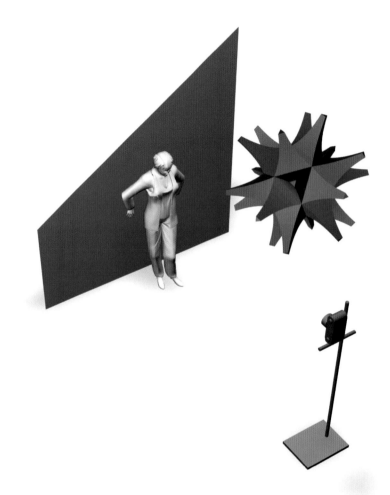

key points

► This graphic high-key effect is the result of bright midday sunlight and carefully considered printing

► A simple unobtrusive background is often preferable when showing off a full-length outfit

The extreme shortness of the shadows indicate the approximate time of the shoot as noon, while the position of the shadows show that the model is almost directly face-on into the bright sunshine. This gives good detail in both the white shirt and the dark fabric of the suit. The dark sunglasses not only complete the "look" and complement the fashion styling of the shot, but are also an absolute necessity for a model who is required to look straight ahead into strong sunlight.

Even in black-and-white, the viewer can almost feel the heat and power of the dazzling sun reflecting off the page. The model's pose—as if pinned to the wall by the sheer force of the sunlight—is an excellent choice to convey and emphasize this feeling.

photographer's comment

This is very interesting film. This shoot was the first time that I ever used it.

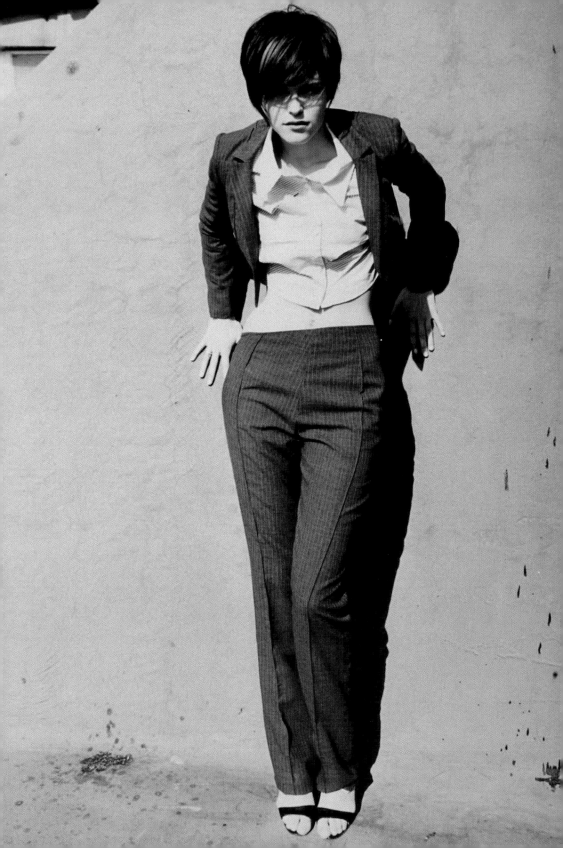

renée

photographer **Jörgen Ahlström**

client	Tatler
use	Editorial
model	Renée
camera	6x7cm
lens	35mm
film	Kodak GPH
exposure	Not recorded
lighting	Available light, daylight fluorescent tube
props and background	White blinds

Daylight is coming in through window blinds directly ahead of the model and is diffused by a fine background that nevertheless allows the pattern of the blinds to register.

key points

► When daylight falls into shadow, for instance under the shoe, the color temperature dramatically increases, which is why there is a blue tint in the shadowy areas on the sole

► Color negative stock is far more suited to high-contrast imagery like this. Transparency stock probably could not hold such a contrast ratio

A second window to the right, again modified by blinds, is to camera right and introduces side light on the shoes. A fluorescent daylight tube is horizontal to the ground not far off the floor, between the camera and the model. This lifts the shadow detail of the floor. Careful directing of the model ensures that the left silvery shoe stiletto picks up a bright highlight from this source, while the right stiletto is tilted to avoid it. A further reflection of the tube is visible in the black supporting part of the right shoe heel.

atelière

photographers **Ben Lagunas and Alex Kuri**

client	Claudio Designer
use	Editorial
assistants	Isak, Christian, Paulina, Janice
art director	Ben Lagunas
stylist	Leonardo
camera	6x6cm
lens	210mm
film	Kodak Tmax CN
exposure	$\frac{1}{250}$ second at f/11
lighting	Tungsten

The camera is straight-on to the model, with a standard head to camera right.

key points

► When lighting for theatrical effect, traditional rules, such as the back light being opposite the key light, need not always apply

► Prop lights can double up as sources

Three-quarters behind the model is a focusing spot directed at her. This gives a back light that shines through the length of gauzy dress fabric she is holding up and adds rim light to the edge of her arm.

The only other source is the crystal chandelier that is visible at the top of the image, basking in a bright pool of its own light. Everything about this shot shines. The fantastic costume, the stylish fashion workshop setting, the beautiful and immaculately made-up model, the theatrical pose, and the sparkling quality of light all combine to condense the glamorous appeal of the world of fashion into a single stunning image. The effect is reminiscent of the work of Cecil Beaton combined with the surrealist work of Angus McBean.

photographer's comment
Using toners with this kind of film produced warm "colors."

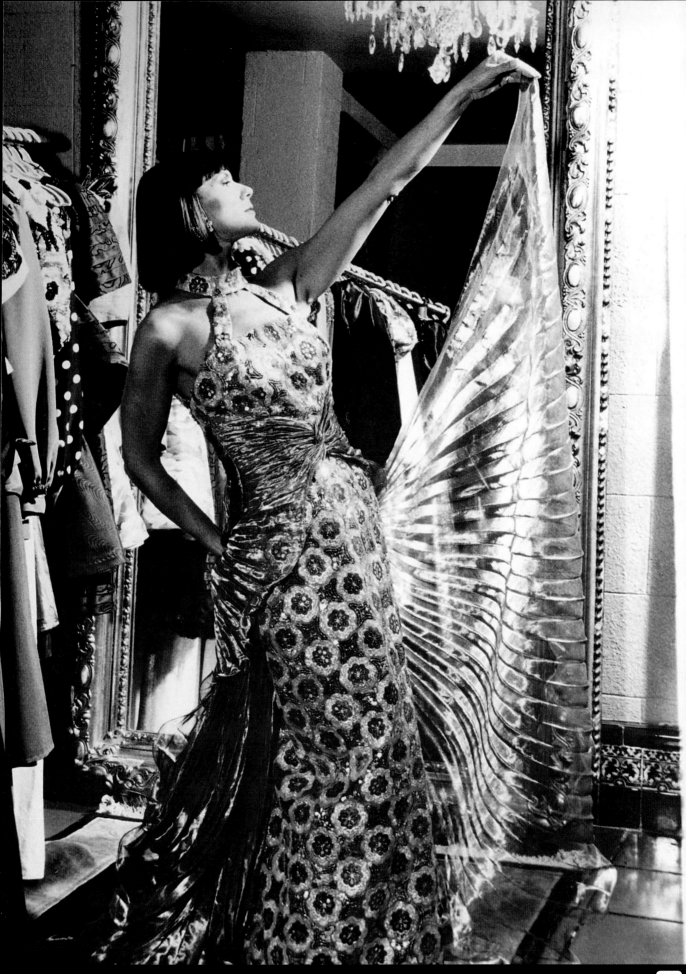

calligraphy face

photographer **Marc Joye**

Not everyone would think of using Japanese calligraphy as a
fashion make-up accessory, but Marc Joye uses this interesting
visual element with subtlety and style.

use	Portfolio
model	Genevieve
stylists	Geni and Mike
camera	6x6cm
lens	150mm
film	EPP 100
exposure	¹⁄₆₀ second at f/11
lighting	Electronic flash

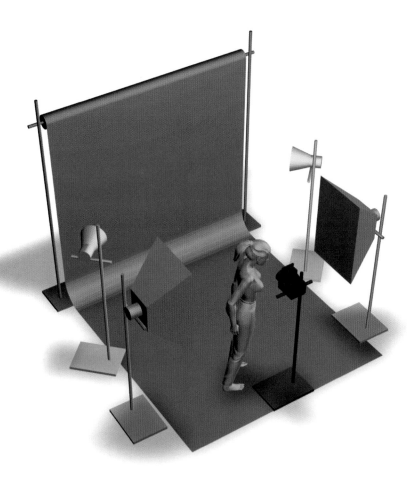

This shot shows Joye's fascination
with added calligraphy in close-up.
"By setting some more light on the
background we created a contre-jour
effect, bright light!" he says. "An
aperture of f/11 was chosen as we liked
a lot of unsharpness, with only the eye
and calligraphy sharp." Two flash heads
evenly illuminate the background. The
model is quite close to the camera
and is standing between two 3½ft (1m)
square soft boxes, one in front of her
face and the other aimed at her back.
The background is overexposed by one
and a half stops to render it light and
gleaming. Notice that the catchlight in
the eye is a reflection of an entire soft
box—an effective finishing detail.

Photographer's comment
Genevieve's body was very light through make-up except for some blue highlights
on her eyes, lips, and breast.

key points

► Imaginative use of make-up can make for an imaginative subject and inspire an imaginative composition

► Depth of field depends on several factors: the focal length of the lens, the distance of the subject from the camera, and the amount of light available, so in this shot f/11 provides a shallow depth of field

samira

photographer **Jason Keith**

use	Editorial
camera	Mamiya RB67
lens	127mm
film	Not recorded
exposure	$\frac{1}{400}$ second at f/11
lighting	Electronic flash

The direct gaze seems in contradiction to the partial hiding of the face by the hand holding the cigarette—an excellent example of an inscrutable portrait.

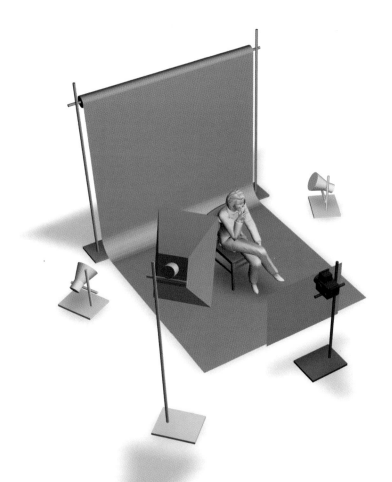

key points

► The black flag placed low in front of the camera has had a remarkably strong impact on this image

A soft box, placed high and just to the left of camera, is all that has been used to light the subject. Although a straightfoward set-up, it is sufficient in providing enough light to pick out the smoke from the cigarette. A black flag has been placed low and in front of the camera to give shade to the lower part of the image, complementing the atmosphere of mystery. Two standard heads have been used to light the blue roll background, with emphasis given to the one on the right, which helps to create some depth.

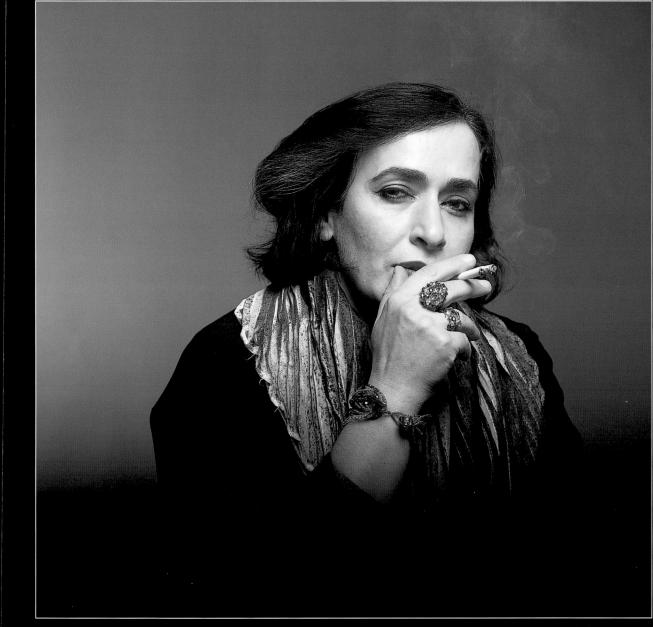

crouching man

photographer **Frank Wartenberg**

use	Publicity
camera	6x7cm
lens	105mm
film	Fuji Velvia
exposure	Not recorded
lighting	Electronic flash

The key to this shot is a very shallow depth of field to make the model's head appear separate from the body.

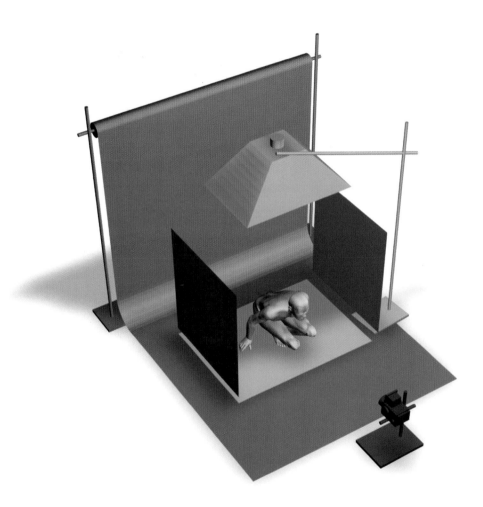

key points

► Controlling a model's pose is not purely a compositional consideration— it involves lighting control as well

► Depth of field is dependent on the distance of the subject from the lens, the aperture, and consequently the amount of light

The more one looks at it, the more surreal, and even disturbing, this shot seems to become. The lighting adds to the disembodied effect by emphasizing graphic areas of light and shade. The pose is highly contrived; the lines on the forehead are there to create distinctive forms and the braced muscles also highlight the landscape-like undulations of the limbs.

The purpose of all this careful posing and composition is of course to establish the perfect crest of bristle-like hair at the point of focus, both in terms of the lens and in terms of the viewer's interest.

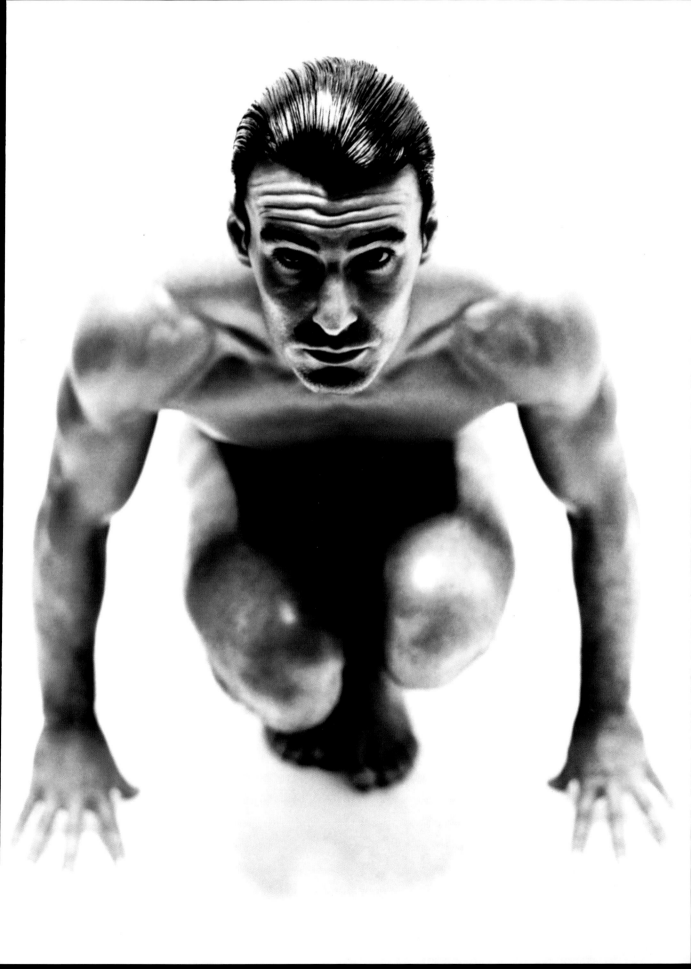

chinese hair

photographer **Frank Wartenberg**

use	Self-promotion
camera	6x7cm
lens	127mm
film	Fuji Velvia
exposure	Not recorded
lighting	Tungsten

There is no shortage of lighting equipment here. Frank Wartenberg has assembled an impressive array of soft boxes and silver styro reflectors, above, below, and around the camera.

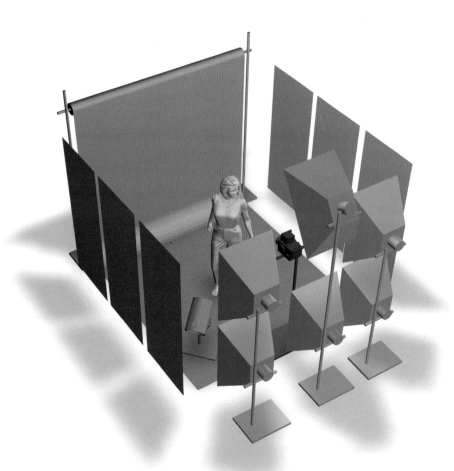

key points

- ► Modeling lights are normally tungsten, so bear this in mind when balancing sources
- ► Silver reflectors will produce more focused light than white reflectors

The main light is a large soft box (used with the modeling light only) positioned behind the camera. Six smaller soft boxes are arranged on either side and below this, again using only the tungsten modeling light. These combine to give an even sheet of light across the subject.

On both sides is a selection of silver reflectors, effectively forming a wall to either side.

The resulting bright and even background provides a foil against which the strands of the model's hair, tousled by a wind machine, stand out in stark silhouette.

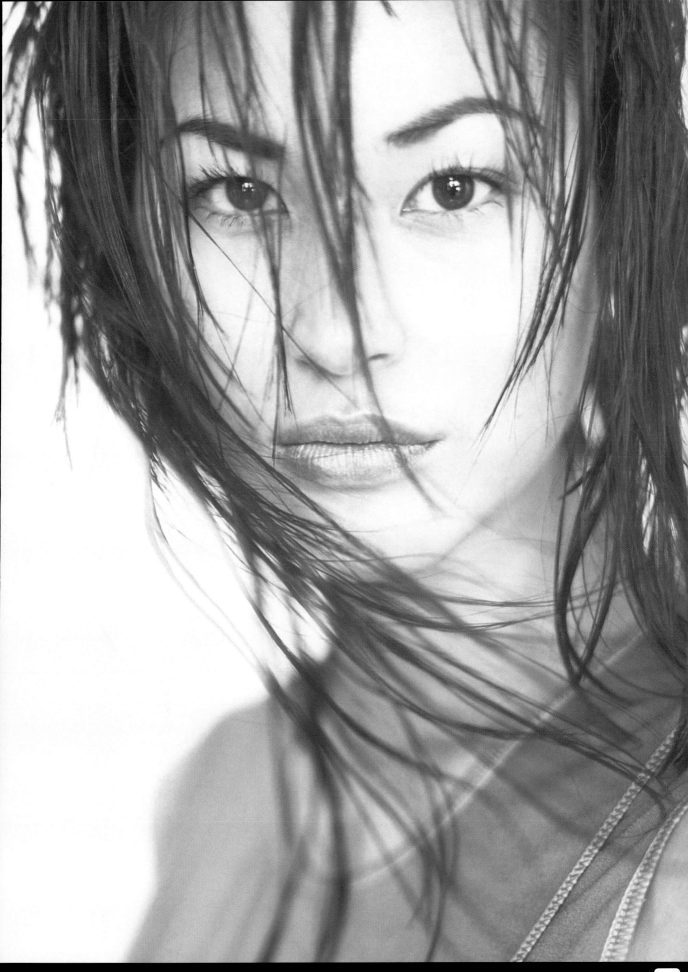

face

photographer **Isak Hoffmeyer**

client	Eurowoman
use	Editorial
model	Kati Tartet
assistant	Helene Elfsberg
make-up	Louise Simony
stylist	Bjorne Lindgreen
camera	Pentax 67
lens	90mm
film	Fuji Provia 400 ISO
exposure	½ second at f/2.8
lighting	Tungsten

The striking symmetry of this shot is part of what makes it so compelling. Equally arresting is the model's gaze, enhanced by bold make-up lines.

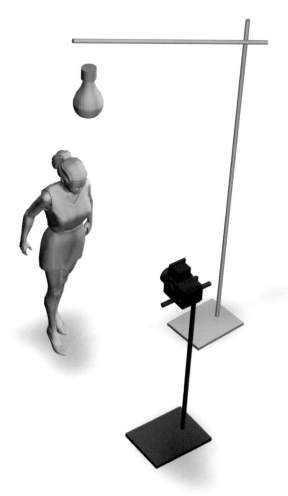

key points

► Symmetry of composition used in conjunction with symmetry of lighting can double the impact of a shot

► Domestic tungsten lighting has a color temperature of around 2800 K, which gives a warm glow

Framing and punctuating the face are the all-important shadows below the chin, nose, and brows, adding a strongly graphic and even geometric element to the composition. These shadows are achieved by the use of a single light source (in fact, a single domestic tungsten light bulb) positioned high above the model's head.

The model seems disarmingly close to the viewer and the resulting shallow depth of field flattens out all but the most important of her features. The evenness on the forehead and nose arise partly from this flattening-out effect, but also from the expert application of make-up, which can also be emulated in Photoshop.

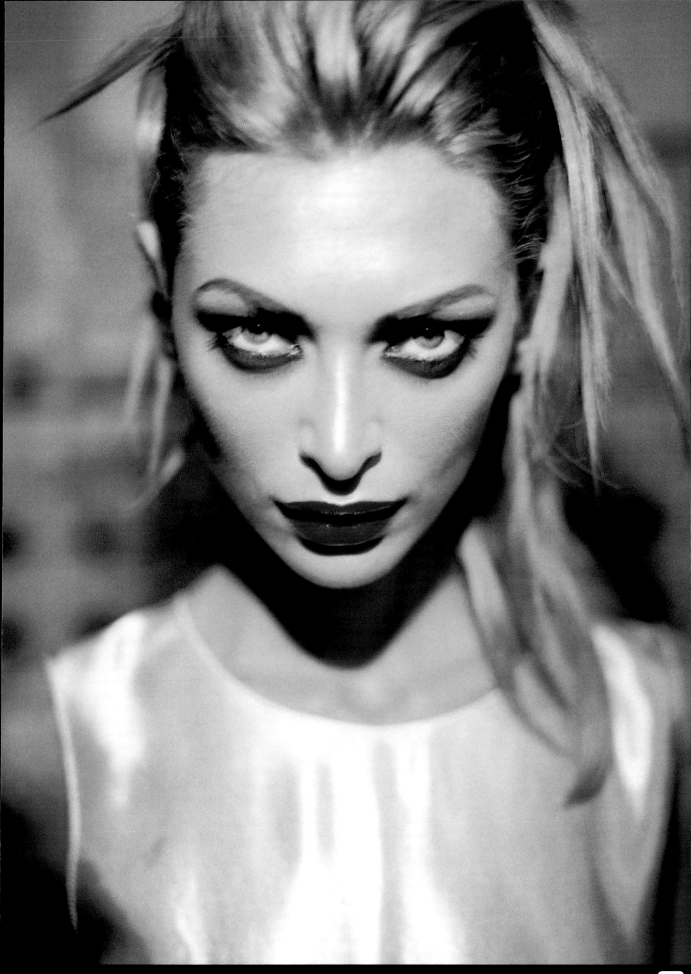

biba cover

photographer **Jeff Manzetti**

client	Biba magazine
use	Cover
model	Estella Warren
hair	Karim Mytha
make-up	Brigitte Hymans
stylist	Nathalie Marshall
camera	Pentax 67
lens	135mm
film	ept 120/160
exposure	f/4
lighting	Flash

In this shot, the photographer has used a highly controlled pool of soft light. The key modeling is provided by one direct source.

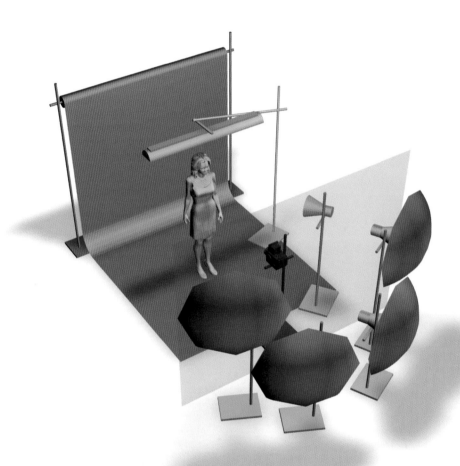

key points

► Black panels will dramatically increase the fall-off within a composition

► Catchlights are an important consideration and should not be left to chance

Two pairs of heads shooting into umbrellas are evenly placed either side behind the camera and come through a wall of diffusion material to provide overall illumination and light the background. A strip light is positioned directly above the model to pick out every single lock and wisp of hair. The placing of the key light is evident from the dual catchlight in the eyes. The leftmost catchlight is from the umbrellas, whereas the right-hand side one is the key light. A standard head with a fresnel lens, to the right of the camera, is set to give just enough modeling under the chin, but the pool of soft light keeps the depth of the shadows to a minimum.

linda

photographer **Jörgen Ahlström**

client	Elle
use	Editorial
model	Linda
camera	6x7cm
lens	90mm
film	Kodak GPY 400
exposure	Not recorded
lighting	Daylight tubes

The straight line catchlights in the eyes reveal something of the lighting set-up that the photographer used for this classic cover-shot image.

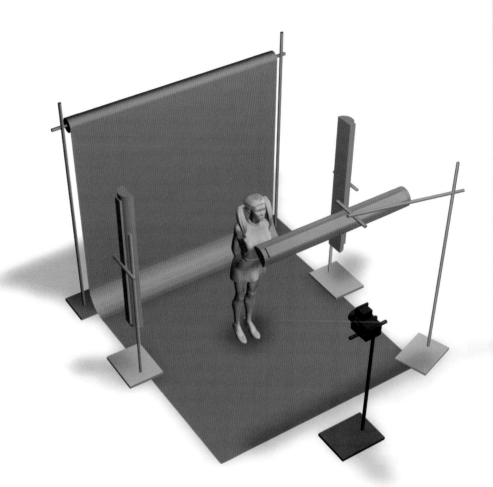

key points

- Using a fluorescent tube rather than a strip light gives a more concentrated light
- Standard fluorescent tubes can be corrected to daylight by using a specific purple gel, or corrected by using a digital camera's white balance

Jörgen Ahlström used Kino Flo daylight tubes–fluorescent tubes balanced to a color temperature of 5600 K, equivalent to that of a standard flash head and daylight. The one that is reflected in the eyes is above the camera and horizontal to the ground. In this position it provides the catchlights in the eyes, emphasizes the eyeshadow

and lips, and adds general lighting across the front of the model. Two more daylight tubes are positioned upright, one either side of the model, in close proximity to her. These give the bright glare on the sides of the arms and highlights on the cheeks. The slight halo effect occurs because these tubes are just behind the model.

bouche suave

photographer **Jeff Manzetti**

client	DS Magazine
use	Editorial
model	Karine Saby
hair	Bruno Wepp
make-up	Thibault Fabre
stylist	Nathalie Baumgartner
camera	6x7cm
lens	135mm
film	Fuji EPL 160
exposure	$\frac{1}{30}$ second at f/4
lighting	Electronic flash

Even though it is quite clear that this is a photograph of lips, there is a way of looking at this image as though it were an abstract study.

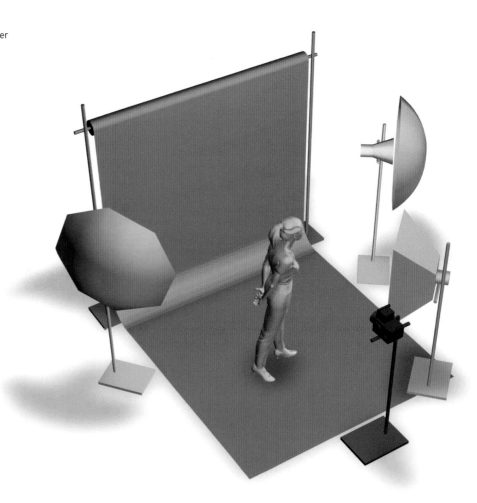

key points

► When composing tight close-up images remember that space is required to place lights appropriately

► Sometimes deliberately degrading an image (i.e. not shooting it ultra-sharp) can give a more interesting look

The effect of being so close in to the subject, with such a smooth, even expanse of pale color in the areas of the face and the background, gives a sense of disembodiment and lack of context for the lips. It is simultaneously a very rounded rendering of the three-dimensional full pouting lips and also a flat, abstract, two-dimensional image of an area of shiny red against a pale background. It all depends on how you

look at it. From a practical lighting point of view, it is desirable to have a long macro or long close-focusing lens to allow for optimum positioning of lighting.

This shot is lit by an Elinchrom octabox (an octagonal soft box) placed to the right of camera. The background is lit by two symmetrically positioned standard heads shooting into umbrellas.

black slip/lace dress

photographer **Wolfgang Freithof**

client	Fernando Sanchez
use	Editorial
models	Claudia Schiffer (Black slip) and Naomi Campbell (Lace dress)
art director	Quintin Yearby
make-up	Sam Fine
hair	Ron Capozzoli
camera	6x6cm
lens	150mm
film	Kodak Tri-X
exposure	1⁄60 second at f/8
lighting	Electronic flash

On this shoot, Wolfgang Freithof was working with the two great supermodels, Naomi Campbell and Claudia Schiffer.

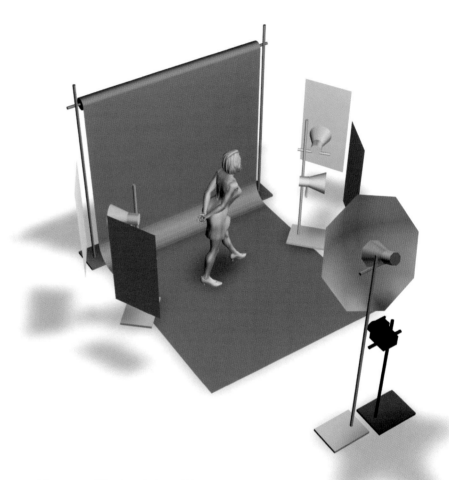

key points

▶ Image-editing sofware is being increasingly used by photographers to complete post-production work

The poses of the two shots and the fact that they were created in the same shoot using the same lighting set-up and modeling fashions from the same collection seem to mark the images a natural pair. Yet for all their similarities, the two pictures give some insight into the personal qualities that professional models can bring to their work. The lighting used is straightforward. Two pairs of standard heads bounce out of a polyboard wedge on each side, and the key light is a standard head shooting through an umbrella above the camera.

photographer's comment

Retouched and colored using Adobe Photoshop.

belly

photographer **Frank Wartenberg**

use	Publicity
camera	6x7 cm
lens	90mm
film	Fuji Velvia
exposure	Not recorded
lighting	Electronic flash

Ever one to use an innovative and imaginative lighting set-up, this shot shows Frank Wartenberg's individual approach to good effect, and demonstrates the superb results that he gets.

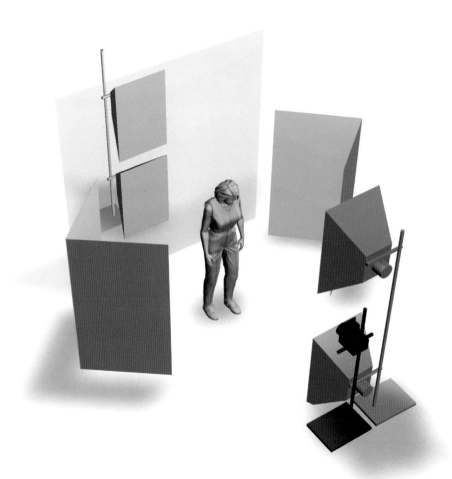

key points

- ► Back light traditionally is a hard source, but of course rules are there to be broken
- ► Experiment with different lighting set-ups—you may find that something unexpected is very effective

There are two soft boxes behind the model, one above the other, directed toward the camera to back light the model. A large pair of diffuser panels painted orange provide a background behind her and the soft boxes are behind these. Face on to the model are two more soft boxes, one above the camera and one below. These give an even spread of light along the length of the model. Two styro wedges act as reflectors to the sides.

miami fashion

photographer **Michael Grecco**

client	Raygun Publishing
use	Editorial
models	Luna and Michael Grecco
assistant	Jason Hill
camera	6x7cm
lens	50mm
film	Kodak EPZ 100
exposure	⅟₆₀ second at f/8
lighting	Electronic flash
props and background	Shot on location at Diesel Jeans Penthouse at the Pelican Hotel, Miami Beach, Florida

Michael Grecco made good use of this mirror-tiled wall to create a piecemeal-effect image that is reminiscent of some of the collage work of David Hockney.

key points

► Location features can provide a stimulus for a composition

► If it is impossible to work around a feature that is a problem, try incorporating it into the shot instead

When working in close proximity to mirrors, the photographer can either try very hard not to be seen and to hide lighting equipment, or can choose to make a feature of allowing all these things to be clearly visible in the final shot and play a part in the composition. The lighting is provided by a standard head, which is bouncing off a white wall at the opposite end of the room to the mirror. To diffuse the light, reduce the contrast and to produce a "sheet" of light, a literal sheet of white silk is draped in between the model(s) and the light.

The mirror gives some frontal light and also enables the viewer to see the strong back light.

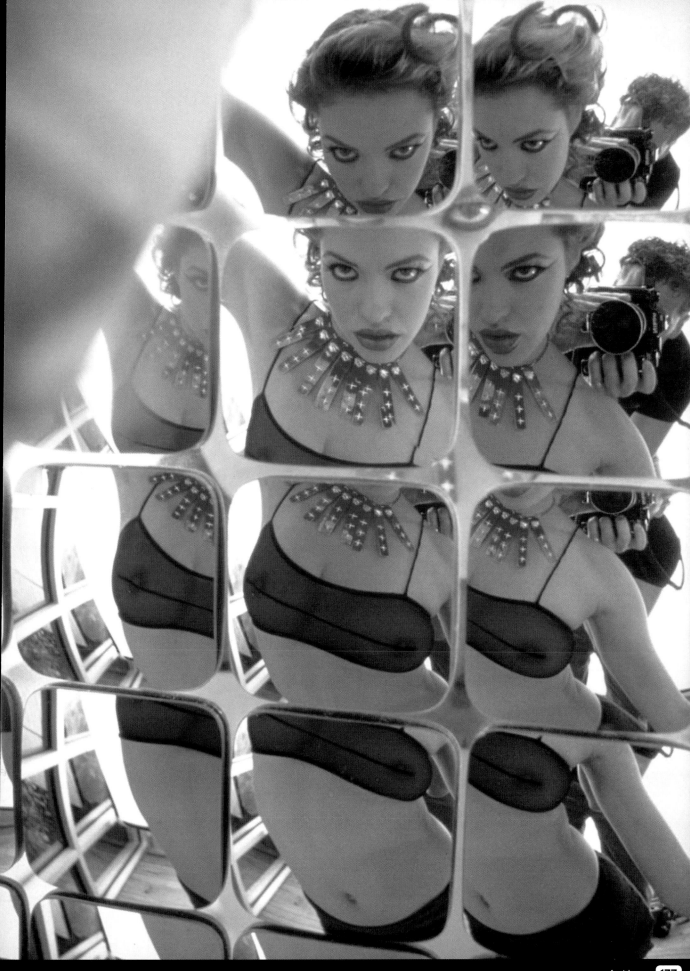

architecture

photographer **Corrado Dalcò**

use	Personal work
model	Reka
assistant	Francesca Passeri
art director	Corrado Dalcò
hair	Caterina
camera	35mm
lens	24mm
film	Fuji Realla 100
exposure	⅛ second at f/2.8
lighting	Tungsten

The unusual background for a shot is, in fact, the decor of the house of a friend of photographer Corrado Dalcò.

key points

- ► It is worth keeping a log of unusual location settings that you come across for future reference
- ► Lighting effects can be achieved by background paintwork and set-dressing rather than by actual lights

The background gives the effect of rays of light as if streaming down from the sun in a child's painting, whereas in actual fact the effect stems from the architectural element of the title. Of the three tungsten standard heads used to light this pair of shots, only one is used as a direct source. That is positioned well back to the left of the camera and acts as a source of illumination on the background. The other two tungsten heads are one directly behind and one to the right of the photographer and bounce off the walls of the building.

The cross-processing lends the unusual color rendition associated with the technique.

futuristic

photographer **Frank Wartenberg**

use	Publicity
camera	6x7cm
lens	90mm
film	Fuji Velvia
exposure	Not recorded
lighting	Electronic flash

To handle a set-up of this complexity successfully, you need to consider each element individually, and then take account of the cumulative effect and the inter-relations of all the sources.

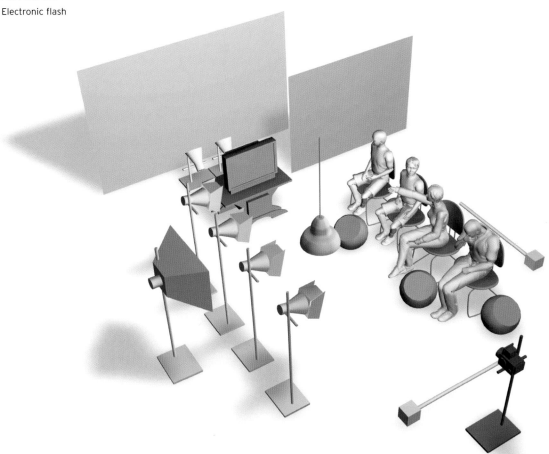

key points

- ► The mix of unmatched light source types can be actively embraced for a particular look
- ► It is a good idea to keep a range of higher output domestic lamps to help balance exposure

The lights within the shot come first and the other elements have to be arranged to accommodate them. Within frame here are an overhead domestic tungsten lamp, an illuminated TV screen, and various neon strips, some of which are blocked from direct view of the camera. These set the parameters, and then Frank Wartenberg has added an array of spots, one per model, and a large soft box for broader model illumination. The variety of source types and positions create the eerie futuristic look.

girl and mask

photographer **Wolfgang Freithof**

client	Sophia Lee for Ann Taylor Loft
models	Marcella and Zoli
make-up	Sidney Jamilla
mask by	Doug Chess
camera	6x6cm
lens	50mm
film	Kodak EPL
exposure	⅟₁₅ second at f/8
lighting	Electronic flash
props and background	White cove

Two standard heads pointing into two flats on either side of the models illuminate the background and the side of the models.

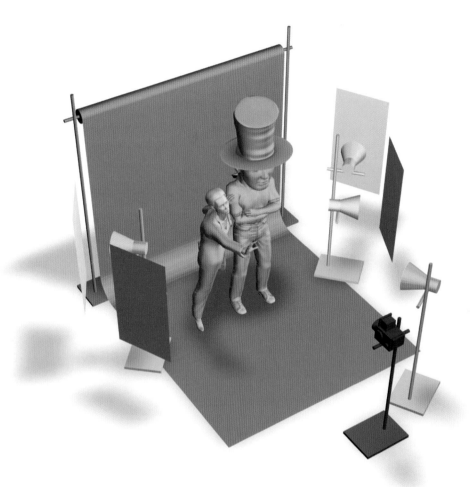

key points

- Working in heavy or cumbersome masks and costumes can be very hot work–bear this in mind and give the models frequent breaks
- Cut-outs can be managed manually, but as long as the background is plain modern digital methods will provide a better result

A standard head is high on a boom in the center near the camera. The background light is one stop brighter than the front light, the effect of which is strong side lighting and background light. The evenness of the light on the background is a deliberate choice in order to minimize the setting behind the models and give them an out-of-context, almost flying, look. From a practical point of view, if it is desired to cut out the image of the models and place them onto an alternative background later, this is easier if the original background is plain and does not interfere with the process.

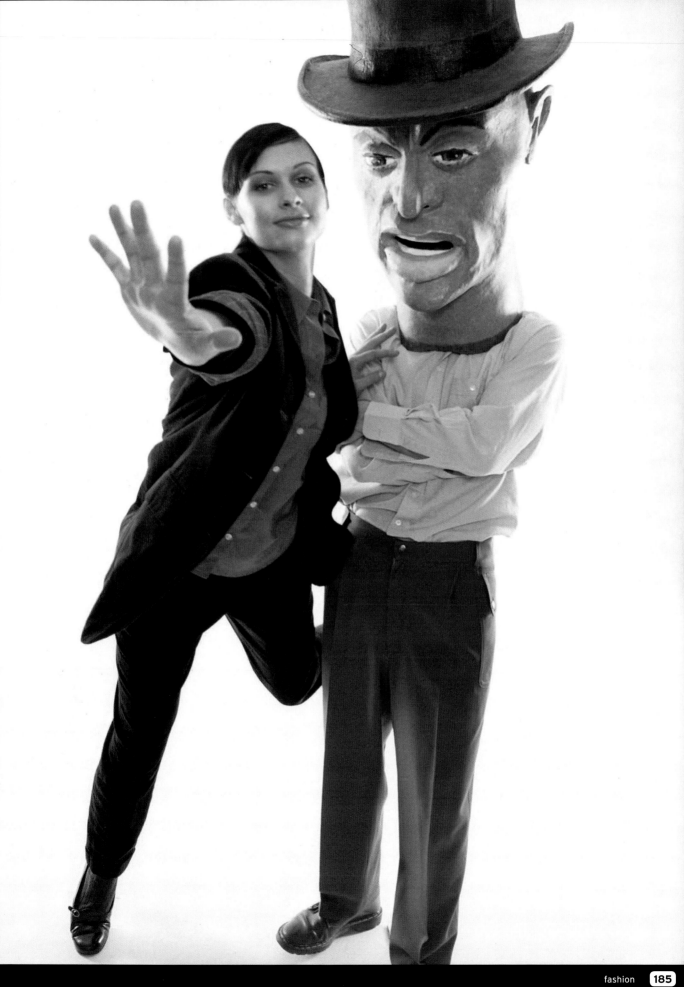

elena and fish

photographer **Wolfgang Freithof**

use	Editorial
model	Elena/Jan Alpert Models
art director	Sophia Lee
make-up	Nikki Wang
camera	35mm
lens	50mm
film	Fuji RDP
exposure	⅟₁₅ second at f/2.8
lighting	Available light, electronic flash
location	Jake's Fish Store

The choice of situation within the fish store location is important in order to capture the fish logo in the window in the background as a counterpoint to the actual fish in the model's hands.

key points

► When working with unknown light sources such as neon or argon lights, it is wise to make test exposures to determine how the color records

► Ring flashes can be used to produce direct, virtually shadowless lighting. Both portable and mains-operated models are available

The blue bar and lines of the counter contribute an important graphic element, coupled with the diamond floor tiles that reflect in the rest of the counter.

The neon lights in the background provide some separation. The fluorescent lights that light the fish store generally have the usual green hue. Wolfgang Freithof has chosen not to compensate for this tinge, but rather to embrace the look, which contributes to the somewhat surreal

feel of the image. The ring flash on the camera lens lights the model and the fish, and this flash overrides the fluorescent lighting. The redness of the dress, lips, and fish body and eyes are thus untainted by the green tinge but sing above the background tones in a startling and eye-catching way. They alone in the shot have the daylight quality of lighting and color, and this looks quite unearthly set against the fluorescent ambient light of the rest of the image.

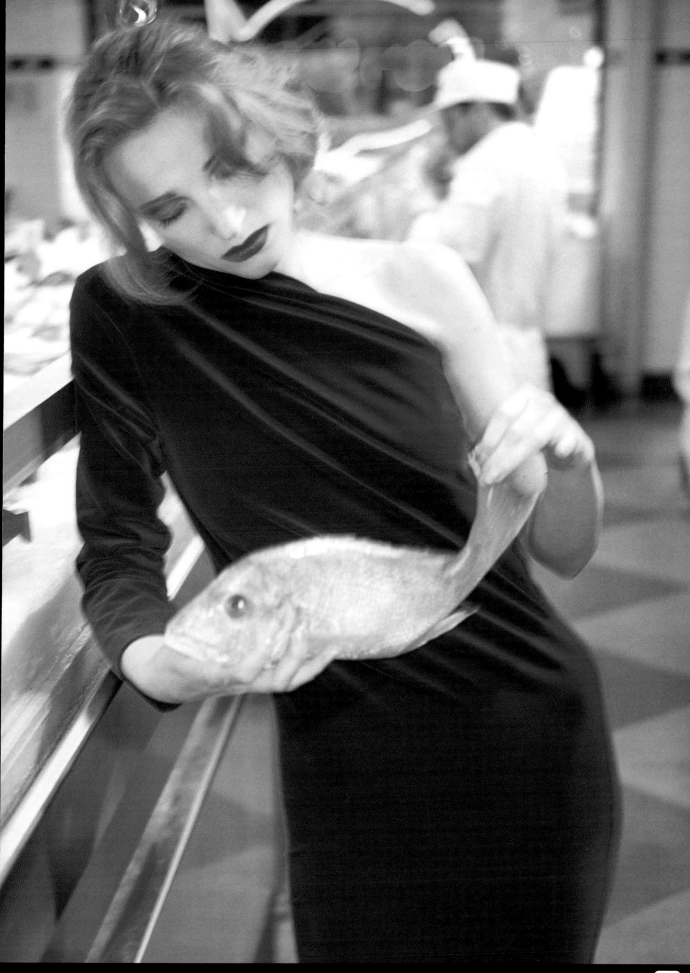

gold boots

photographer **Frank Wartenberg**

use	Publicity
camera	6x7cm
lens	105mm
film	Fuji Velvia
exposure	Not recorded
lighting	Electronic flash
props and background	Golden background

This shot draws on many different inspirations. The hair is Medusa, the hands and arms are Hindu deity, and the gold boots and shorts are a Midas touch of pure kitsch.

key points

- ► When using a separate light meter, remember to take into account light lost by using a filter
- ► Some reflectors focus light, some disperse light, and others reduce light

The material and contours of the gold boots are great for introducing a playful element into the lighting, which is sourced simply by a large circular soft box positioned directly behind the camera. To provide a degree of modeling, a series of silver reflectors placed on the right of the camera focus the spill light in to key the shot. As if the gold background, gold floor, and gold costume and make-up weren't enough to make an impact, Frank Wartenberg really presses the point home by using an 81B warm-up filter.

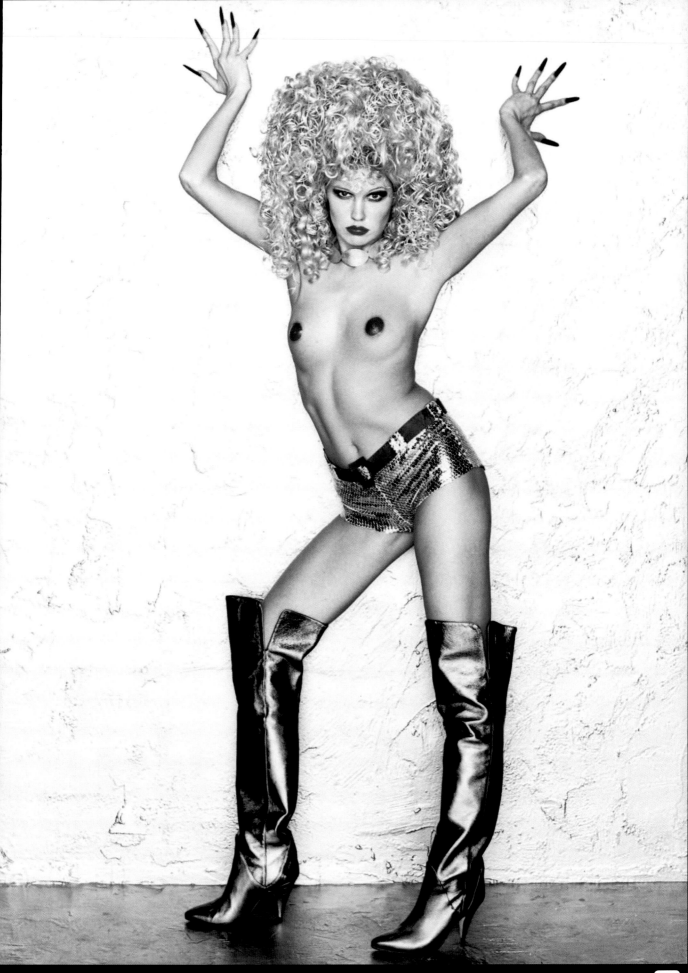

jonathan rhys-meyers

photographer **Jason Keith**

use	Editorial
camera	Mamiya RB67
lens	127mm
film	Not recorded
exposure	$\frac{1}{400}$ second at f/11
lighting	Electronic flash
props	Black velvet ground

Certain lighting set-ups can often create unusual-looking tones, particularly in regards to skin. Here, in this image of the Irish actor, a retro film look has been created.

key points

► White reflective umbrellas placed a long distance from the subject create a large spread of soft, low-impact light

Using white reflective umbrellas rather than silver has created a softer, flatter light; this, combined with the distance of the subject from the umbrellas and the fact that one umbrella has been placed either side of the camera, has ensured that there are very few shadows. The black velvet background has also ensured that as much light as possible has been absorbed.

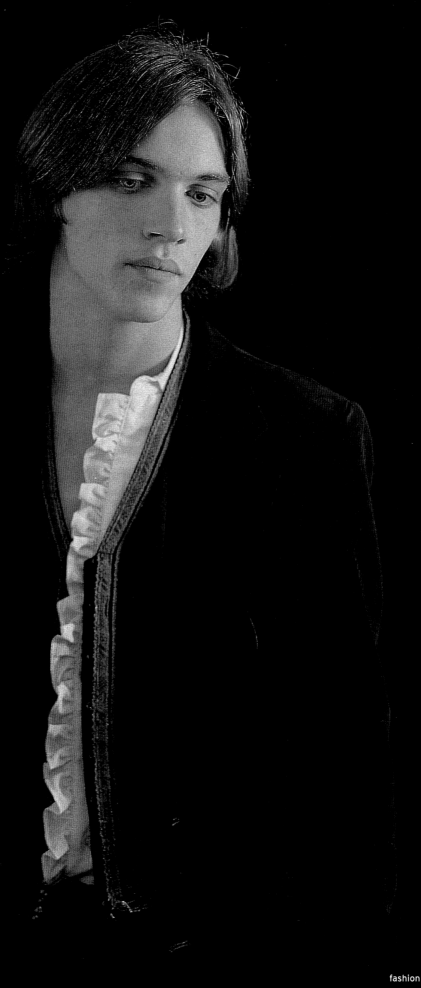

frederika

photographer **Jason Keith**

use	Portfolio
model	Frederika
camera	Nikon D70
lens	50mm
digital ISO	200
exposure	$\frac{1}{400}$ second at f/10
lighting	Electronic flash
props	Wallpaper

An alternative police mug shot? The head-on angle of the shot, the stark, even lighting (even the specular highlight in the sunglasses), and the incongruous wallpaper all help to highlight the beauty of the subject by contrast.

key points

► Soft lighting and sumptuous sets aren't necessarily needed to create a near erotically charged atmosphere

The combination of a large silver reflective umbrella, placed high and behind camera, with silver reflectors either side of the model and a white reflector running along the floor from camera to the foot of the model, have produced a very strong neutral light. For most of us, this would be unflattering, illuminating all our blemishes and faults, yet here it has simply helped to emphasize the model's unblemished skin and natural beauty—from which even the wallpaper cannot detract.

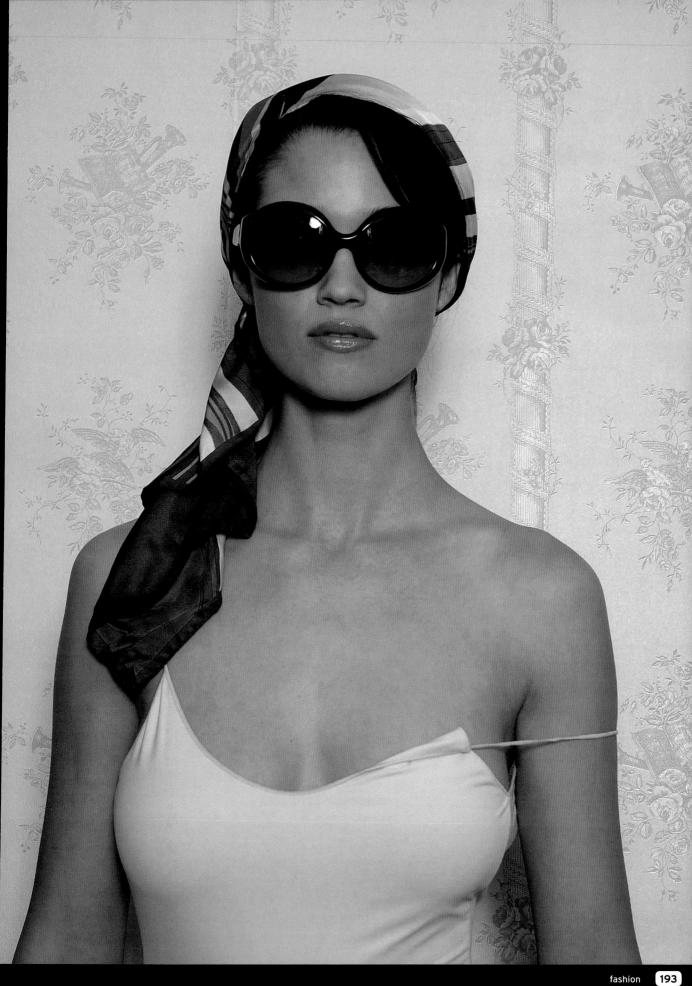

glamor

A wide range of photographs is included in this section, demonstrating the use of such elements as setting and costume and looking at the creation of different moods, from the romantic to the raunchy. Glamor images produced for commercial, editorial, personal, and fine art work are featured. Whatever the shot, the key element is the lighting.

Glamor is an age-old theme, and creative artists are forever looking for new approaches to familiar territory. What was once considered too strong for widespread consumption has now become more commonplace. Audiences also have become more sophisticated and are no longer satisfied with all-too-accessible, unsubtle imagery. A trend has developed for a more visually literate approach, where there is room for artistic presentation that has strong powers of suggestion.

Glamor imagery is used in a far more widespread way than ever before. No longer the province exclusively of adult magazines, bold glamor work now features in magazines, bill-hoardings, greetings cards, and posters. The photographs here demonstrate how creative, world-class photographers are rising to the challenge of providing appropriate imagery for this market.

One indication of the close relationship between photography and other visual arts is the extent to which many of the photographers featured treat the glamor subject matter as fine art material, an opportunity to explore the range of composition and subject, sometimes in a surprisingly detached and impersonal way.

A noticeable feature of many of the images in this section is the lack of passivity of the models. Women now tend to be portrayed in a less demeaning way—in the world of commercial and art photography at least. The market demands a more sophisticated approach.

The glamor imagination

Glamor is a subject area that is very prone to changes of fashion. What is glamorous, sophisticated, or outrageous at one time can seem amusingly dated, tame, and gauche when viewed with some years' perspective. The photographer should be aware of current tastes and produce images that either chime with the popular imagination of the moment or pushes public taste a step further.

Keeping up with the times necessitates keen observation. The photographer must always be collecting ideas, noticing details and interesting effects, to build up a stock of inspiration to draw on for a shoot.

The flip side of this is to use the imagination to envisage what "might be" rather than what has been witnessed at first hand. Glamor photography is an imaginative, fantasy area, and it is important to experiment.

Cameras

Medium format has been used by many of the photographers featured here, as it gives good definition while allowing quick working in an area where close detail in the final image will be essential and spontaneity during the shoot will be paramount. Historically many photographers also used 35mm for convenience. The 35mm negative or transparency inherently required more enlargement in the reproduction process and thus gave larger grain which added to the texture of the final image. However, with modern film stock technology, grain is finer on certain films so a photographer needs to know the whole range of stocks available to choose the right one. Polaroid 35mm instant stocks were used quite widely. They gave instant results, useful for checking "work in progress" during what might be a relatively "free," experimental session. However, digital photography can now provide instant feedback, and this has resulted in fewer photographers using Polaroid.

As with portrait photographers, an increasing number of glamor photographers are experimenting with digital backs on medium format cameras and with digital 35mm SLRs. The instant feedback of working digitally has wide appeal, as does the quick post-production workflow and the potential cost-saving benefits of having no film to develop.

Lighting equipment

A range of equipment is needed for the glamor shoot. The basic kit used most frequently by the photographers featured here consists of soft boxes, standard heads, and silver, gold, white, and black reflectors, and the occasional ring flash. A plethora of devices for modifying light is always useful, for example, honeycombs, diffusing screens, colored gels, umbrellas, and filters.

Since glamor work frequently features bare skin, it is important to know how different filters and gels can enhance the range of skin tones, especially as Polaroid tests cannot be relied on for giving an indication of color, but only for exposure and contrast. Many of the shots here include warm-up orange filters to give tanned-looking skin, while contrast filters to give more graphic body forms are also frequently used.

The texture and color of the subject's skin will influence the lighting set-up chosen. For bright, burnt-out skin, a close-in light source will be appropriate. For more graduation and fall-off of light on curved surfaces, carefully placed black panels are useful. Different types of light (focusing spots, reflectors, soft boxes, ring flashes) all give different kinds of catchlights in eyes, and choice of lighting on specific details can make all the difference.

The team

The team for a glamor shoot may be large or small. At the absolute minimum there may be only the photographer, doubling up as the model in order to make spontaneous use of the light of the moment. More usually, though, a good make-up artist and stylist are needed, as well as an assistant or two. If a client is involved, there may well also be an agency art director present at the shoot, representatives of the client, and other marketing and publicity staff.

The professional model will take all this in his or her stride, but it is true to say that for the intimate work that glamor photography entails, a rapport between photographer and model(s), (and between the models themselves, if a couple or group are involved) will often be established most naturally and effectively without an audience of onlookers. For this reason the photographer may want and need to establish a comfortable, sympathetic atmosphere before the actual shoot starts. It is important that the model should know exactly what is required from the shoot beforehand to avoid any misunderstandings or awkward refusals at a crucial stage of a shoot, though an element of improvisation may also be important. The choice of a natural, imaginative, spontaneous, and responsive model will help enormously.

Location and setting

There are two main considerations with regard to settings. The initial choices are whether the shoot is to take place on location or in the studio.

Within the location option there are thousands of variables to weigh up. Is the setting what is being advertised? Is the setting an essential context for the use of the product?

Is the choice of an exact setting (for example, the Bahamas) an essential prerequisite, or will a generic brief (for example, a sunny beach) be adequate? Whose decision is it? Who will research the exact location? If it is not the photographer, then it must be someone with a good awareness of the lighting considerations (direction of the sun, shadow-casting buildings and trees, for example) as well as an eye for a photogenic spot. Who has to approve the final choice of location? Are there any release considerations for shoots on private property or of particular sites? Could the location be simulated more conveniently and cost-effectively in the studio instead? Who will pay for what?

Using a studio set gives infinitely more control over the variables. The set can be built to facilitate the ideal viewpoint; for example, a room setting for an interior shot can be constructed without all the walls of a real interior. Even the weather is available on demand: wind can be simulated to order, as can mist, fog, rain, snow, angle and intensity of sunshine.

The drawback can be the cost and time involved in building a very elaborate, detailed, or difficult set. While for some sets the basic studio props can be adequately arranged by the photographer and/or stylist, for others a large set-construction team is required, consisting of a construction manager coordinating a team of carpenters, electricians, painters, and others. Props may have to be hired, which then involves the administration and coordination skills and time of a production manager, liaising with out-of-house suppliers. The budget for all this needs to be calculated accurately beforehand and then watched closely when the shoot goes ahead.

Mood, styling, and lighting

Obviously a primary concern for a glamor shoot is the mood created by both the styling (costume, setting, model posing) and by the lighting, whether from artificial sources or natural available light. Whatever the initial source of light favored, it will probably have to be modified to obtain the required quality, ranging from as hard as possible to very soft.

Color is a major factor in creating a particular mood or feel, as is widely recognized in everyday life. Think of the common associations of color with mood: red for anger, blue for coolness, green as a soothing, relaxing hue. From a practical point of view, remember, too, that certain colors are also thought by some people to be unlucky and can engender a great deal of superstition (something to be aware of if any member of the team turns out to be particularly superstitious about the presence of the color green on set, for example).

Although the photographer may have in mind the exact look that he or she wants, there have to be practical considerations too. Sometimes there are unexpected intrinsic limitations to the location of the shoot, for example, little space for positioning of lamps, problems of proximity in terms of focal lengths, difficulty with feeling comfortable for the photographer, assistants, and, most importantly, the model. All of these can demand some quick solutions on the part of the photographer. The mood, styling, and lighting may have to be adapted to accommodate the unforeseen. You can minimize the possibility of surprises on the day by preparing for the shoot as much as possible. Nevertheless, it is necessary to keep an open mind and to be prepared for anything!

celeste

photographer **Jason Keith**

use	Portfolio
model	Celeste
camera	Nikon D70
lens	70mm
digital ISO	200
exposure	⅟640 second at f/5.6
lighting	Electronic flash

Shooting almost straight into the light from the soft box has produced an ephemeral portrait that complements the distant dreamy expression on the model's face.

key points

- ► The secret to the success of this image lies in shooting almost directly into the soft box located on the other side of the model

The unusual juxtaposition of camera, model, and soft box is the strength of this gentle yet striking portrait. A white reflector to right of camera has helped to throw light on the side of the face nearest the camera providing depth to the silhouette and giving the camera-side eye an all important catchlight. The image was converted into monochrome using Photoshop's Channel Mixer, and the colors were balanced to achieve the tone required.

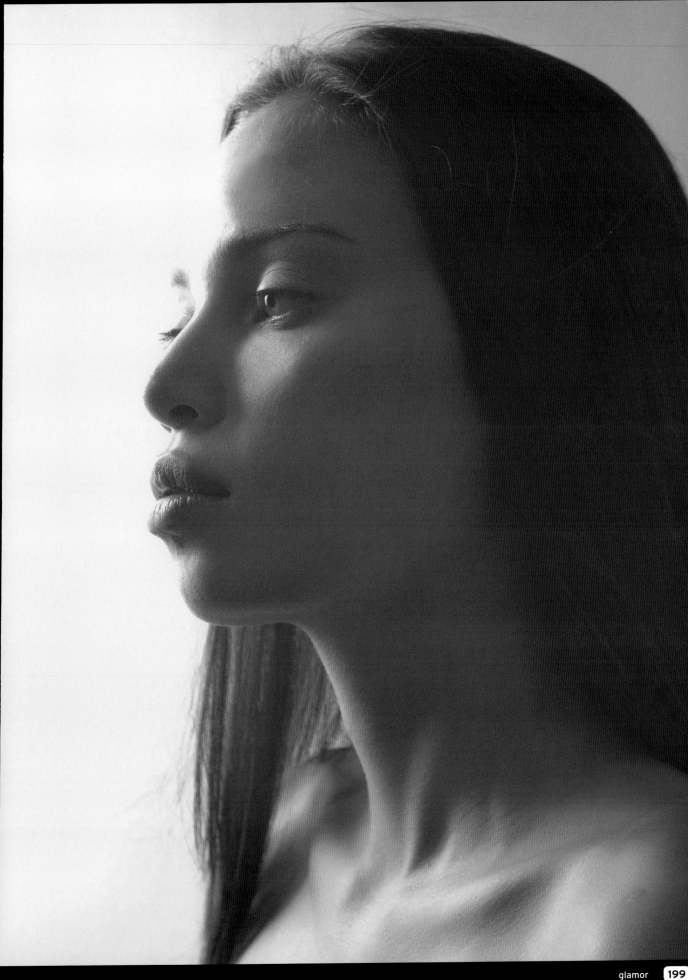

cover girl

photographer **Frank Wartenberg**

client	Foto Magazine
use	Editorial–cover shot
model	Jacqueline
assistant	Jan
stylists	Karin and Matina
camera	35mm Nikon F4
lens	105mm
film	Agfa Scala
exposure	Not recorded
lighting	Available light
props and background	Studio

With the benefit of a window at the right height, of the right size, and facing in the right direction, it is possible to light a shot brightly and purely with the available light, even in an interior setting such as the studio used here.

key points

- ► This shot demonstrates how effectively natural daylight flooding through a window can take the place of a soft box in a studio
- ► It is essential with sunlight to work quickly: the lighting conditions are always changing

The model faces a large window that provides bright (but not harsh) light, which is spread evenly across the body. The pose creates opportunities for gentle shadows to give subtle modeling outlines to the figure.

Compositionally, it is significant that some of the fingers and part of a foot should be visible. If you cover the bottom edge of the shot to conceal these, their importance is obvious: the

shot looks unbalanced and the limbs of the model seem to disappear out of frame all too abruptly, giving a disconcerting lack of "geography" to the body.

The directness of the expression engages the viewer and the minimal clothing and careful pose combine, partly to reveal, partly to conceal the body, adding immeasurably to the allure and intimacy of the shot.

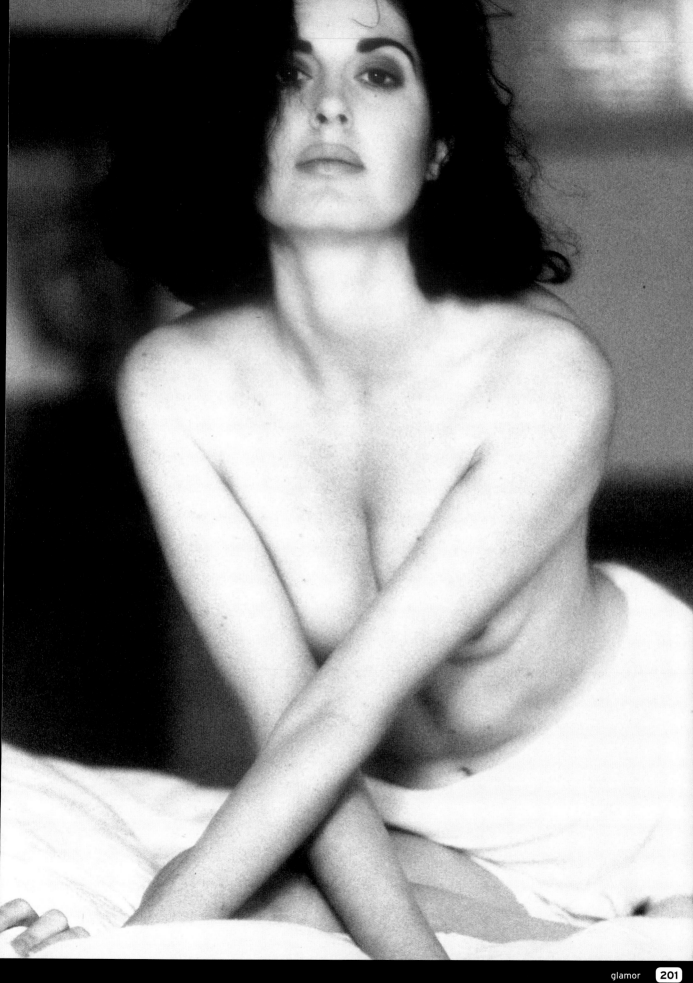

caroline

photographer **Juan Manuel García**

client	La Agencia, Miami
use	Advertising
model	Caroline Gómez
assistants	Carlos Barrera, Carlos Bayora
stylist	Alejandro Ortíz
camera	6x6cm
lens	150mm
film	Ektachrome 100
exposure	90 seconds
lighting	Light brush
props and background	Blue velvet background, support for model to lean on

Using a light brush allows close control of the illumination on every part of the frame, enabling the photographer to create the exact type of light needed. However, it requires a long exposure, and the stillness of the model is critical. For this reason, Juan García placed a steadying apparatus for the model to lean on.

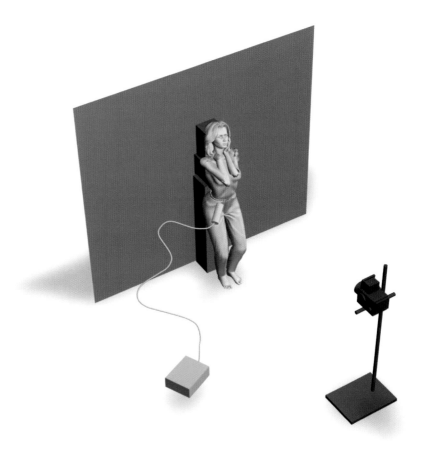

key points

► To complement the effect of light brushing, diffusion can be used on the camera lens

► Light intensity and balance can also be altered by changing the power and aperture or by making multiple exposures

The light brush was held only 20in (50cm) from the model, so for the duration of the exposure the photographer was in the frame, wielding the lightbrush. He is not visible in the final image as there was no light falling on him.

The light brush was applied with smooth movements. Then a blue filter was used on the point of the light, to increase the small size of the light and to record the background area around the model. The main factors when using the light brush are the accessories used, the direction of the light, the movement of the light brush, the distance between the light brush and the model, and the length of exposure. The model needs to remain perfectly still during the exposure, hence the support system used here.

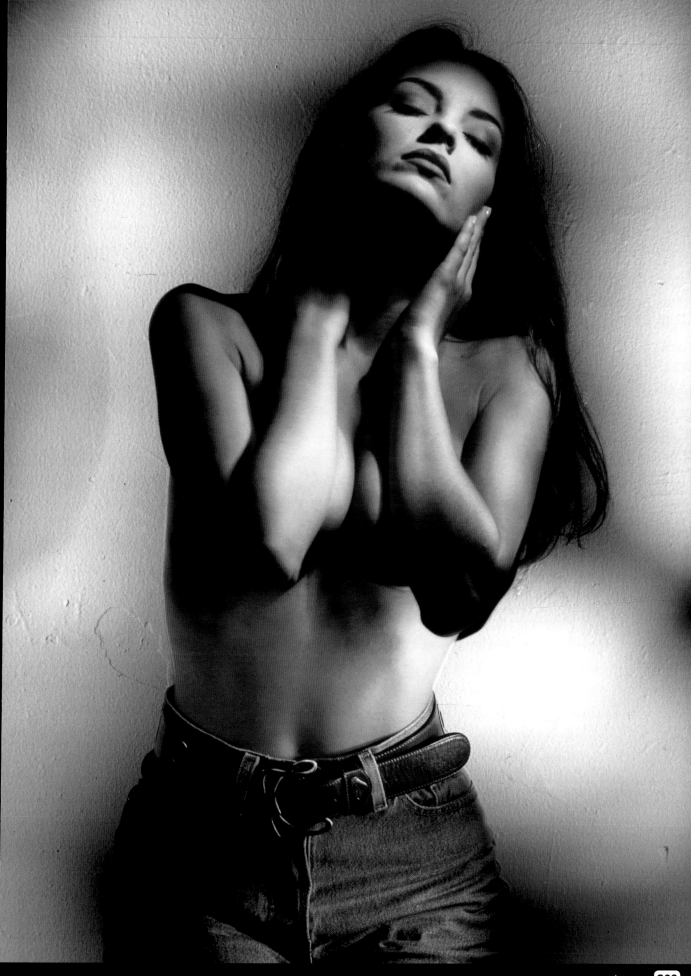

innocence

photographer **Julia Martinez**

use	Personal work
camera	Mamiya 645
lens	90mm
film	Tmax 100
exposure	f/11
lighting	Electronic flash

This shot demonstrates the importance of always being aware and alert and on the look-out for a potential shot. Julia Martinez had finished the main session of a shoot and the model was dressing and rearranging her hair after the main business of the day was over.

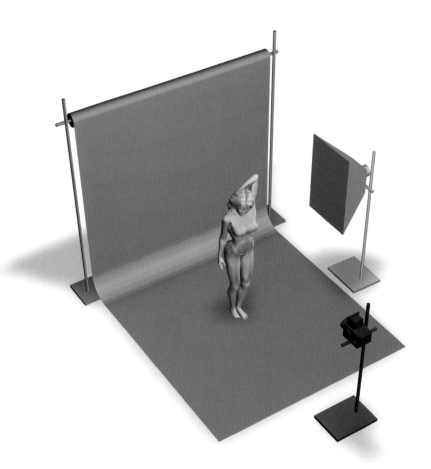

key points

- There isn't time to set up lighting with opportunistic shots. The "experimental" element that this introduces can give interesting results
- Using a diffuser under the enlarger at the printing stage causes the shadow areas to "bleed" into the highlights—the opposite effect to using it on-camera

As the model swept back her hair, Julia noticed the potential for another interesting shot and, as she had one last frame left on the film, she quickly called "Hold it!" She swiftly took the shot as the model paused for a moment, standing in the light of just one soft box. In the circumstances there was no time to set up reflectors, so this is lit purely by the soft box. The side of the face is in almost complete shade, but there is enough light to give the impression of the face. The model's coloring and clothing combine to give a strong chiaroscuro effect. The result is a stylish look and a balanced picture.

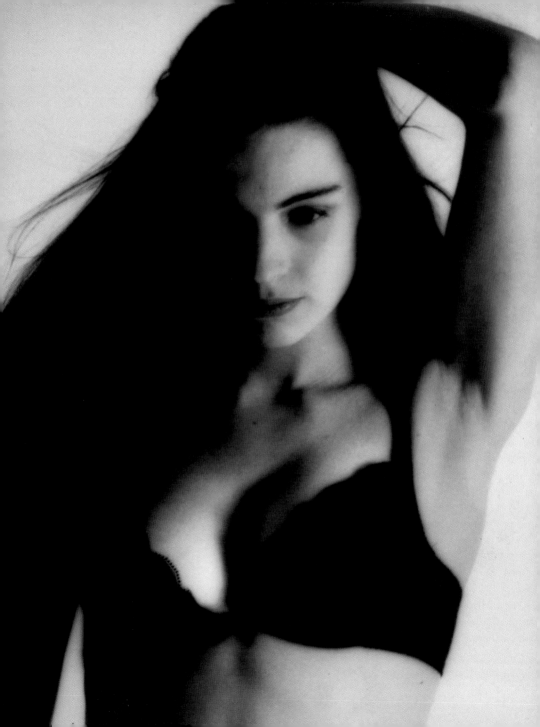

draped nude

photographer **Gérard de Saint Maxent**

The abstract composition is characteristic of Gérard de Saint Maxent's work. The stylized composition is very distinctive.

client	Personal work
use	Postcard
camera	645
lens	200mm
film	Kodak Tmax 400
exposure	¹⁄₆₀ second at f/11
lighting	Electronic flash

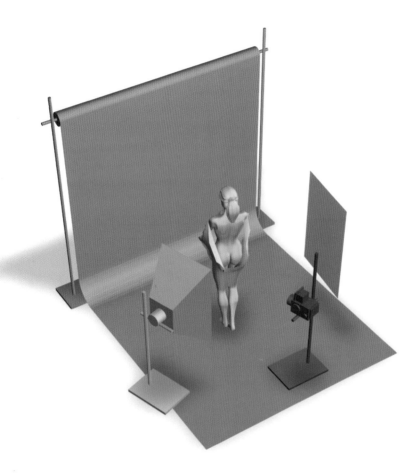

The drapery and curves are like those of classical statues, with the soft folds of fabric and flesh combined as a single entity. The choice of fabric is important in this respect: the cloth and skin need to be virtually indistinguishable from one another for the statue imagery to work, with the same even, sculpted, marble-like texture across all areas.

A single keylight is used in the form of a soft box to one side, and a reflector on the opposite side. This serves the function of adding a slight touch of detail in the deeper areas of the folds of cloth and in the extreme lower-right corner of the frame.

key points

► Tight lighting ratios are required
 for higher-contrast films otherwise
 detail will be lost in either the
 highlights or shadows

► When an emphasis primarily on form
 is required, a black and white image
 can work best. (Black and white
 prints can of course be made from
 color film or files, if the photographer
 wishes to shoot color to keep his or
 her options open)

nude

photographer **Frank Wartenberg**

client	Stern Magazine
use	Editorial Stern Cover
assistant	Bert
art director	Frankie Backer
camera	Mamiya RZ67
lens	185mm
film	Agfa 25
exposure	Not recorded
lighting	Electronic flash: five heads
props and background	Gray backdrop material, box to sit on

This is a superb example of how something seen in its entirety can also look like an abstract. It is obvious that this picture is a back view of a nude, but with careful posing of the model, styling of the hair, and sympathetic use of lighting, the shot has been made into both a classical study and an abstract work of art.

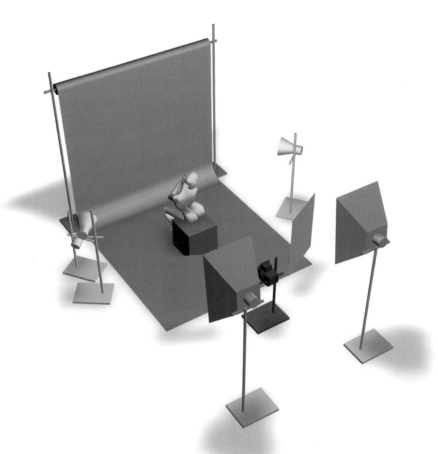

key points

► Even the most familiar subject can be given an abstract form

► Abstract presentation of a familiar form reveals new qualities and a new way of looking at things for the viewer

Two large soft boxes some distance behind and above the camera give a blanket of soft light, which is in turn reflected off the model's back and hair, giving skillfully crafted highlights, complementing these sculpturally perfect features of the body. Two silver reflectors, one either side of the camera and at the same proximity, brighten the highlights even further. The hair is styled to display an array of alternating tones. Compositionally,

the considered fashioning of the coiffure and position of the head and the upper part of the body create an extraordinary, abstract effect.

The two standard heads on the background are supplemented by a spot to the left, which gives a pool of slightly brighter light to ensure separation. Finally, notice how the positioning of the model gives a deliberate low-light rim down the left side of the torso.

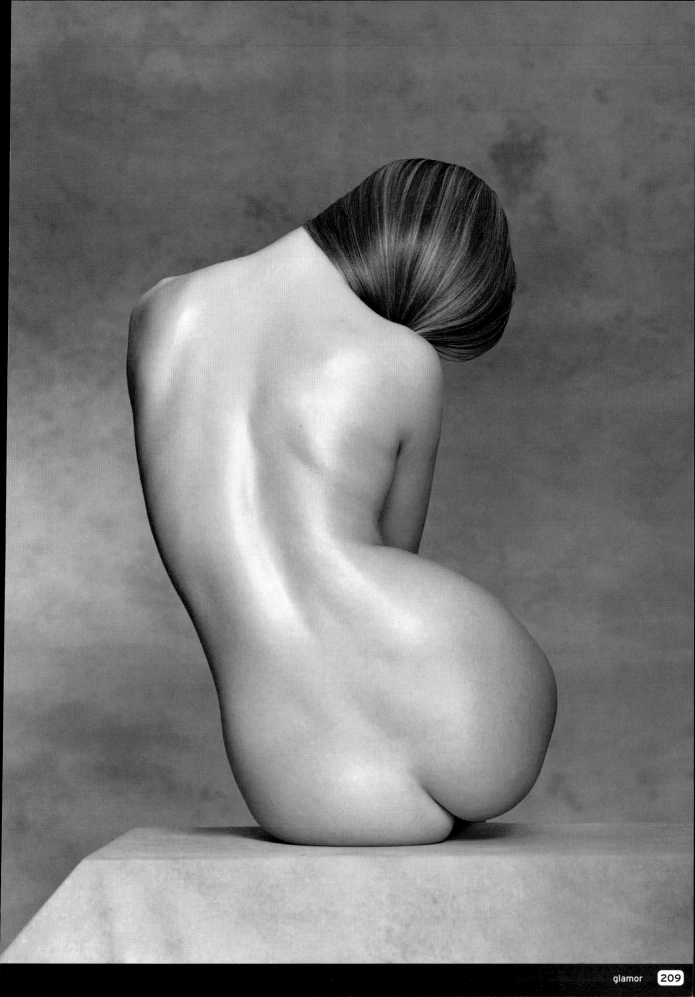

moda kit

photographers **Ben Lagunas and Alex Kuri**

client	Arouesty Asociados
use	Advertising campaign for Moda Kit
assistants	Patricia and Gabrielle
art director	Carlos Arouesty
stylist	Elvia Orrco
camera	6x6cm Hasselblad 205TCC
lens	180mm CF Sonnar
film	Kodak Tmax 100
exposure	$\frac{1}{125}$ second at f/16
lighting	Electronic flash: one soft box

When producing images for advertising, photographers often need to allow space in the image for copy to be added. The large, dark, even areas that frame this shot are ideal for this purpose.

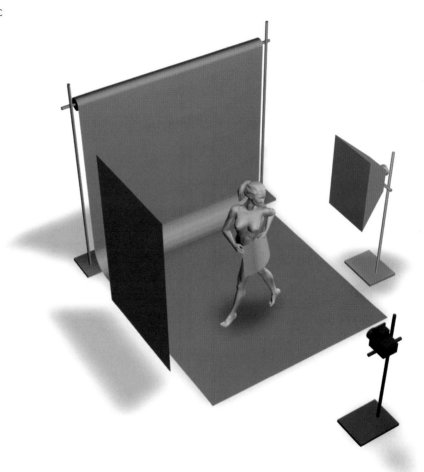

key points

► It may be necessary to build in space around the subject, depending on how the image is to be used. Shooting and supplying a full frame image does not always mean that you have to fill the available frame with the subject

► Working within the parameters of a brief can be inspiring

► Even when using plain black as a background, there are endless materials, textures, types of reflectivity, and finishes to choose from

The soft box lights the outline of the model and enough of the product for identification. The black bounce prevents any accidental fill from reflecting-in, ensuring both the smooth blackness of the background and side, and the essential modest shading of the model. The image achieved is striking, attractive, provocatively sensual, yet also tastefully discreet. It also puts across the product strongly and is a practical, flexible image for advertising purposes. In other words, it fits the client's brief exactly.

Photographer's comment

The product is in the bag—inexpensive clothes. This was an original and controversial campaign. We had to show nudes, but not as pin-ups or pornography. We didn't want to offend the buyers. The art director looked for an intimate but unusual moment. He loved the final result, with the light modeling of the body.

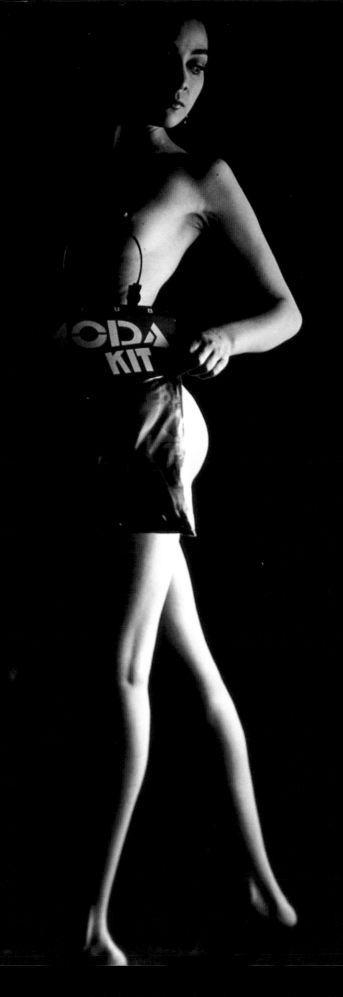

helen

photographer **Terry Ryan**

client	Couture
use	Point of sale and packs
model	Helen
assistant	Nicolas Hawke
make-up	Alli Williams
camera	6x6cm
lens	120mm macro
film	Kodak Ektachrome 100 Plus
exposure	f/22
lighting	Electronic flash: three heads
props and background	Large cotton backdrop

Since this is a product pack-shot image, it is essential that the legs should be foremost in the final image. The graphic qualities of the pose draw attention to the product effectively, and the high-key look is a subtle way of emphasizing the smoothness of the hosiery.

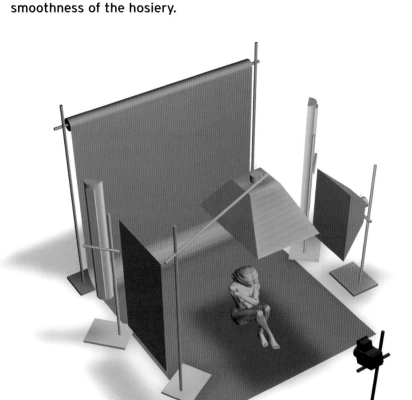

key points

- Directional lighting helps to differentiate areas of a subject when that subject consists largely of white against white, but careful exposure control is required
- With a uniformly colored subject details such as the hair color of the model become important to lend contrast and "substance" to the shot

The swimming pool light to the right of the camera gives evenly distributed light over the whole subject. However, the pose provides contrasting areas of relative shade on the upper part of the legs and thighs, although the shot is basically a low-contrast image. The reflector to the left of the camera

and choice of color of the product, background, and model's skin tones combine to ensure this.

The hair, the only area of remarkably different tone, is lit separately from above by an overhead soft box. This gives detail and texture to the coiffure.

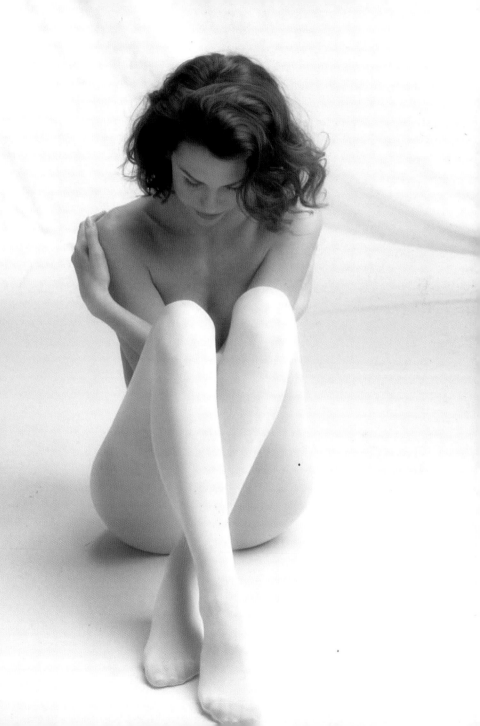

gabriella and dog

photographer **Frank Wartenberg**

client	Self-promotion
use	Portfolio
model	Gabriella
assistant	Bert Spangemacher
stylist	Uta Sorst
camera	Mamiya RZ67
lens	110mm
film	Kodak EPR 64
exposure	Not recorded
lighting	Electronic ring flash
props and background	Golden painted wall and ground

The choice and positioning of the electronic ring flash is crucial. It is set directly face-on to the model and the dog, and is large enough to burn out the gold background over a large area.

key points

► Note the difference in resulting color between the gold-painted area that is facing the light directly (i.e. the wall), and that lying at 90 degrees to it (i.e. the floor)

► The orange 81A warm-up filter used here deepens the skin tones

The resulting catchlights in the eyes are a compelling aspect of the photograph. The eyes of the dog have a fiendish, unearthly glint, echoed by the shine on the nose and the studs of the collar, and the piercing pin-pricks of red in the eyes of the model are a small but significant detail in defining the mood of the shot.

The pose ensures that the faces of the model and of the dog are equidistant from the camera, so that the plane of focus is exactly the same for both pairs of eyes. The flash simultaneously back lights the shot, inasmuch as it is reflected by the gold paint on the wall, giving interesting shadow-cum-reflections on the floor. The depth of field reduces the separation that might otherwise be expected; there is little or no rim-light defining the edge of the model, but instead, fine but dark fall-off shadow areas that "ink in" her outline.

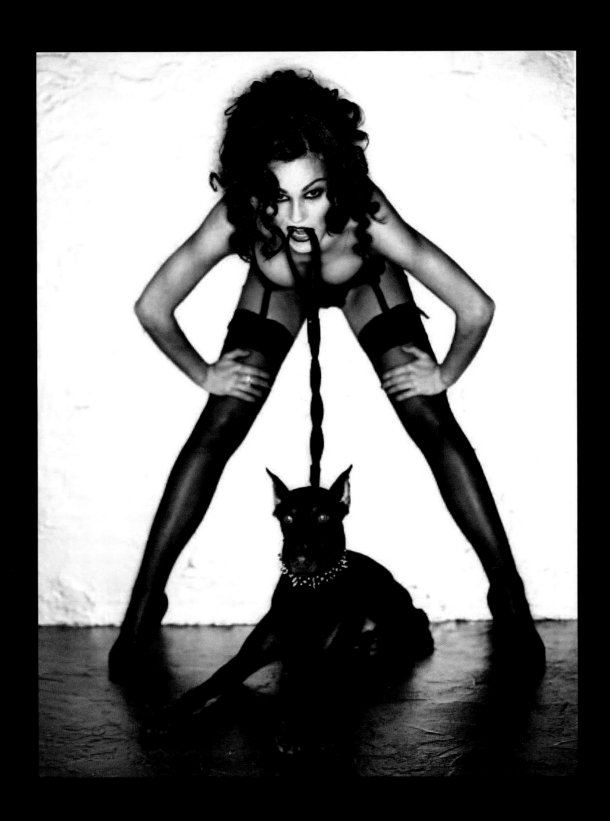

skin to skin collection II

photographers **Ben Lagunas and Alex Kuri**

use	Fine art personal work
assistants	Natasha, Victoria, Suzanne
art director	Ben Lagunas
stylist	Charle
camera	Mamiya RZ67
lens	250mm
film	Kodak Tmax 100
exposure	$\frac{1}{30}$ second at f/16
lighting	Available light

The background for this outdoor shot consists of trees and grass, so a green filter was used to lift these areas, lighten the foliage, and provide more detail.

key points

► Careful positioning of black panels can substantially increase the directionality of available light

The models are positioned between two black panels, and natural bright sunshine is the only source of light. The result is a tunnel of darkness with very strong overhead lighting—the panels ensure that absolutely no reflected fill can bounce in from the sides.

The long lens, which was used from a distance of about 19½ft (6m), means that the bodies of the entwined models fill the frame almost completely. The shine from the sunlight reflected on the models' bodies emphasizes their form exquisitely.

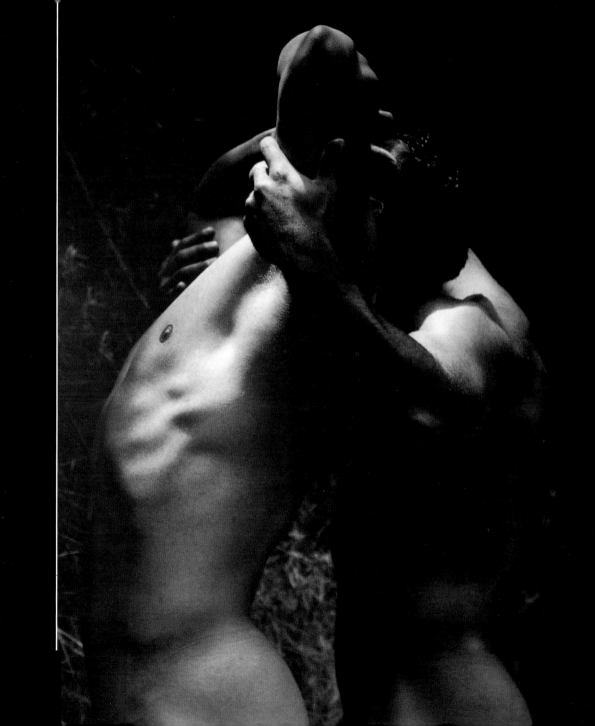

underwear

photographer **Frank Wartenberg**

use	Presentation/underwear
model	Nic
assistant	Jan
stylists	Laurent, Uta
camera	Nikon F4
lens	105mm
film	Polaroid Polagraph
lighting	Available light plus reflector
props and background	Gray background

This is an archetypal image of male beauty. It was used in an advertising context to promote underwear and was thus targeted partly at the potential male consumer, but also, of course, at the men's underwear-buying female partner contingent.

key points

► Daylight can be controlled to a certain extent by the use of bounces and flags

The appeal of this advertising image has to be double-edged. On the one hand, it is important that men should be able to relate to the image, to create a desire for them to purchase the product. At the same time the image must appeal to women, who may well be the purchasers of gifts for partners. The glamor and eroticism of the shot have an important function in this respect. The contextualizing is therefore an important aspect of the image's capacity to compel the viewer. The model is lit by a reflector, which bounces daylight from a window on to the body, giving much greater directionality and intensity to the available ambient light.

The sunny aspect lends an air of romanticized idealism, without undermining the masculinity of the image. This quality is assured by the choice of idealized model and the strong, graphic styling.

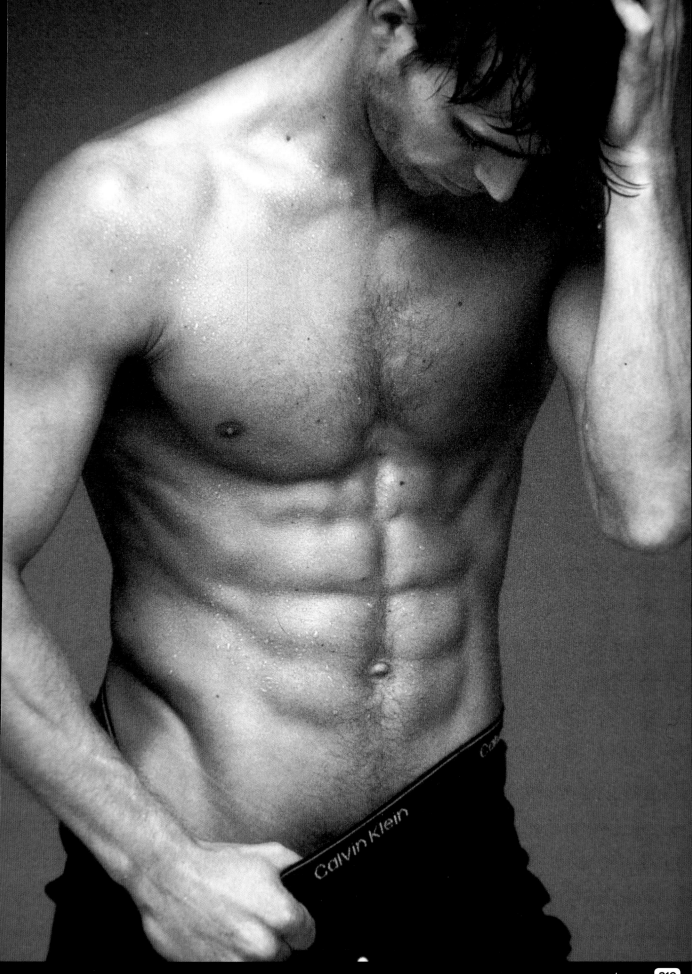

lingerie

photographer **Frank Wartenberg**

client	Brigitte Magazine
use	Editorial
assistant	Jan
camera	Nikon F4
lens	105mm
film	Polaroid Polagraph
exposure	Not recorded
lighting	HMI spot
props and background	Artist's studio (location)

The lighting in this shot is dual-purpose. It establishes a time of day and thus contributes to the narrative implicit in the shot, and it contributes to the practicalities of illustrating the model clearly within the busy setting.

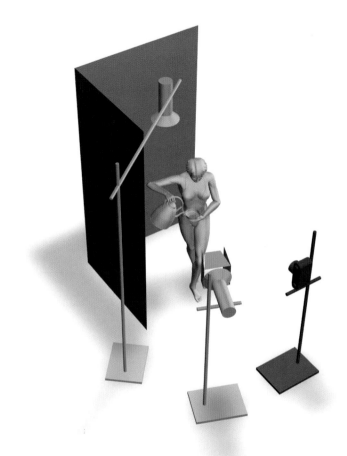

key points

► The choice of lighting can establish a motivation and internal logic for the other facets of a shot (props, costume, and so on)

► It is important for the photographer to be aware of "tones and zones"

The stark spot emulates late-morning sunlight streaming through a window. All the details conspire to create the eroticism that the photographer wanted: the morning sunshine and suggestive "morning after" coffee, the model's sensual lingerie, the wittily placed painting leaning against the wall so that the figure in it seems to avert his gaze, with a troubled expression, from the part of the model that is in startling proximity to his eyes.

The spot is carefully positioned so as to give outline detail in the model's shadow, but without too much density. It also casts shadows of the items hanging on the clothesline. Since these shadows fall on a darker-toned surface, the shadow is denser—essential if the model's right arm is to stand out.

Photographer's comment

I wanted a natural but erotic scene.

amy

photographer **Jason Keith**

use	Portfolio
model	Amy
camera	Nikon D70
lens	135mm
digital ISO	200
exposure	$\frac{1}{250}$ second at f/13
lighting	Electronic flash

One simple main light source was all that was required to create this natural and delicate shot. A long focal length lens has created a close-up yet flattering view.

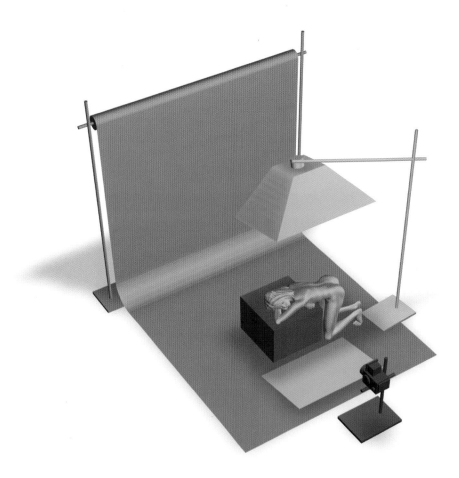

key points

► Using a diffused top light is the secret to the delicate lighting shown here

By having the soft box, which is mounted on a giraffe above the model, pointing slightly forward toward the camera has helped to soften the skin tones. A white table and white reflector running from the base of the table up at an angle toward the camera has helped to light the side of the face farthest from the soft box. The image was converted into monochrome using Photoshop's Channel Mixer and the channels were adjusted until the light, delicate tone was achieved.

jacqueline in the box

photographer **Michael Grecco**

"Skin tones require a surprising amount of additional blue in order to record as neutral," says Michael Grecco. "I am forever adding blue filtration."

use	Personal work
model	Kelly Anderson
camera	6x6cm
lens	120mm
film	Kodak EPY 64 (tungsten-balanced)
exposure	$\frac{1}{15}$ second at f/8
lighting	Electronic flash
props and background	Los Alamos, New Mexico, nuclear lab equipment

For this particular shot, Michael Grecco used a ½ booster blue filter, resulting in the pale blue-tinged skin that he wanted. Although this was an outdoor daylit shoot, it was an overcast day and the model crouching inside the dark box needed additional flash lighting. This was provided by a Comet 1200 PMT. Since tungsten-balanced film was being used, the box (lit only by the ambient daylight) records as a rich, deep blue, while the skin retains its almost neutral tones and glows in the gloom from within the unnerving location set, giving this extraordinary and haunting look.

Photographer's comment
The sudden rain added an ethereal look to this picture, taken at the Los Alamos nuclear lab's junk yard.

key points

► Full blue filtration results in the loss of two stops of light

► When this is used over a flash head the inverse-square law also applies

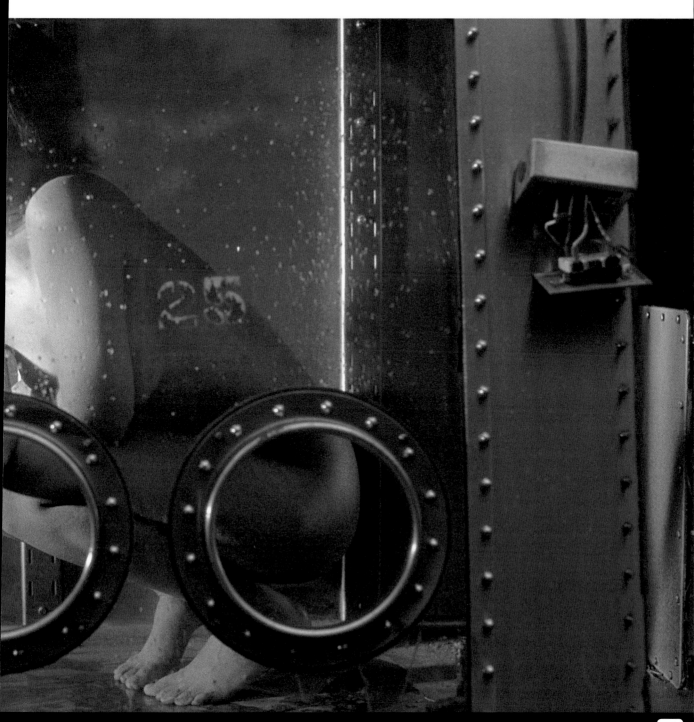

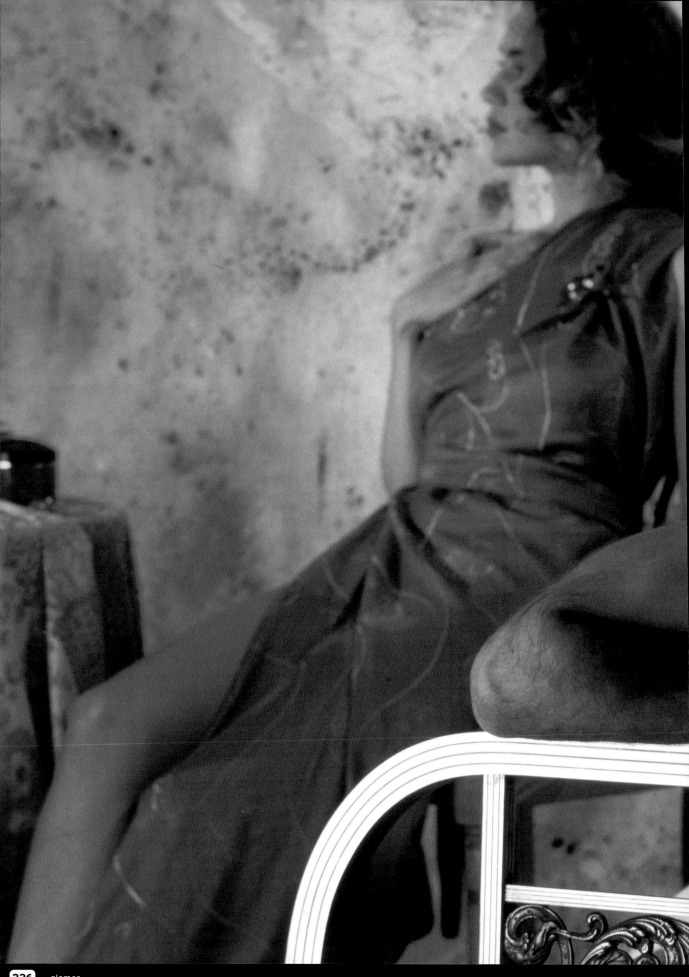

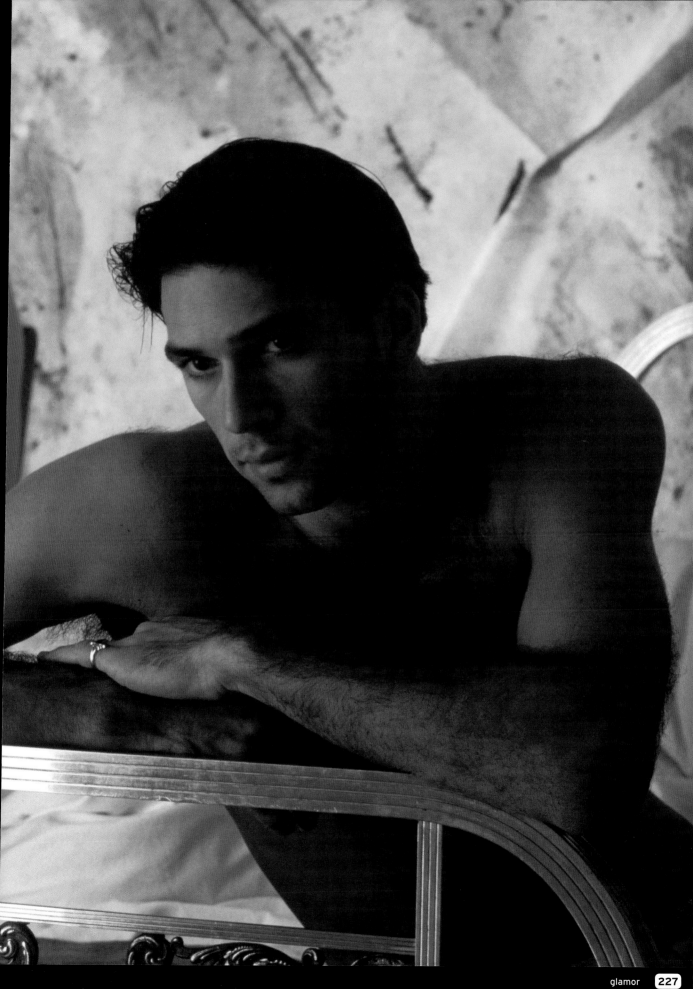

bedstead

photographer **Frank Wartenberg**

client	Select magazine
use	Editorial
models	Alan and Ludmilla
assistant	Jurgen
art director	Frank Wartenberg
stylists	Susan, Sabine
camera	Mamiya RZ67
lens	180mm
film	Kodak EPR
exposure	Not recorded
lighting	Electronic flash: five heads and two soft boxes
props and background	Bed, chair, table, painted backdrop

The voyeuristic quality of this shot derives from the tangible tension conveyed by the two characters featured. This seems to be an intensely private moment, perhaps of friction, uncertainty, or attraction—several interpretations are possible.

key points

► Tensions between contrasting areas of lighting can be suggestive of tensions in the subject matter

► Separation can be achieved by using a long lens to reduce the depth of field instead of using a backlight

The posing and expression of the models play a major part in creating this effect, as do the color, setting, and texture of the subject. The wall, the clothing, and the skin are all of similar color tones, lit to imply the confused connections between them. Five flashes give even light on the woman and the background, and the use of an orange filter over the camera

lens lends relative uniformity to the color range. Only the bedstead, lit by two soft boxes, has a cold glow of its own, the intensity of light outweighing the effect of the light orange filter on the camera. The male model, lit by the same two soft boxes, is posed to give areas of shadow on the body and face to emphasize the moody atmosphere of the shot.

Photographer's comment
The whole set was built in the studio.

massage

photographer **Frank Wartenberg**

photographer	Frank Wartenberg
client	Fit for Fun
use	Editorial/cosmetic
assistant	Bert
stylist	Laurent Bovas
camera	Mamiya
lens	185mm
film	Fuji Velvia
exposure	Not recorded
lighting	Electronic flash: six heads
props and background	Built set, light orange background

The use of the 81A orange filter contributes a rich, luxurious warmth to this shot. The overall lighting is quite soft, supplied by the two front soft boxes, and there are hard highlights on parts of the model's body, her hair, and the masseurs' arms.

key points

- ► You should light the whole of the set from the beginning, even if you plan to frame little of the background. This allows for greater latitude with framing and model-directing, without interruption for repositioning
- ► Even the smallest amount of rim-light separation can make all the difference in clearly defining a model's features

These areas of contrasting hard light and the shining areas that they produce are significant in three respects. First, the shine on the body is important to establish the idea of a massage oil being applied. Secondly, the shine on the back of the hair and on the arms of the masseurs gives the idea of warm sunlight streaming in through a rear window. These aspects are achieved by the close-in rear soft box. Its proximity provides apparently harder directional light. Thirdly, the hard light from the focusing spot picks out the back of the hair and gives the outline of light below the ear. This detail provides the essential separation between the face and the shoulder.

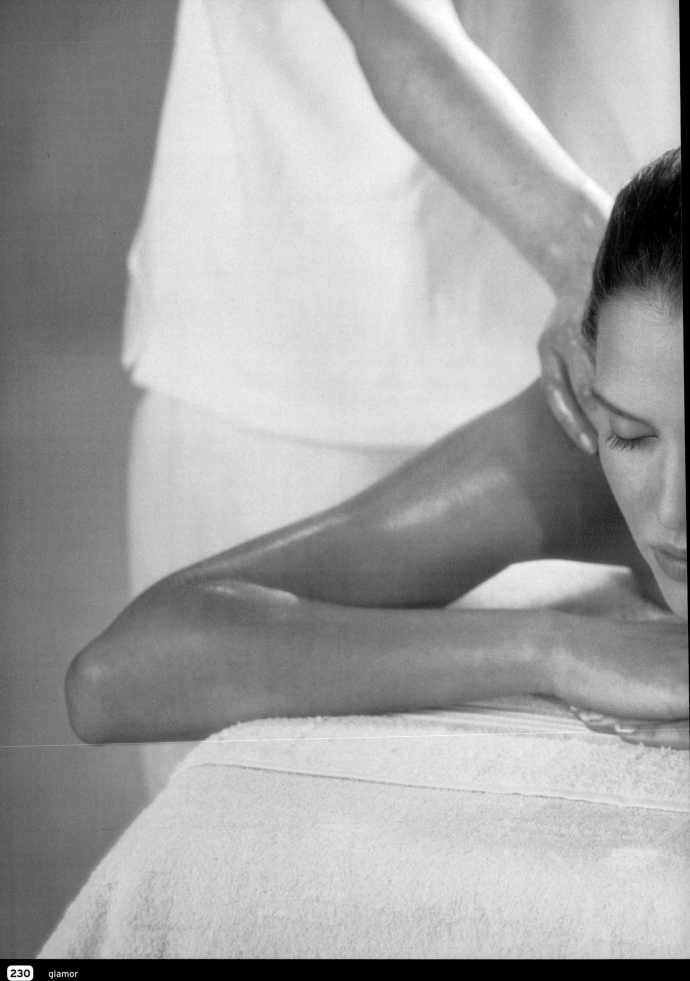

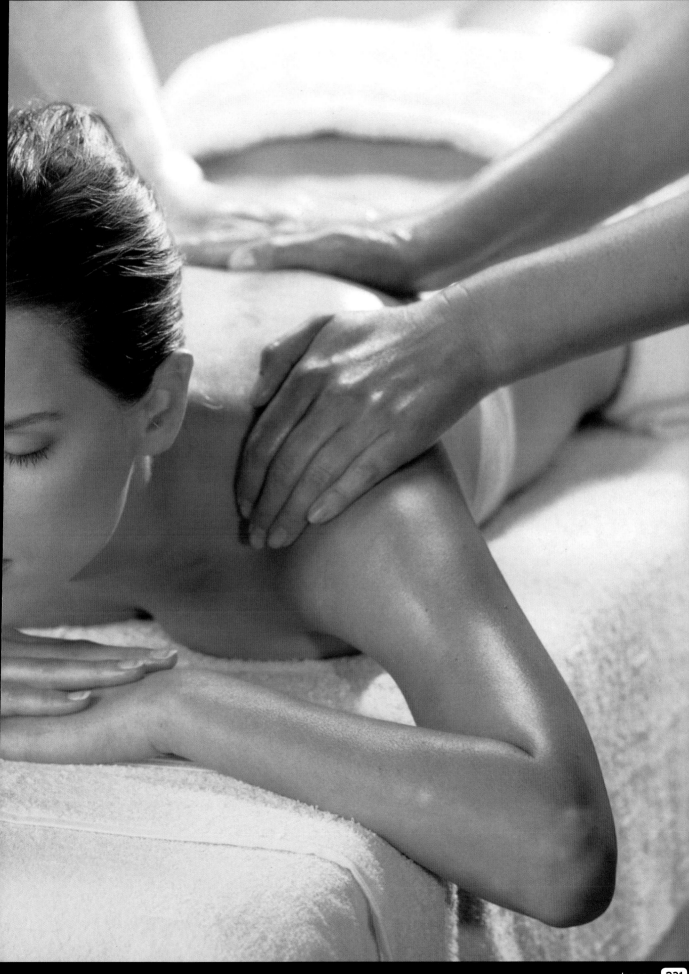

the cat lady

Photographer **Frank Wartenberg**

use	Self-promotion
camera	Mamiya RZ67
lens	110mm
film	Fuji Velvia rated at 40 ASA
exposure	Not recorded
lighting	Electronic ring flash
props and background	Wild cat backdrop

This is an example of the idea that "enough is plenty." If only a single ring flash is needed, then just use one. Frank Wartenberg is not afraid to use a whole host of lights if the occasion demands it, but in this case only a single source was needed.

key points

- ► A lot can be achieved with even the minimum of lighting
- ► High-key detail can add to the stark impact of a deliberately startling shot

The positioning of the black material on the floor was an important decision, because it introduces a horizon line where the floor meets the wall, and helps the viewer to make sense of the model's pose. The "geography" of the shot might otherwise have been difficult to understand. The ring flash gives a wall of light on the leopardskin background. The cloth has texture, movement, and tone enough of its own to give the variation and interest required. The white, fetishy stiletto shoes are very evenly lit, giving a highly graphic form. Here, it is the contrast in color between the high-key shoes and the low-key area of the background that provides separation.

Photographer's comment

I wanted a powerful and erotic photo!

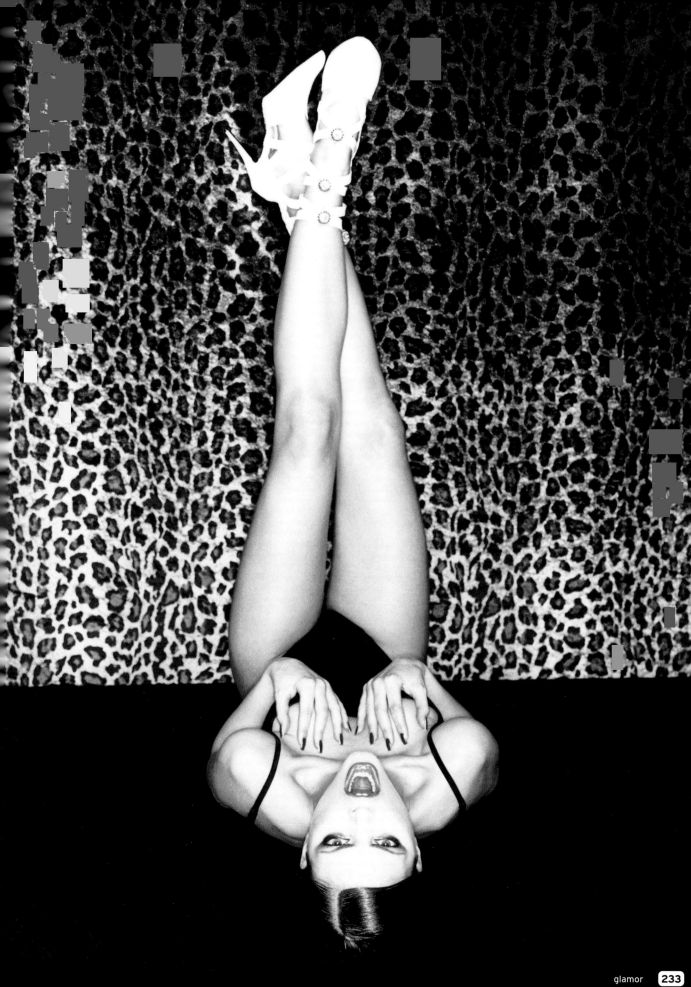

erotic art

photographer **Frank Wartenberg**

Areas of dark are just as important as light in this shot. The blackness of the leather seat and the regular pattern of the black tights give two major areas of visual impact. The large, long soft box running almost the entire length of the couch gives a dazzling highlight along its edges but the fabric of the clothing remains matt in texture and unlifted by catchlights.

client	Art Buyer's Calendar
use	Advertising
model	Brigitte
assistant	Marc
art director	Frank Wartenberg
stylist	Ulrike, Uta
camera	Nikon F4
lens	85mm with orange filter
film	Polaroid Polagraph
lighting	Electronic flash: one soft box
props and background	Gray background, old leather furniture

The gray of the background represents the brightest area of the shot and the model's body displays every tone in between, encompassing a highlight on the midriff that is equivalent in brightness to the background, down to a shadowy hand that is almost as dark as the leather. The position of the soft box, slightly closer to the model on the camera left side, gives some directionality, so the model's front is bathed in light while the head and arms are flung into more shadowy territory. The modeling on the breast (nearest to the camera) displays the gradation of light from one side to the other.

Photographer's comment
Erotic art—the body like a statue.

key points

▶ A high-contrast stock, even when modified with an orange contrast filter, can still be lit to give a medium-contrast look

▶ Observe the splendid example of graduated light on a perfectly smooth, rounded subject

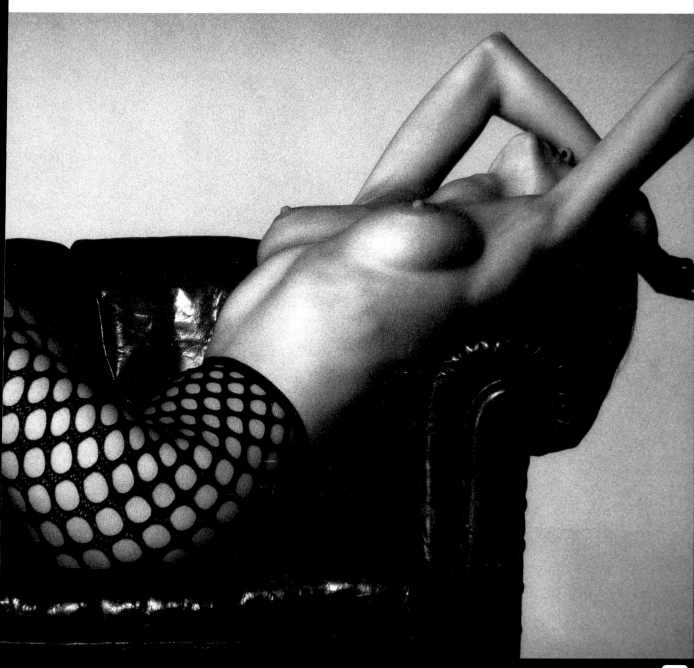

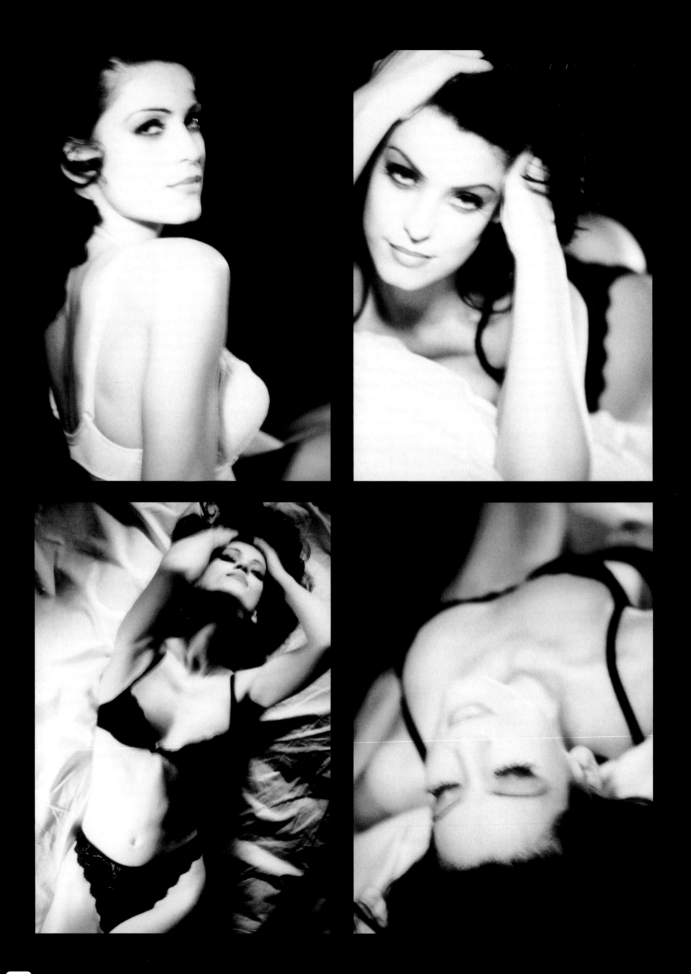

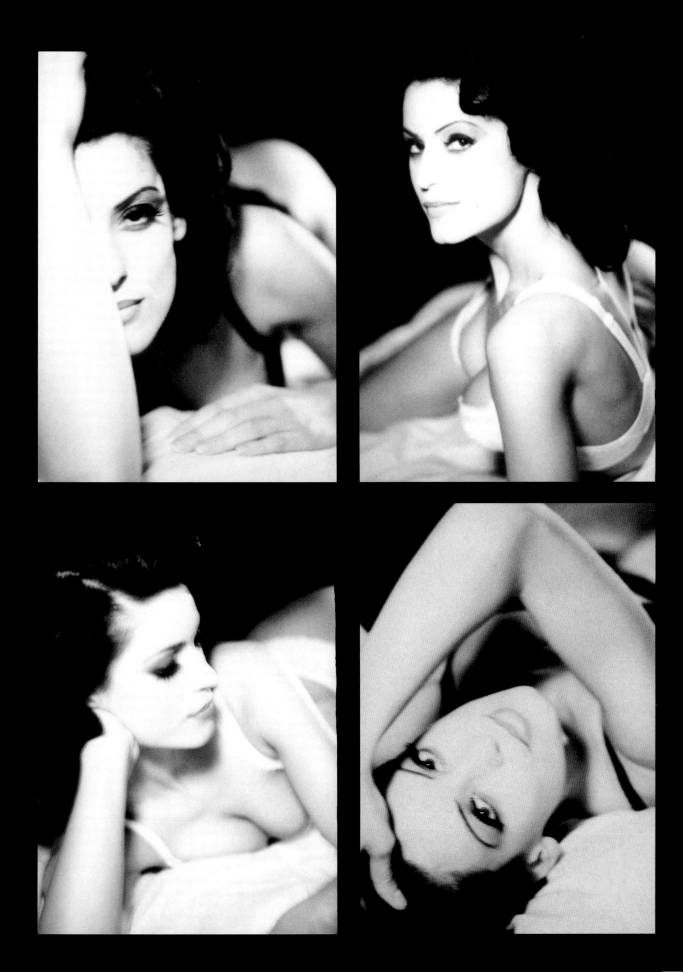

natasha series

photographer **Günther Uttendorfer**

client	Kankan magazine, Slovakia
use	Editorial
model	Natasha, Slovak Model Management
assistant	Martin Fridner
art director	Ivan Sloboda
make-up	Martina Valentova
camera	35mm
lens	105mm
film	Polapan
exposure	⅛ second at f/2.5
lighting	Tungsten
props and background	Bed with white sheets, black paper

This is another example of a very simple set-up, with just one 500-watt tungsten head with a standard reflector and frost, the only source used throughout the whole sequence.

key points

► A red filter would heighten the contrast even further, but it can become difficult when working quickly to be sure that the focus is accurately set

► When using instant Polaroid film stocks, make sure that the processor is scrupulously clean, as it is easy to scratch the film

The head is placed to camera left and its position stays constant for the whole shoot. It is the model and the photographer who move, introducing variations in composition and lighting, and revealing the textures in the fabrics of the model's clothing and the sheets. The model's lingerie also changes between shots, giving different plays of light and dark in the sequence. What comes through in all the pictures is the model's personality, engaging with the camera. This quality is heightened by considering the shots as a sequence, as they are shown here.

A shutter speed of ⅛ second introduces the feeling of movement and gives the images a slightly soft edge.

Photographer's comment

It really is a lot of fun if a woman reveals her character in front of the camera and interacts with it. This creates for me the erotic feeling of a series.

low key

photographer **Marc Joye**

Use	Portfolio
Model	Genevieve
Camera	6x6cm
Lens	80mm
Film	Kodak Tmax 100
Exposure	⅟₆₀ second at f/16
Lighting	Electronic flash: two heads
Props and background	Plinth, dark red fabric

A few high-key areas make for an overall low-key image. This may sound like a contradiction in terms, but the explanation is to do with the proportion of the overall image that is high-key (very little in this case) in relation to how much of it is low-key.

key points

- ▶ "Keylight" is generally used to mean the dominant or more powerful light source. It is usually the first consideration when planning the set-up and often dictates the nature of the supporting lighting
- ▶ Careful use of geometric form can give a powerful, balanced visual impact

There is no direct light on the background, which occupies a large amount of the frame, and this determines the feel of quiet grayness. The geometric form of the model is more important than close detail, and the directional lighting emphasizes the graphic element of her pose, with the visual balance of relatively small areas of high-key shine on the extreme right of the model (her back) and on her left (the front of the lower legs). The fulcrum is the V-shape formed by the thigh and abdomen, and the sense of balance is picked up by the fine rim of light on the left edge of the plinth.

Just a fraction of the left side is visible, giving the fine line of light, while the right side is turned away to ensure that no edge light appears.

Photographer's comment

Here the model was moving and changing poses that were very powerful.

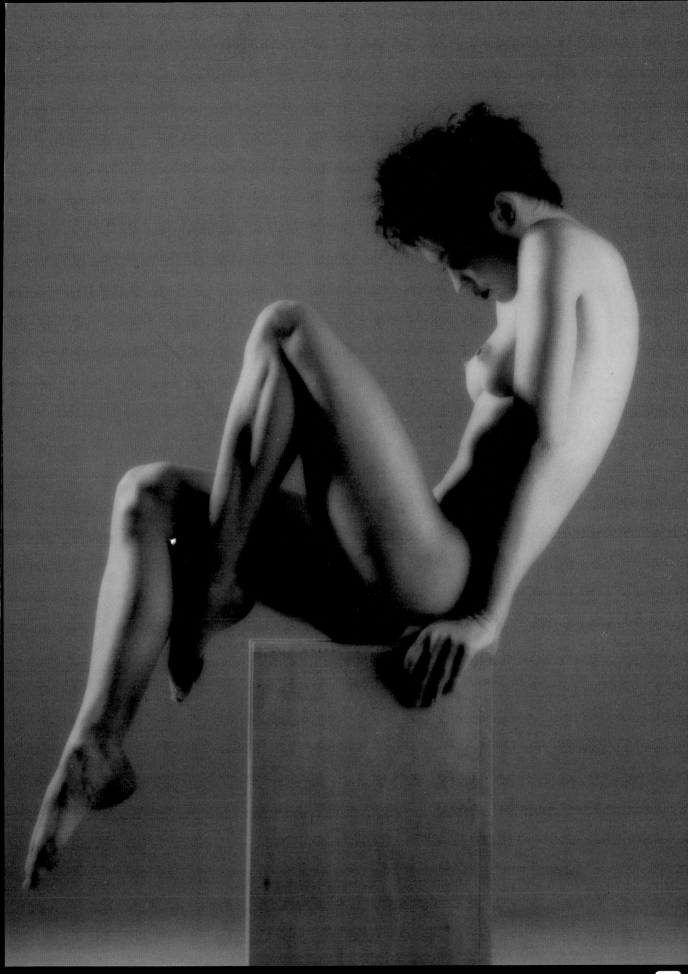

gabriella

photographer **Frank Wartenberg**

client	Stern Magazine
use	Cover/Fashion
model	Gabriella
assistant	Bert
stylists	Gudrun, Uta
camera	Mamiya
film	Fuji RDP 100
exposure	Not recorded
lighting	Ring flash
props and background	Golden wall

Although the only source of light is a single ring flash, this shot is illuminated by almost all-round lighting, ensured by the use of a bank of reflectors arranged in a semicircle in front of the model and a reflective golden wall behind her.

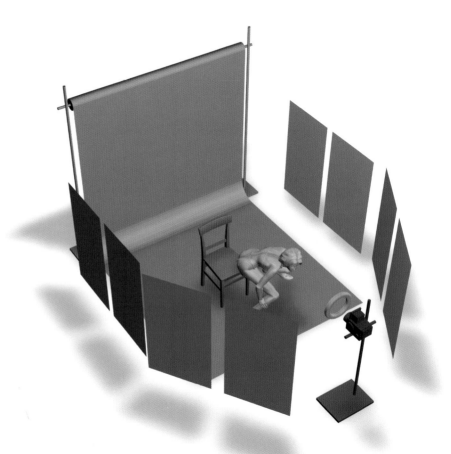

key points

► Reflective props and accessories can add interesting glints of detail if lit appropriately

► Sometimes areas of both sharp and soft focus on the same main subject can enhance the image

The only break is that provided by two black panels, one to each side of the model, which have the effect of allowing some fall-off to occur on the side edges of the limbs and body. Even the chair is made from reflective metal, giving glowing metallic blue areas behind the model. The pose of the model means that her face is considerably closer to the flash than the rest of her body, and the resulting difference in tone is immediately apparent, as the face is comparatively burnt out though sharp, while the body has a darker golden tone and is in softer focus.

The highlights on the bangles, shoe, chair seat and back, and on the model's lips add balanced points of interest across the image.

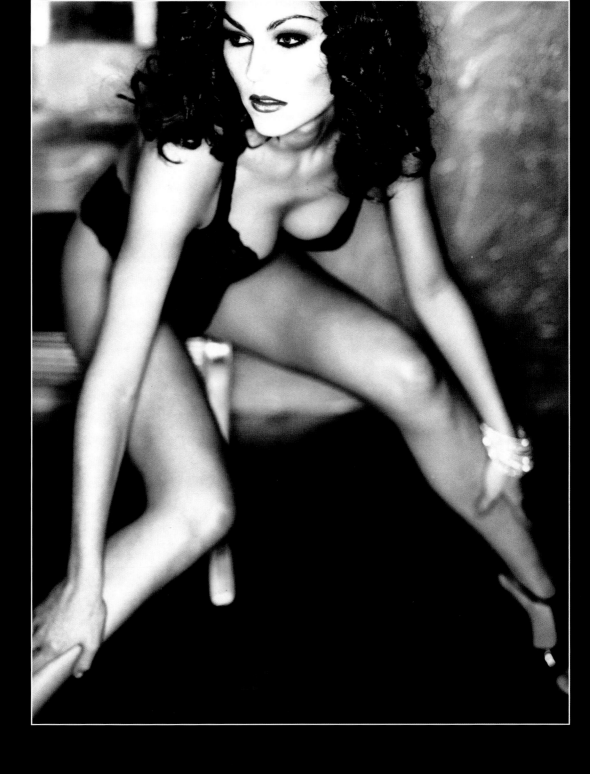

feathers

photographer **Marc Joye**

use	Portfolio
model	Genevieve
camera	6x6cm
lens	80mm
film	Tmax 100 and Fuji RDPII
exposure	¹⁄₆₀ second at f/16
lighting	Electronic flash: four heads
props and background	Feathers

The incredibly large feathers that comprise this extraordinary head-dress are in fact small feathers laid on to a print of the shot of the model, and the whole assembly rephotographed. Notice the gentle shadow behind the head feathers—the work of subtle manual retouching to complete the three-dimensional illusion.

key points

► Simple, physical techniques used in a sophisticated way can result in a shot that others might execute in a time-consuming, expensive electronic way

The background is illuminated much more brightly than the model. Two strobe heads aimed at the backdrop give a bright, even background. The position of the soft box to the side of the model does not give much strong, direct light on the front of the body, and the strobe behind her on the opposite side gives backlighting that adds to the tendency toward silhouette. The pattern on the torso stands out by virtue of the color, in contrast with the soft black and white base image and pastel feather shades.

Photographer's comment

After shooting the photos, I designed some black calligraphy on the model's body. After printing I reworked the calligraphy in red and added some pigeon feathers as a hat and to cover the pubic hair.

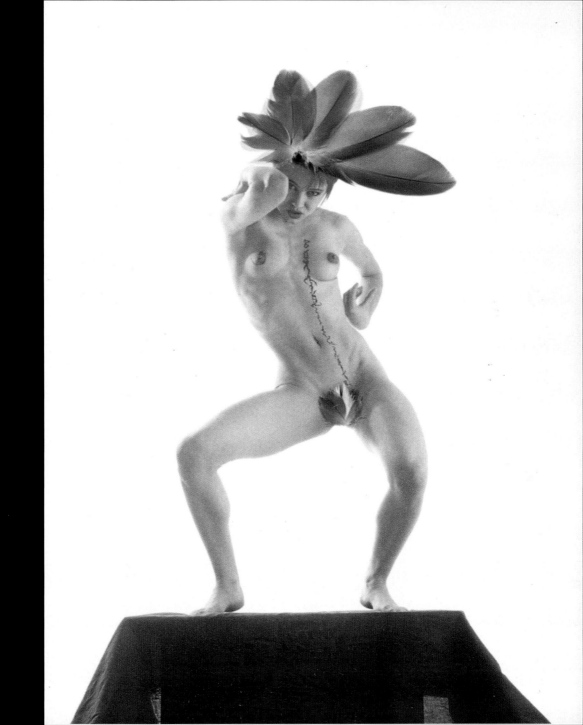

lady iguana

photographer **Wolfgang Freithof**

client	Self-promotion
use	Select magazine
model	Michelle/Ford
art director	Sophia Lee
hair/make-up	Ron Capozzoli
body paint	Claudine Renke
camera	35mm
lens	105mm
film	Fuji Provia 100
exposure	1/60 second at f/4
lighting	Electronic flash: three heads
props and background	White seamless background

The corset was painted onto the model using a precut mold onto which liquid make-up was applied to stamp the design directly onto the model's skin.

key points

▶ Light shot direct through a silk umbrella gains good diffusion without entirely losing the "point source" look: notice the highlights on the knees merging into softer diffused lighting further along the limbs

▶ Black panels give a strong fall-off in the light to enhance outline separation

The model was standing between two 4x8ft (1.2x2.4m) black panels to ensure that the outside contours remain strong against the white background. Freithof shot 2 1/2 stops overexposed to give what he describes as "a painterly quality" to the picture. The main light is a standard head at a height of 12ft (3.6m), directly over the camera, shooting through a silk umbrella. The background is lit by two standard heads at 45 degrees, which are set 1/2 stop over the keylights. This makes sure that the background is very bright and gives some separation between the background and the model's outline.

Photographer's comment

I collaborated with a cartoonist (Henrik Rehr) to add some extra visual effects. I received many enquiries from this picture from diverse ad agencies and also from a German publisher.

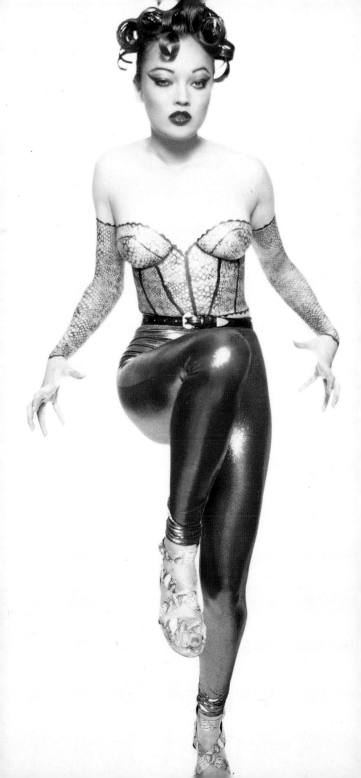

elle

photographer **Frank Wartenberg**

client	Fit for Fun
use	Editorial
model	Elle
assistant	Bert
art director	Anette
stylists	Laurent, Uta
camera	Mamiya RZ67
lens	360mm
film	Agfa Scala
exposure	Not recorded
lighting	Electronic flash: six heads
props and background	White backdrop, Plexiglas on floor

This witty shot is brought off well by the careful attention to styling, graphic form, lines and tones and, of course, choice of lighting, to make the most of each area of texture. Every ripple in the jeans is clearly defined; you can count the vertebrae along the back; and every strand of hair is distinctly visible.

key points

► A low-contrast stock can produce a higher-contrast image if a large contrast ratio is applied

The model is in the center of a semi-circle of light made up of three soft boxes to the front and completed by two silver reflectors, one at each side. Three standard heads evenly illuminate the white background. This is a low-contrast image with a small lighting ratio (about 1:1.5): the key is not significantly brighter than the fill so there is a good tonal range.

The Plexiglas surface placed on the ground creates the opportunity for a reflection of the model to occur on the floor to add interest. From this viewpoint, the shot taken with the camera at about the same height as the model's head—only the reflection of the feet can be seen. If the camera had been higher up than this, more of her reflection would have been visible.

directory

photographer **Jörgen Ahlström**

address Tegnérgatan 37
111 61 Stockholm
Sweden

telephone +46 (0)8 650 51 80

email info@jorgenahlstrom.com

agent Turpin & Kloss
(England)
306a St Pauls Road
London N1 2LH
UK

telephone +44 (0)20 7354 8568

email hello@turpinandkloss.com

pp. 134, 150, 166

photographer **Peter Barry**

telephone +44 (0)20 7262 4874

Peter Barry's work is extremely varied–fashion, advertising, still life, and food –so every day is different, exciting, and stimulating. Constantly learning and experimenting with new techniques, his two main passions are people and food. He has travelled all over the world and met many fascinating people. As a result, he feels that photography is not so much work as a way of life.

p. 96

photographer **Johnny Boylan**

address 29-35 Rathbone Street
London
W1T 1NJ
UK

telephone +44 (0)20 7323 3822

fax +44 (0)20 7612 1010

email johnnybfab@aol.com

Photography becomes a way of life, an obsession. Luckily for Johnny Boylan it also provides a good living. Every new commission, whatever it is, is a challenge. That challenge need not necessarily be photographic. The sourcing of a location; a model; finding an unusual artifact; getting over the logistical problems of travelling to some backwater in another continent. Photography can be make-believe and fantasy, but most of all it is an art form of supplying your client. There is no room for error and it is unforgivable to supply something that is unusable, whatever the reason.

pp. 24, 74, 82, 98

photographer **Maria Cristina Cassinelli**

address Superí 4555
(1430) Buenos Aires
Argentina

telephone +58 (11) 4542 9217
+58 (11) 4544 8446

fax +58 (15) 4998 4198

email info@cristinacassinelli
.com.ar
cassinellifoto@sion.com

web www.cristinacassinelli
.com.ar

Endowed with a unique creative style, Cristina brings out the essence of her subject, whether a still life, a portrait, or a building immersed in a landscape.

pp. 58, 60

photographer **Simon Clemenger**

telephone +44 (0)20 7736 9229

fax +44 (0)20 7736 9292

pp. 128, 148

photographer **Corrado Dalcò**

address via Sciascia 4/A
4-43100
Parma
Italy

telephone +39 (0)521 272 944

fax +39 3288 680 491

Corrado Dalcò was born in 1965 in Parma. He studied for five years at the P. Toschi Institute of Art in Parma, specializing in graphic design. He is a self-taught photographer, and worked as a freelance photographer abroad before founding his own photographic studio in 1991. He won an international competition in 1993 ("5ième Biennale") for young Italian photographers and his photos were published in the Photo Salon catalog. Corrado works mainly with agencies in Milan, concentrating on fashion.

pp. 110, 178

photographer **Frank Drake**

address Pelican Studios
17 Goldney Road
Clifton
Bristol
BS8 4RB
UK

telephone/fax +44 (0)117 914 0960

Frank Drake is self-taught; he decided on photography as a fine art after meeting Henri Cartier-Bresson in Paris in the 1970s. He worked with Peter Gabriel's Real World Records for six years, photographing musicians from around the world. He moved into fashion photography in 1996 after studying Art and Social Context at the University of the West of England.

p. 46

photographer **David Dray**

address 60 Milton Avenue
Margate
Kent
CT9 1TT
UK

telephone +44 (0)1843 22 36 40

David Dray is a graphic artist working on the Isle of Thanet in Kent. He trained at the Canterbury College of Art, where he first started using cellulose thinners to produce montages from gravure printing. Later he applied the thinners technique to color photocopies to achieve the results shown in this book. He uses this technique with his own photography or (as appropriate) with other photographers' work to maintain complete control in design briefs.

p. 94

photographer **Michael Freeman**

address 4 Callcott Street
London W8 7SU
UK

telephone +44 (0)20 7229 3977

fax +44 (0)20 7229 3788

email michaelhfreeman@
btinternet.com

pp. 18, 20, 30, 40, 42, 54, 106, 122, 142

photographer **Wolfgang Freithof**

address W. Freithof Studio Inc.
342 West 89th Street 3
New York NY
10024 USA

telephone +1 212 724 1790

fax +1 212 741 0256

email wolfgang@wfx.net

web www.wfx.net

agent Robert Fischer & Co
9 W. Hubbard Street
Chicago IL 60610 USA

New York-based Wolfgang Freithof is a freelance photographer with an international clientele spanning a wide range of assignments from fashion, advertising, editorial, record covers, to portraits, as well as fine art gallery shows.

pp. 138, 170, 184, 186, 246

photographer **Juan Manuel García**

address Carrera 11A #69-38
Bogotá
Colombia

telephone +57 (1) 212 6005
+57 (1) 616 4434 Cod.155

fax +57 (91) 249 5843

Juan Manuel García has been an avid photographer since childhood. As an adult he trained in photography in both Europe and the USA. He works in many different genres of photography. He tries to show an element of fantasy behind reality. He is passionate about photographing people and fashion. He has also specialized in still life photography utilizing lighting methods that he devises himself. He has developed various industrial photography projects and also works on commission from some of the world's top companies including McCann Erickson Corp., Young & Rubican, Bates J. Walter Thompson, and other advertising agencies in Colombia. García is also involved in the magazine industry, and produces the covers for the most important magazines in Colombia. He also owns the largest photography studio in Colombia, which is equipped with three sets and a digital photography station. García has won several awards in Colombia and Latin America for best food photographer. He has also won accolades for his fashion, product, and landscape photography.

p. 202

photographer **Michael Grecco**

address Michael Grecco
Photography, Inc.
1701 Pier Avenue
Santa Monica
CA 90405 USA

telephone +1 310 452 4461

fax +1 310 452 4462

Michael Grecco has an extensive background as an editorial and advertising portrait photographer. Along with his advertising work for Paramount, Fox, UPN, USA Network, and Warner Bros., Michael does regular assignments for *Entertainment Weekly*, *GQ*, *Movieline*, *Playboy*, *Time*, and many others. Michael has also been featured twice in *American Photo*. He has won numerous awards for his work including 1995, 1996, and 1997 Communication Arts and the American Photography annual. He teaches at the prestigious Santa Fe Photographic Workshops.

pp. 176, 224

photographer **Roger Hicks**

email roger.hicks@wanadoo.fr

web www.rogerandfrances.com

Roger is a wordsmith and photographer, both self-taught. He is the author of more than 50 books, as well as being a regular contributor to photographic magazines. He has illustrated "How-To" books, historical/travel books, and of course photography books, and has written on a wide variety of subjects including airbrushing, automotive subjects, the Tibetan cause, and the American Civil War. He works with his American-born wife Frances E. Schultz on both self-originated and commissioned projects, to provide packages of words and pictures suitable for both sides of the Atlantic.

p. 38

photographer **Isak Hoffmeyer**

address Store Kongensgade 87, 1
1264 København
Denmark

telephone +45 40 51 15 29

web www.gitteandersen.com

agent Gitte Andersen

address Enigheden
Rentemestervej 2
2400 København
Denmark

telephone +45 35 86 12 42

fax +45 35 86 18 42

email mail@gitteandersen.com

web www.gitteandersen.com

Isak Hoffmeyer has been shooting freelance for the past few years and has worked in Denmark, England, and Sweden.

p. 162

photographer **Marc Joye**

telephone +32 2 250 11 00

After studying film and TV techniques, Marc Joye moved over to advertising photography, where he found he had a great advantage in being able to organize shoots. He prepares his shoots like a movie, with story boards to get the sales story into the picture.

pp. 154, 240, 244

photographer **Jason Keith**

web www.jasonkeith
photo.com

From West Cornwall and via Edinburgh, Scotland, Jason Keith now lives and works in Barcelona. He specializes in fashion and portrait photography for editorial, advertising, and design.

pp. 56, 66, 80, 100, 108, 144, 156, 190, 192, 198, 222, 255

photographer **Ben Lagunas and Alex Kuri**

address BLAK Productions
Galeana 214 Suite 103
Toluca C.P. 50000
Mexico

telephone +52 (722) 215 9093
+52 (722) 215 8483
+52 (722) 215 8347

fax +52 (722) 215 9093

email blak@blakworld.com

web www.blakworld.com

Ben and Alex studied in the USA and are now based in Mexico. Their company, BLAK Productions, provides full production services such as casting, scouting, and models. They are master photography instructors at the Kodak Educational Excellence Center. Their editorial work has appeared in international magazines, and they also work in fine art, with exhibitions and work in galleries. Their commercial and fine art photo work can also be seen in the *Art Director's Index* (RotoVision); *Greatest Advertising Photographers of Mexico* (KODAK); and other publications. They work around the world with a client base that includes ad agencies, record companies, direct clients, magazines, artists, and celebrities.

pp. 22, 64, 152, 210, 216

photographer **Lewis Lang**

address Lewis Lang Photography
PO Box 1781
Englewood Cliffs
NJ 07632-0781 USA

telephone +1 201 567 9259

email Lewsivisn@aol.com

web www.members.aol.com/
Lewisvisn/home.htm

Lang began his career as a filmmaker, making commercials and documentaries for both broadcast and cable TV. A friend suggested that he use 35mm photography to teach himself about lighting and composition. He ended up loving photography and leaving filmmaking. He has since been a freelance journalist, a fashion photographer, and a fine art photographer.

pp. 68, 84, 92

photographer **Peter Laqua**

address Laquafotodesign
Lupfenstrasse 74
78056 Villingen-
Schwenningen
Germany

telephone +49 7720 95 72 00

fax +49 7720 95 72 10

Born in 1960, Peter Laqua studied portraiture and industrial photography for three years. Since 1990 he has had his own studio. A prizewinner in the 1994 Minolta Art Project, he has also had exhibitions on the theme of Pol-Art (fine art photography) and on the theme of "Zwieback" in Stuttgart in 1992.

pp. 48, 70

photographer **André Maier**

address 511 Avenue of the
Americas, Suite 298
New York
NY 10011 USA

telephone +1 212 388 2272

email andre@andremaier.com

web www.andremaier.com

German photographer André Maier studied professional photography at the London College of Printing in England, and now lives and works in New York City. The diversity of his style—ranging from photojournalism to fashion and conceptual portraiture— has earned him numerous exhibitions in Europe and New York. He now concentrates on expressing creative ideas and concepts through carefully planned make-up, original sets, and computer retouching. His clients include record companies, magazines, and ad agencies.

pp. 116, 136

photographer **Jeff Manzetti**

address Studio Thérèse
13 rue Thérèse Paris
75001 France

telephone +33 (1) 42 96 26 06

fax +33 (1) 42 96 24 11

email jeff@jeffmanzetti.com

web www.jeffmanzetti.com

Jeff Manzetti's career took off rapidly, beginning with campaigns for international clients such as Swatch (worldwide), Renault, Lissac, Dior, and L'Oreal, as well as many editorials for *Elle* magazine. Jeff's work has always focused on beauty and personalities. His work has appeared as covers and spreads in *Figaro Madame*, *DS*, *Biba*, and *20 ans*. He has photographed celebrities such as Isabelle Adjani, Isabelle Huppert, and Sandrine Bonnaire. His energy and humor extend to his work, as reflected in his advertising campaigns for Cinécinema and Momo's restaurant in London. He has also directed numerous videos and commercials in France, to great acclaim.

pp. 112, 120, 132, 164, 168

photographer **Julia Martinez**

address Viva Photography
Portman Cottage
2 Port Terrace
Cheltenham
GL50 2NB
UK

telephone +44 (0)1242 237914

fax +44 (0)1242 252462

After completing her photography degree and being sponsored by Kodak, Julia launched her own photographic business, Viva Photography. She specializes in model portfolio shots, portraits, and beauty photography commissions. She has also found that her career as a model has returned after shooting her own model portfolio. She now combines a career in front of and behind the lens, which makes life very confusing but always enlightening! She can be contacted for photographic commissions and model work at the number given.

p. 204

photographer **Rudi Mühlbauer**

address Kreilerstrasse 13A
81673 München
Germany

telephone +49 (0) 89 432 969

Born in 1965, Rudi has been taking photographs since early childhood. His areas of specialization are: advertising, still life, landscapes, and documentaries. He also does electronic imaging and retouching for advertising agencies.

p. 90

photographer **Dolors Porredon**

address Calle Girona 9
08402 Granollers
Spain

telephone +34 938 703 795

Born in Granollers in 1949, Dolors started her photography career in 1972 as a self-taught photographer. She has subsequently worked on political and humanitarian assignments centered on the human figure in Africa and in Asia. Currently, Dolors collaborates with fashion companies and exhibits portrait photography focused on the subject of infancy and maternity. Her work has been published in newspapers, photography magazines, and on television programs. She has been exhibiting her work since 1985 around Spain and also in Paris, Edinburgh, Cologne, and Brussels. She represented Spain in the World Photography Convention in Ajaccio (Corsica) in 1990 organized by the GNPP Association of French Photographers.

p. 76

photographer **Renata Ratajczyk**

address 323 Rusholme Road,
#1403 Toronto
Ontario
M6H 2Z2 Canada

telephone +1 416 538 1087

email renatara@ica.net

web www.lightvisionart.com

Renata is a photographer and digital artist. Her work includes fashion and fine art portraiture, as well as editorial, travel, and advertising photography. She has a painterly, imaginative, often surrealistic style. She often enhances her work by a variety of techniques including hand-coloring and digital imaging. Her work has been published in a variety of magazines, on book covers, in calendars, on greeting cards, and has been used for advertising. Renata has her own stock library and is represented by several stock agencies. Her studio is located in Toronto, Canada, but she also likes working on location.

p. 140

photographer **Massimo Robecchi**

address 44 Boulevard d'Italie
MC 98000 Monaco
Montecarlo

telephone/fax +33 93 50 18 27

Massimo Robecchi moved to Monaco after several years working in Italy. He specializes in pictures of people and still life. He is represented worldwide by Pictor International for stock photos.

p. 50

photographer **Terry Ryan**

address Terry Ryan Photography
193 Charles Street
Leicester LE1 1LA
UK

telephone +44 (0)116 254 4661

fax +44 (0)116 247 0933

Terry Ryan is one of those photographers whose work is constantly seen by a discerning public without receiving the credit it deserves. His clients include The Boots Company Ltd, British Midlands Airways, Britvic, Grattans, Pedigree Petfoods, the Regent Belt Company, Volkswagen, and Weetabix. The dominating factors in his work are an imaginative and original approach. His style has no bounds and he can turn his hand equally to indoor and outdoor settings. He is meticulous in composition, differential focus, and precise cropping, but equally, he uses space generously where the layout permits a pictorial composition. His work shows the cohesion one would expect from a versatile artist: he is never a jack-of-all-trades, and his pictures are always exciting.

pp. 78, 212

photographer **Gérard de Saint-Maxent**

address 8, rue Pierre l'Homme
92400 Courberoie
France

telephone +31 (1) 47 88 40 60

Gérard de Saint-Maxent has worked in advertising and publicity since 1970. He specializes in black and white photography.

pp. 114, 206

photographer **Kazuo Sakai**

address Studio Chips
Daiei Building, 3F
10-18 Kyomachi Bori 1
Nishiku, Osaka
550-0003 Japan

telephone +81 6 447 0719

fax +81 6 447 7509

Born and raised in the Osaka area of Japan, Sakai has run the independent Studio Chips since 1985. He uses both traditional and digital technology to achieve the final result.

p. 146

photographer **Craig Scoffone**

address Craig Scoffone Studios
P.O. Box 8426
San Jose California
95155 USA

telephone +1 408 295 0519

email csoff@inow.com

web www.scoffone-
studios.com

Craig Scoffone has been producing top-level photographic images for San Francisco Bay Area clients for more than 15 years. Besides producing fashion images, Craig also supplies Silicon Valley-based companies with product photography.

p. 124

photographer **Alan Sheldon**

pager +44 (0)20 87000

code 0392243

Alan Sheldon photographs people. For the last few years he has specialized more and more in celebrity shots, with a lot of emphasis on videos, CD, press, and PR. His clients include Carlton, *ES* magazine, Virgin, Absolut Vodka, and Planet Hollywood. He shoots at parties, on location, and in the studio. In his personal work, he has been heavily influenced by Richard Avedon, though when he was an assistant he also worked with names like Annie Leibowitz.

pp. 26, 28, 32, 52, 86

photographer **Antonio Traza**

address 8 St Paul's Avenue
London NW2 5SX
UK

telephone/fax +44 (0)20 8459 7374

cell +44 (0)468 077 044

Antonio Traza specializes in photography for advertising, editorial, and design groups. His images include work in portraiture, fashion, and fine art.

p. 126

photographer **Günther Uttendorfer**

address Photography and Video
Geliusstrasse 9
12203 Berlin
Germany

telephone +49 (30) 834 1214

fax +49 (30) 834 1214

Günther says, "I moved to Berlin because this city gives me great inspiration. My style of photography nowadays shows my affinity with shooting movies. If I'm shooting women I always try to get one special side of their character on to the pictures."

pp. 236

photographer **Frank Wartenberg**

address Leverkusenstrasse 25
22761 Hamburg
Germany

telephone +49 (40) 850 8331

fax +49 (40) 850 3991

email mail@wartenberg-
photo.com

web www.frank-
wartenberg.com

Frank began his career in photography alongside a law degree, when he was employed as a freelance photographer to do concert photos. He was one of the first photographers to take pictures of The Police, The Cure, and Pink Floyd in Hamburg. He then moved into fashion photography. Since 1990 he has run his own studio and is active in international advertising and fashion markets. He specializes in lighting effects in his photography and also produces black and white portraits and erotic prints.

pp. 34, 36, 44, 72, 88, 118, 130, 158, 160, 174, 182, 188, 200, 208, 214, 218, 220, 226, 230, 232, 234, 242

photographer **Stu Williamson**

address Stu Williamson
Photography
Railway Station House
Rockingham Road
Market Harborough
Leicestershire
LE16 7QE, UK

telephone +44 (0)1858 469544

fax +44 (0)1858 469544

email info@stuwilliamson.com

web www.stuwilliamson.com

A former session drummer, Stu turned professional photographer in 1981. He has won most of the major photographic awards in the UK as well as lecturing worldwide for Ilford, Kodak, KJP (Bowens), Pentax, Contax, Lastolite, BIPP, and the MPA. He became well known for his "Hollywood" makeover style using the Lastolite Tri-Flector, which he invented, working in both monochrome and color. He now works almost exclusively in monochrome, both commercially and in fine art photography—his clients value his unique way of seeing—and sells to European calendar companies via his London agents.

p. 62